THE PORTABLE VAN GOGH

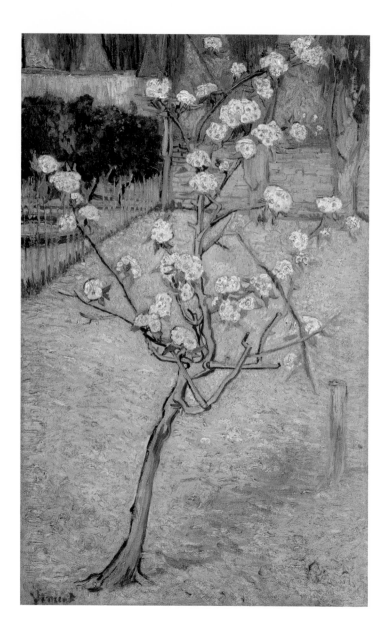

THE PORTABLE

VAN GOGH

with an essay by *Robert Hughes*

UNIVERSE

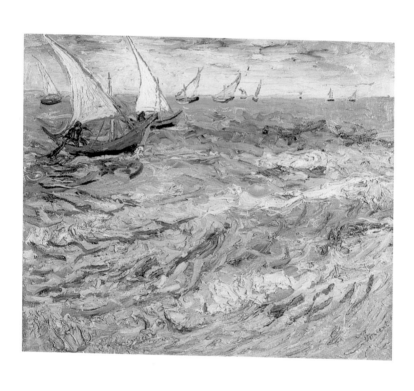

CONTENTS

F ew artists have been more driven by the need for self-expression than the irritable and impatient Dutchman Vincent van Gogh (1853–1890). Even if none of his paintings had survived, the letters he wrote to his brother Theo — more than 750 of them have been preserved — would still be a masterpiece of confessional writing, the product of a mind literally obsessed with the need to explain itself, to reveal its passions and make its most intimate crises known. As a kind of failed monk, maddened by inequality and social wrongdoing, van Gogh was one of the holy scapegoats of nineteenth-century materialism; and the pitch of what he called his "terrible lucidity" was so high that anyone can still hear it — which is why *Sunflowers*, painted in 1888, remains much the most popular still life in the history of art, the botanical answer to the *Mona Lisa*.

Van Gogh's greatest triumphs as a painter were achieved in Provence, and he had gone there to provoke them. The light of the South, he hoped, would fill his paintings with a chromatic intensity strong enough to act on the soul and speak to the moral faculties. No painter could have been less concerned with Impressionist happiness than van Gogh, which was just as well, since none was less equipped to enjoy it. One cannot imagine the colorists of the next generation, men like Matisse or Derain, assigning the psychological and moral weight to color that van Gogh did; not because they were frivolous, but because their seriousness took a less didactic and religious turn than the Dutchman's. Van Gogh was one of the comparatively few artists whose anguish really was inextricable from his talent, which is why it is still difficult to visualize, without a twinge of nausea, one of those writhing, heat-struck visions from Arles or Saint-Rémy hanging in a millionaire's drawing room.

Most of van Gogh's motifs in Arles itself have disappeared. The Yellow House has vanished, his room is no more, and the night café — in whose billiard parlor he had tried, he said, by means of an acid green and a violent red "to express the terrible passions of

humanity [and] the idea that the café is a place where one can ruin oneself, run mad, or commit a crime" — was torn down decades ago. But the look of the lunatic asylum at Saint-Rémy, and the landscape around it, is still remarkably unchanged. For a year and eight days, from May 1889 to May 1890, van Gogh was under treatment there. This "treatment" consisted of little more than cold baths, and what his illness was, nobody can say with confidence. The one fact that everyone knows about its symptoms was that, in the aftermath of a raging quarrel with his friend Gauguin, he cut off his earlobe and presented it, as a mock eucharist, to a prostitute in Arles. We say he suffered from manic depression, which is a way of skirting issues of the mind that we still hardly comprehend. It did not prevent him from seeing clearly, or recording what he saw; the Saint-Rémy madhouse still looks exactly like his paintings, down to the last detail of the rough stone benches, the ochre stucco of its garden façade, and even the irises blooming in its roughly tended flower beds. "There are people who love nature even though they are cracked and ill," he wrote to Theo van Gogh; "those are the painters." He had fits of despair and hallucination during which he could not work, and in between them, long clear months in which he could and did, punctuated by moments of extreme visionary ecstasy.

In these moments, recorded in such paintings as *The Starry Night*, 1889, everything van Gogh saw was swept up in a current of energy. Sight is translated into a thick, emphatic plasma of paint, eddying along linear paths defined by the jabbing motion of his brush strokes as though nature were opening its veins. The curling tide of stars in the middle of the sky may have been unconsciously influenced by Hokusai's *Great Wave* — van Gogh was an avid student of Japanese prints — but its rushing pressure has no parallel in Oriental art. The moon comes out of eclipse, the stars blaze and heave, and the cypresses move with them, translating the rhythms of the sky into the black writhing of their flamelike silhouette. They commit the turbulence of heaven to the earth, completing a circuit of energy throughout all nature. More alive than any painted tree had ever been (and more so than any real cypress looks), these trees of the South, traditionally associated with death and cemeteries, had an emblematic value for van Gogh. "The

cypresses are always occupying my thoughts — it astonishes me that they have never been done as I see them. The cypress is as beautiful in line and proportion as an Egyptian obelisk — a splash of *black* in a sunny landscape." Even the church spire partakes of this general heightening. There is no church near Saint-Rémy with a spire that looks remotely like the tall Gothic spike in *The Starry Night*. It seems to be a northern fantasy, not a Provençal fact.

On the other hand, one can walk in the olive groves outside the asylum walls and measure the way he changed them, resolving the form of the dry grasses and the flickering blue shadows on them into sprays of paint strokes, and turning the olive trunks themselves into bodies grown cankered and arthritic with bearing, like the knobbly Dutch proletarian bodies he had painted at Nuenen. Again there is the sense of a continuous field of energy of which nature is a manifestation; it pours through the light and rises from the ground, solidifying in the trees. Because olives grow so slowly, the broad relationships of tree and field, foreground and background that van Gogh grasped in the landscape near the asylum have changed very little in the last century, so that many of the motifs he painted within five hundred yards of the gate are still quite recognizable. One can still pick, with reasonable accuracy, the spot from which he took his view over the grove towards the convulsed grey horizon of Les Alpilles. But there was at least one motif inside that radius that any other northern painter coming to Provence would have seized on with gratitude: one can imagine what Turner might have made of the Roman ruins of Glanum, just across the road from the asylum. Van Gogh never painted them. Only Christian ceremonial architecture interested him — that, or the humblest cottages and cafés — and presumably the relics of colonizing Rome were filled with authoritarian suggestions that he would not admit to his own field of symbols.

Art influences nature, and van Gogh's sense of an immanent power behind the natural world was so intense that, once one has seen his Saint-Rémy paintings, one has no choice but to see the real places in terms of them — without necessarily seeing what he saw. In this way the eye deduces what he wanted to typify, finding those aspects of nature that he could isolate as symbols. One of these was a complicated though ad hoc sense of rhymes within natural forms:

similarities between the near and the far, which suggested a continuous thumbprint of creation, a pervasive identity marking the world. Faced with the strange contortions of limestone that make up the low mountain range between Saint-Rémy and Les Baux, another painter might have found them formless and unpaintable; one can imagine them appealing to Mathias Grünewald, or to the Leonardo of the Deluge drawings, but never to Poussin or Corot. Van Gogh, however, found in them a perfect rhyme between their fierce plasticity when seen from afar, the tendonlike clenching and uncoiling of the boulders against the sky, and the crowding of details within the larger form: the channels, veins, and scooped hollows of the limestone and how these resemble the grain of old olive roots, silvery-grey as well; how the macroscopic finds its echo in the microscopic view; and how both together accord with the twisting linework of his brush.

One of van Gogh's favorite sights was over the Plaine de la Crau, the alluvial basin that stretches away below Les Baux. Its flat fields, portioned by hedgerows and lanes, offered him a strenuous exercise in notation; their monotony demanded close looking. The plain was, he said, "as infinite as the sea" — only more interesting, because people lived on it. If he had used a routinely "expressive" way of drawing it, with all detail subjugated to generalized scribbles and blots, van Gogh's ink studies of the Plaine de la Crau would have been featureless. Instead, like one of the Japanese *sume-e* painters he admired, he was able to work out a different kind of mark for every natural feature of the landscape, near and far, thus avoiding the narcissistic thinning out of the world that goes with shallow Expressionism. Few drawings in the history of landscape have the richness of surface that van Gogh gave to his Provençal sketches. The life of the landscape seems to be bursting through the paper in myriad marks, the brown ink becoming almost as eloquent as the color in his paintings.

However concentrated they became — and some of his self-portraits, like the gaunt face that stares from its background of ice-blue whorls in the Louvre, 1889, bring the act of self-scrutiny to a pitch no painter since Rembrandt in his old age had reached — van Gogh's paintings were not the work of a madman; they were done by an ecstatic who was also a great formal artist. Today the doctors

would give him lithium and tranquillizers, and we would probably not have the paintings: had the obsessions been banished, the exorcising power of the art could well have leaked away. Van Gogh confronted the world with an insecure joy. Nature was to him both exquisite and terrible. It consoled him, but it was his judge. It was the fingerprint of God, but the finger was always pointed at him.

Sometimes the gaze of God was, too: the disc of the sun, huge and searching, the emblem of merciless Apollo. The color on which his search for emotional truth converged was yellow — an extraordinarily difficult color to handle because it has few levels of value. "A sun, a light, which for want of a better word I must call pale sulphur-yellow, pale lemon, gold. How beautiful yellow is!" What van Gogh called "the gravity of great sunlight effects" filled his work and freed him to try odd emblematic compositions such as the figure of *Sower with Setting Sun*, 1888, a blackened silhouette, shrivelled by the chromatic pressure of the sun-disc behind it, letting fall the yellow streaks of grain (like flakes of sunlight) on the earth. Such paintings were filled with a symbolism that one can only call religious, although it has nothing to do with orthodox Christian iconography. The dominating presence of the sun conveys the idea that life is lived under the influence of an immense exterior will, and that work like sowing and reaping is not simply work but an allegory of life and death. Explaining the companion piece to *Sower with Setting Sun*, a man with a sickle moving through a writhing field of pollen-colored paint, van Gogh wrote to Theo that "I saw in this reaper — a vague figure struggling in great heat to finish his task — I saw then in it the image of death, in the sense that humanity would be the wheat one reaps; so it is, if you like, the opposite of the sower I tried before. I find it strange that I saw like this through the iron bars of a cell."

So it is wrong to suppose that van Gogh's color — rich and exquisitely lyrical though it is — was meant simply as an expression of pleasure. Moral purpose is never distant, and rarely absent, from his Provençal landscapes; they are utterances of the religious heart, and their central premise, that nature can be seen to reflect simultaneously the will of its Creator and the passions of its observers, is one of the most striking examples of the "pathetic fallacy" in painting. It was also of central importance to later Expres-

sionism. Van Gogh was only thirty-seven when he shot himself, but in the four years from 1886 to 1890, he had changed the history of art. The freedom of modernist color, the way emotion can be worked on by purely optical means, was one of his legacies — as it was Gauguin's, too. But van Gogh had gone further than Gauguin; he had opened the modernist syntax of color wider, to admit pity and terror as well as formal research and pleasure. He had been able to locate more cathartic emotion in a vase of sunflowers than Gauguin, with his more refined Symbolist sense of allegory, had been able to inject into a dozen figures. Van Gogh, in short, was the hinge on which nineteenth-century Romanticism finally swung into twentieth-century Expressionism.

 —ROBERT HUGHES

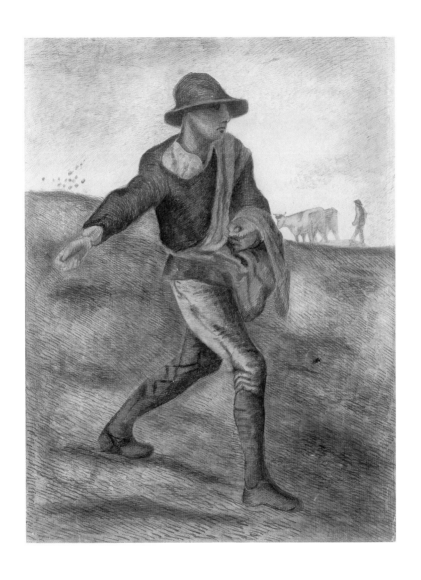

Sower (after Millet) · April–May 1881

Van Gogh Museum, Amsterdam

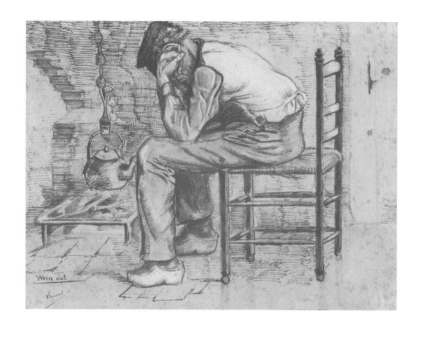

Peasant Sitting by the Fireplace ("Worn out") · September 1881
P. and N. de Boer Foundation, Amsterdam

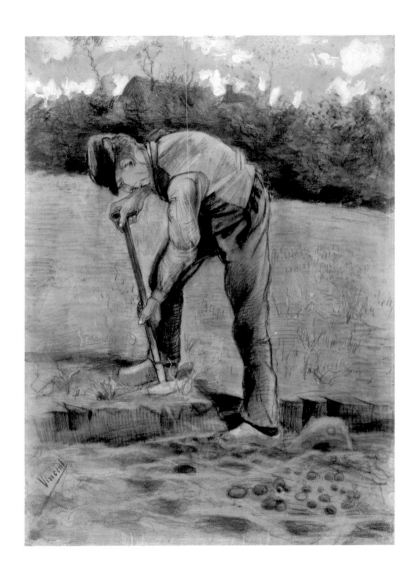

Digger · October 1881
Van Gogh Museum, Amsterdam

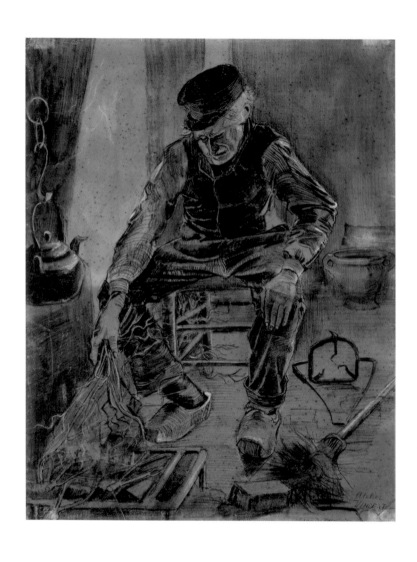

Farmer Sitting at the Fireplace · November 1881
Kröller-Müller Museum, Otterlo

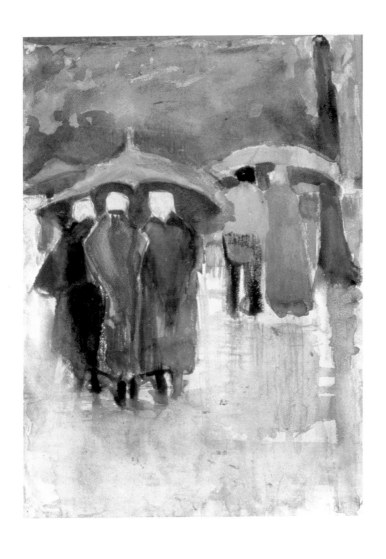

Scheveningen Women and Other People under Umbrellas · July 1882

Haags Gemeentemuseum, The Hague

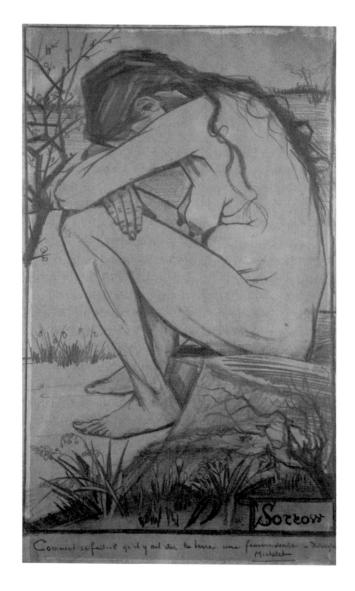

Sorrow · April 1882

Walsall Museum and Art Gallery, Walsall

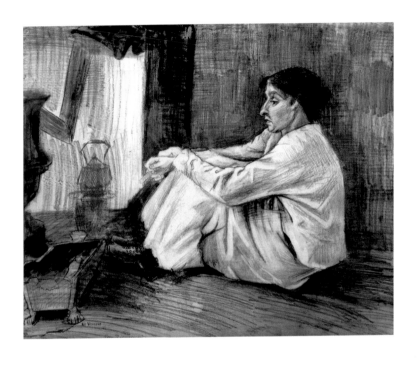

Sien with Cigar Sitting on the Floor near Stove · April 1882
Kröller-Müller Museum, Otterlo

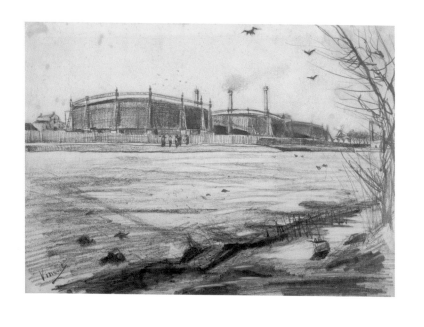

Gas Tanks · March 1882
Van Gogh Museum, Amsterdam

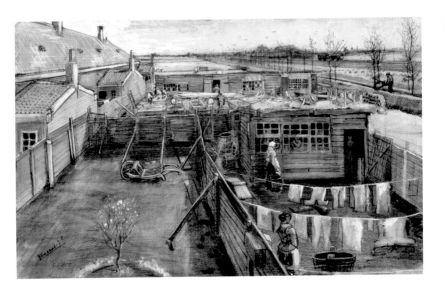

Carpenter's Yard and Laundry · May 1882
Kröller-Müller Museum, Otterlo

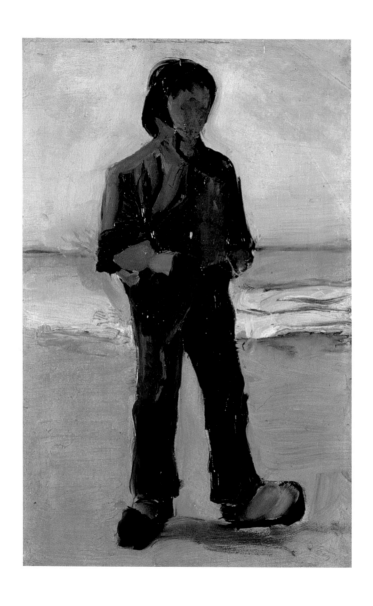

Fisherman on the Beach · August 1882

Kröller-Müller Museum, Otterlo

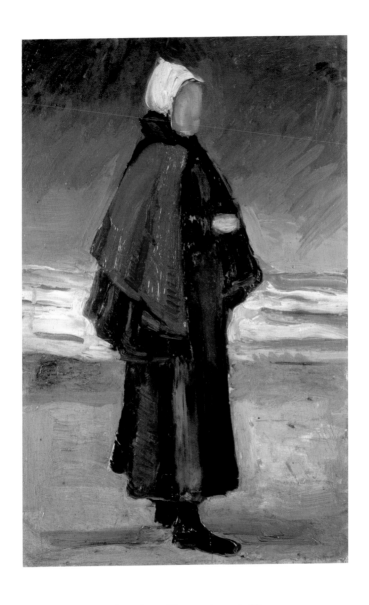

Scheveningen Woman · August 1882
Kröller-Müller Museum, Otterlo

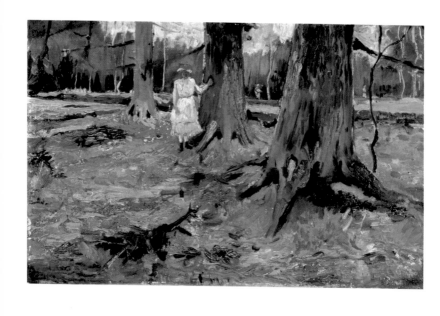

A Girl in a Wood · August 1882
Kröller-Müller Museum, Otterlo

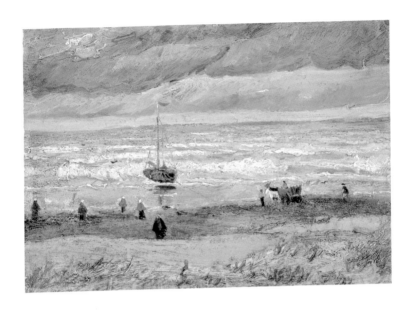

Beach with Figures and Sea with a Ship · August 1882
Van Gogh Museum, Amsterdam

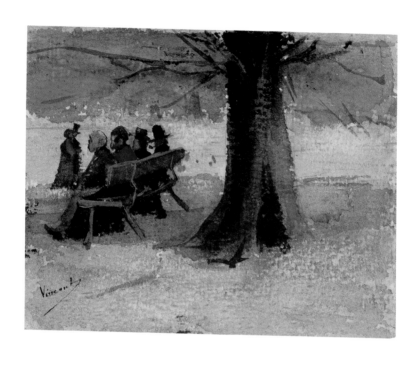

Bench with Four Persons · September 1882
Van Gogh Museum, Amsterdam

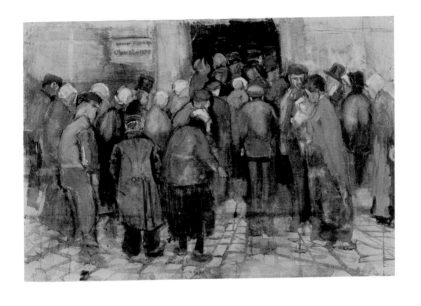

The State Lottery Office · September 1882
Van Gogh Museum, Amsterdam

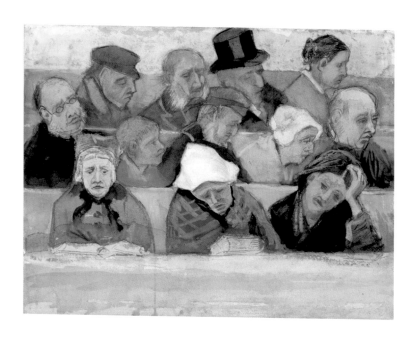

Church Pew with Worshippers · September 1882
Kröller-Müller Museum, Otterlo

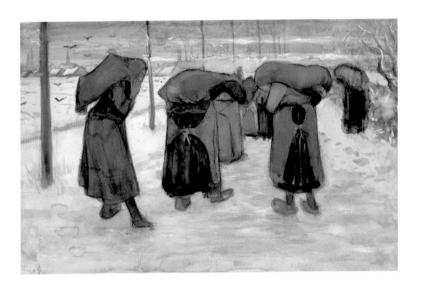

Women Miners · November 1882
Kröller-Müller Museum, Otterlo

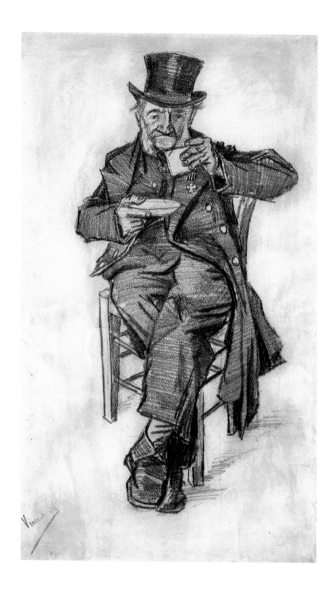

Orphan Man with Top Hat, Drinking Coffee · November 1882
Van Gogh Museum, Amsterdam

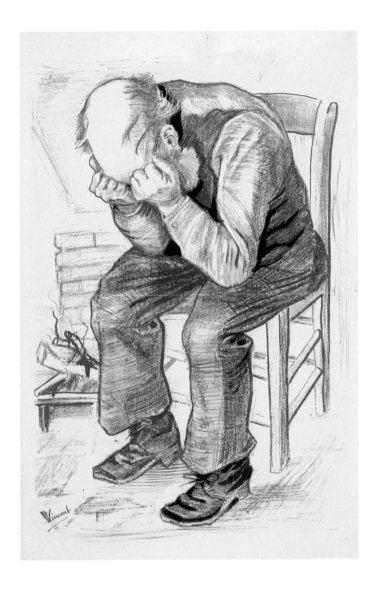

Old Man with His Head in His Hands ("At Eternity's Gate") · November 1882
Van Gogh Museum, Amsterdam

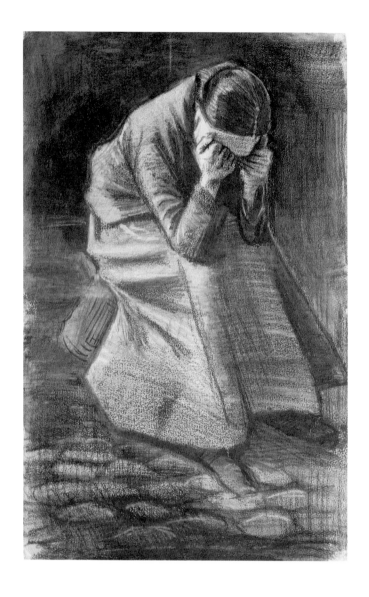

Woman Sitting on a Basket, with Head in Hands · March 1883
The Art Institute of Chicago, Chicago

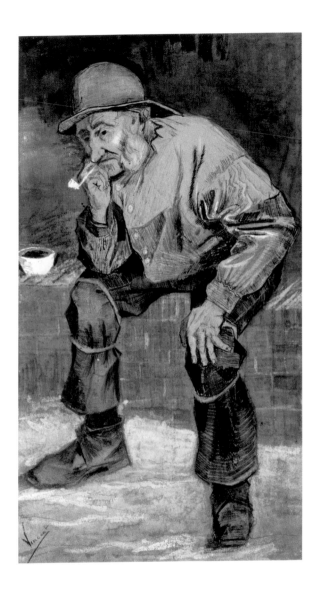

Fisherman with Sou'wester, Sitting with Pipe · February 1883

Kröller-Müller Museum, Otterlo

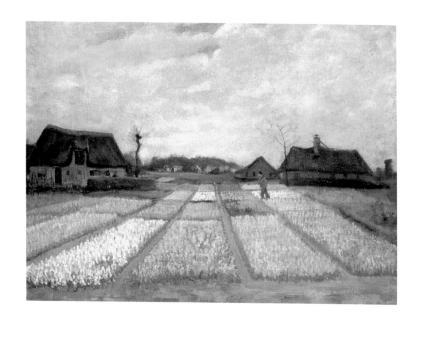

Bulb Field · April 1883
National Gallery of Art, Washington, Collection Mr. and Mrs. Paul Mellon

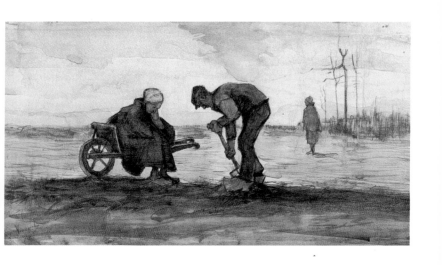

Weed Burner, Sitting on a Wheelbarrow with His Wife · July 1883
Private collection
> **Peat Boat with Two Figures** · October 1883
Drents Museum, Assen

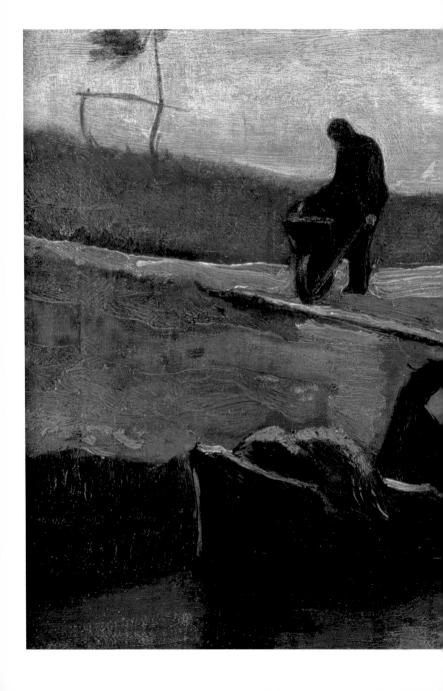

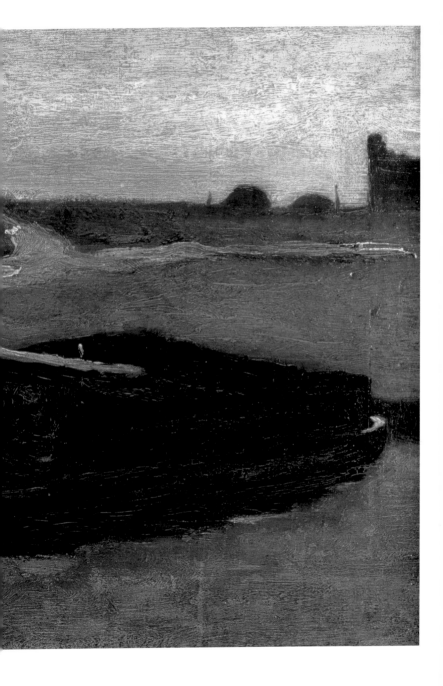

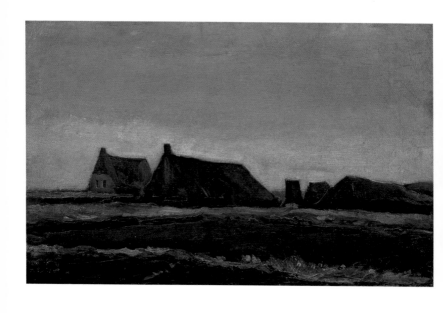

Farms · September–October 1883
Van Gogh Museum, Amsterdam

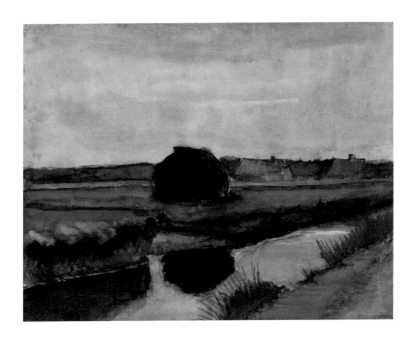

Landscape at Nightfall · October 1883
Van Gogh Museum, Amsterdam

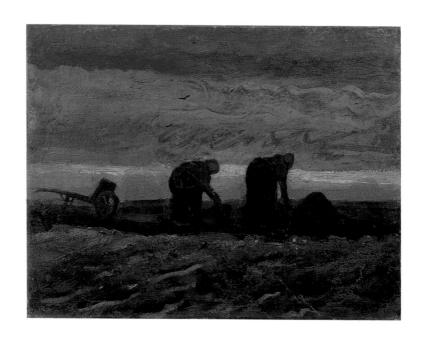

Two Women Working in the Peat · October 1883
Van Gogh Museum, Amsterdam

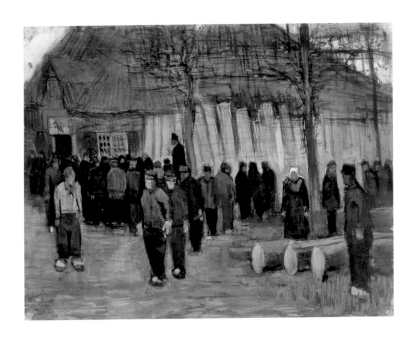

A Timber Auction · December 1883

Van Gogh Museum, Amsterdam

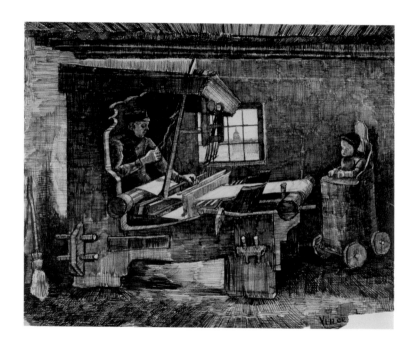

Weaver Facing Right, Interior with One Window and High Chair · January 1884
Van Gogh Museum, Amsterdam

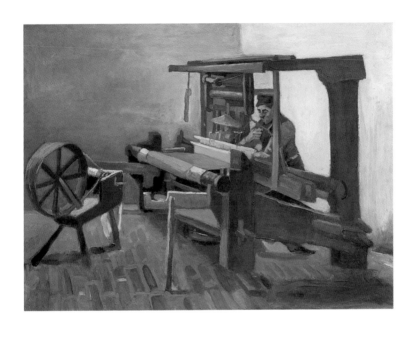

Weaver Facing Left with Spinning Wheel · April 1884

Museum of Fine Arts, Boston

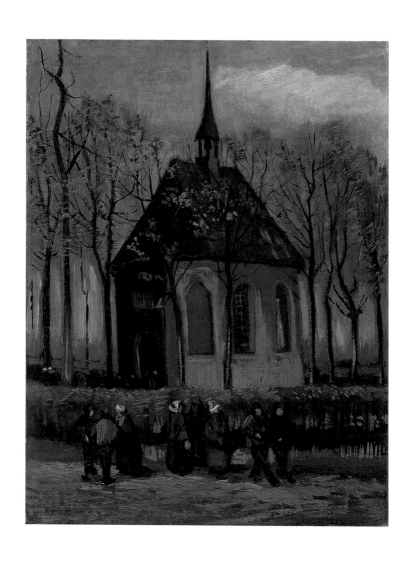

Church in Nuenen with People Leaving · January 1884
Van Gogh Museum, Amsterdam

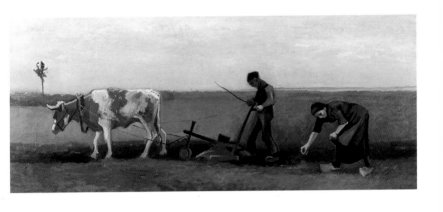

Plowman and Potato Reaper · August 1884
Von der Heydt-Museum, Wuppertal

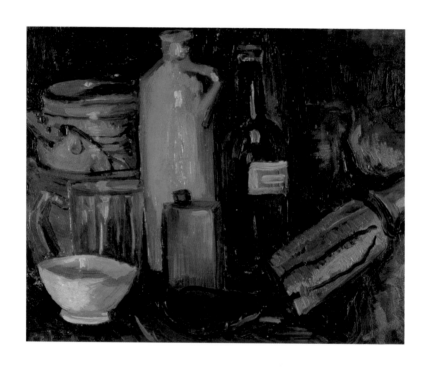

Still Life with Pots, Jar and Bottles · November 1884
Haags Gemeentemuseum, The Hague

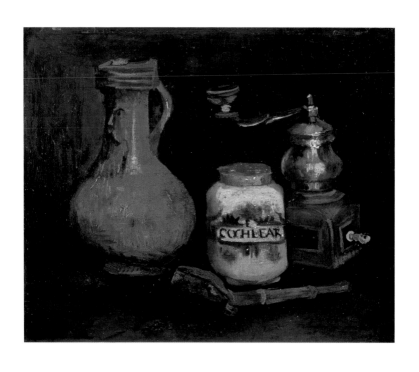

Still Life with a Bearded-Man Jar and Coffee Mill · November 1884
Kröller-Müller Museum, Otterlo

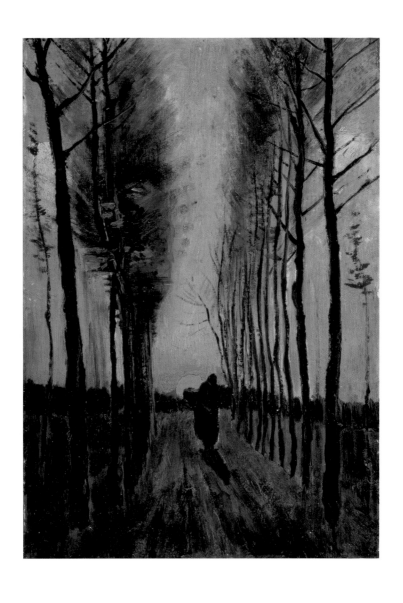

Lane of Poplars at Sunset · October 1884
Kröller-Müller Museum, Otterlo

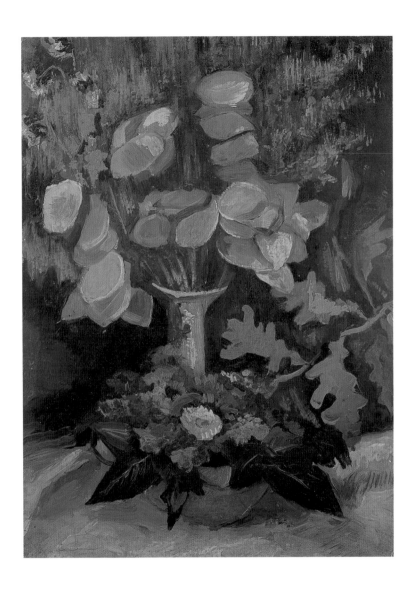

Vase with Honesty · Fall 1884

Van Gogh Museum, Amsterdam

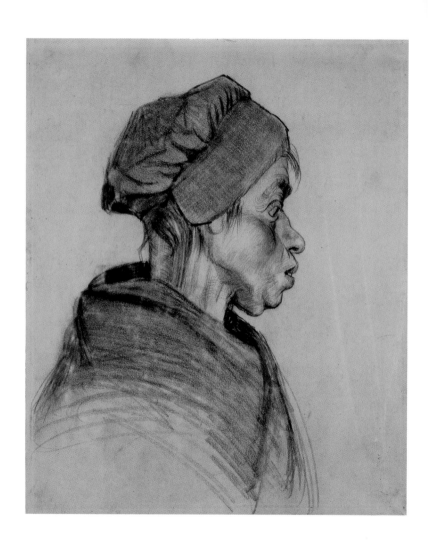

Peasant Woman, Head · December 1884–January 1885
Van Gogh Museum, Amsterdam

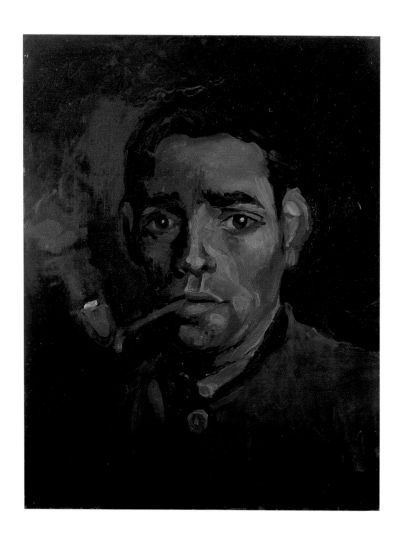

Head of a Young Man, Bareheaded, with Pipe · November 1884–February 1885
Van Gogh Museum, Amsterdam

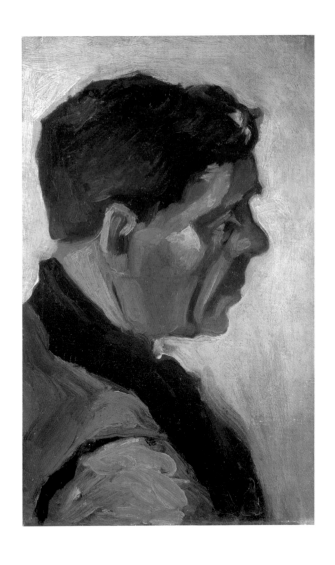

Peasant, Head · January–February 1885
Kröller-Müller Museum, Otterlo

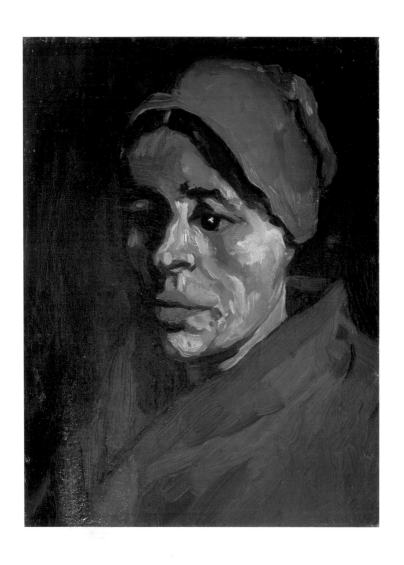

Peasant Woman, Head · February 1885
Kröller-Müller Museum, Otterlo

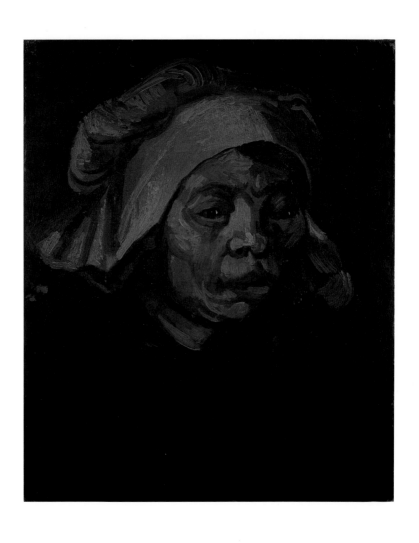

Peasant Woman, Head · March 1885
Van Gogh Museum, Amsterdam

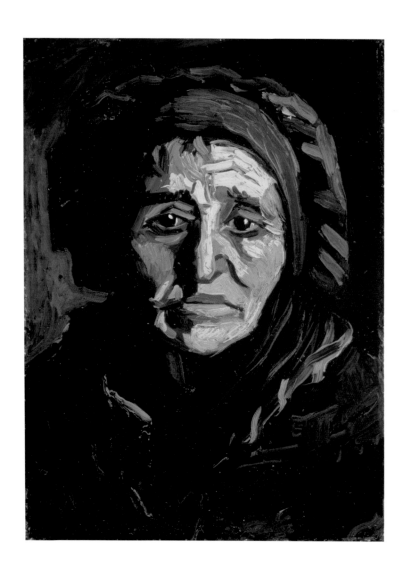

Peasant Woman, Head · February 1885
Kröller-Müller Museum, Otterlo

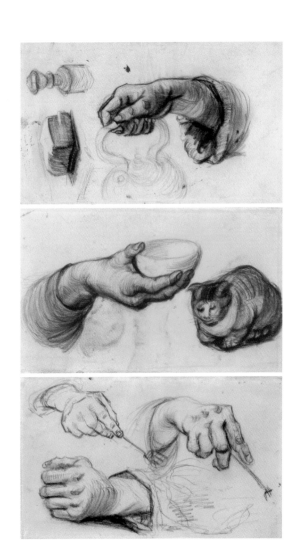

Hand with Handle of a Kettle
Hand with Bowl and Cat
Three Hands, Two with a Fork · April 1885
Van Gogh Museum, Amsterdam

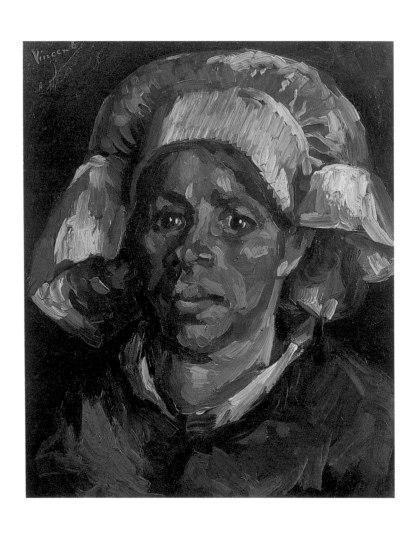

Gordina de Groot, Head · May 1885

Collection Mrs. M.C.R. Taylor, Santa Barbara

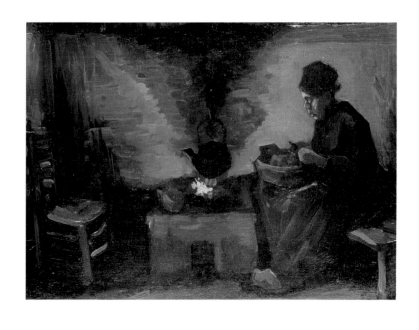

Peasant Woman, Sitting by the Fire · May–June 1885
Musée d'Orsay, Paris

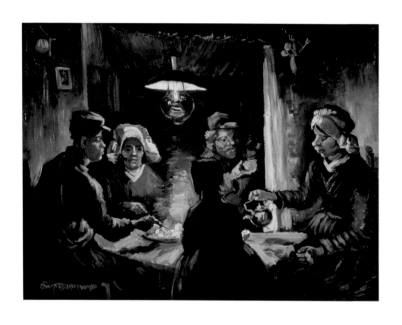

The Potato Eaters · April 1885
Kröller-Müller Museum, Otterlo
> **The Potato Eaters** · April–May 1885
Van Gogh Museum, Amsterdam

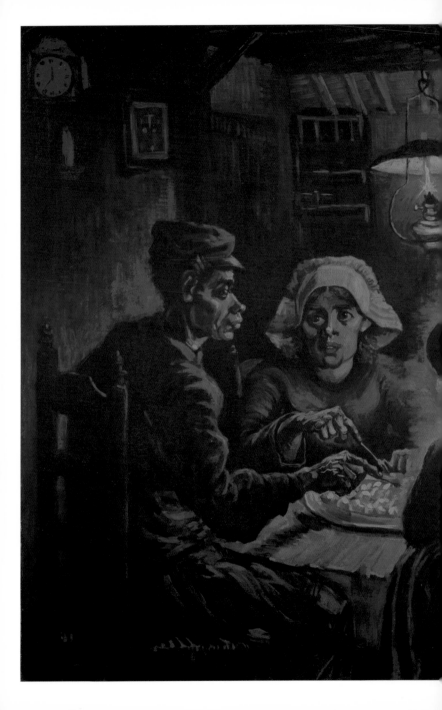

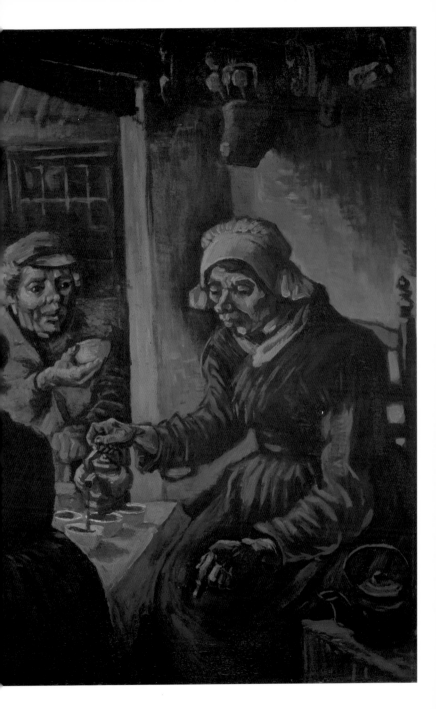

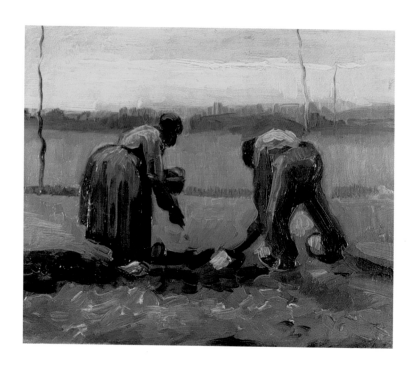

Peasant Man and Woman Planting Potatoes · April 1885
Kunsthaus Zürich

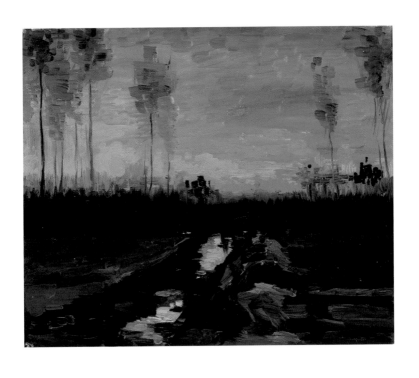

Landscape with Sunset · April 1885?
Museo Thyssen-Bornemisza, Madrid

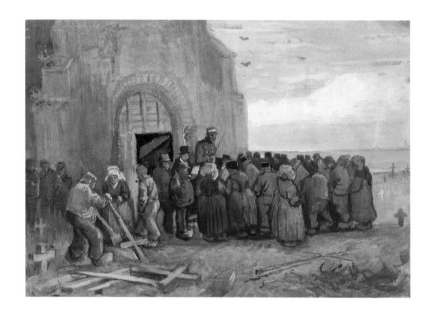

Auction of Crosses near the Old Tower · May 1885
Van Gogh Museum, Amsterdam

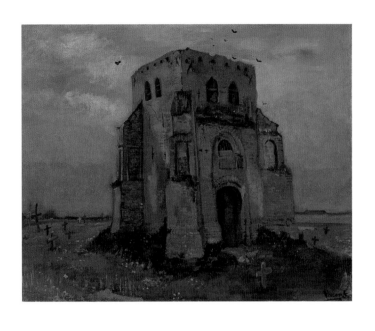

Peasant Cemetery · May–June 1885
Van Gogh Museum, Amsterdam

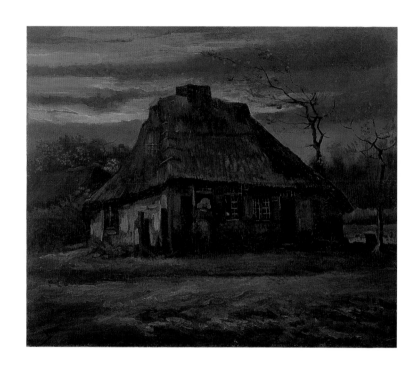

Cottage at Nightfall · May 1885
Van Gogh Museum, Amsterdam

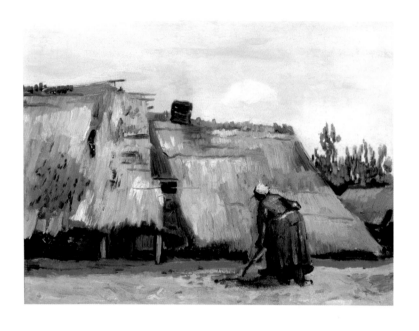

Cottage with Woman Digging · June–July 1885
The Art Institute of Chicago, Chicago

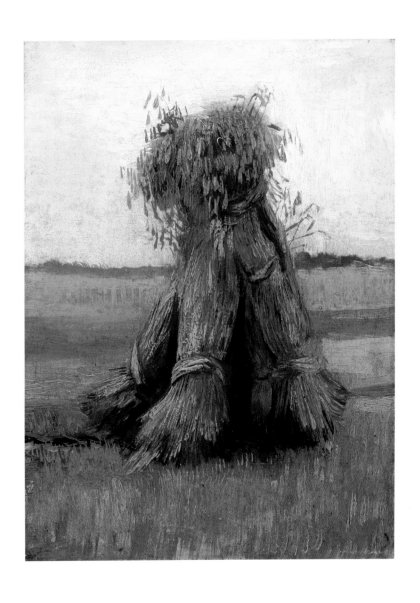

Sheaves of Wheat in a Field · August 1885
Kröller-Müller Museum, Otterlo

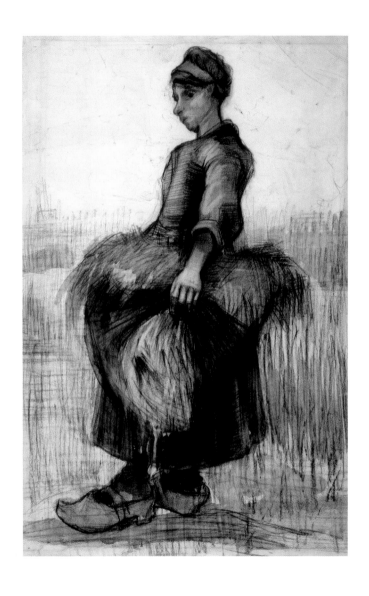

Peasant Woman, Carrying Wheat in Her Apron · August 1885

Kröller-Müller Museum, Otterlo

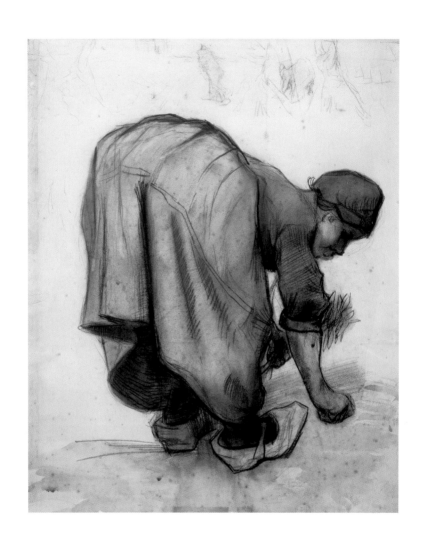

Peasant Woman, Stooping, Seen from the Back · July 1885
Kröller-Müller Museum, Otterlo

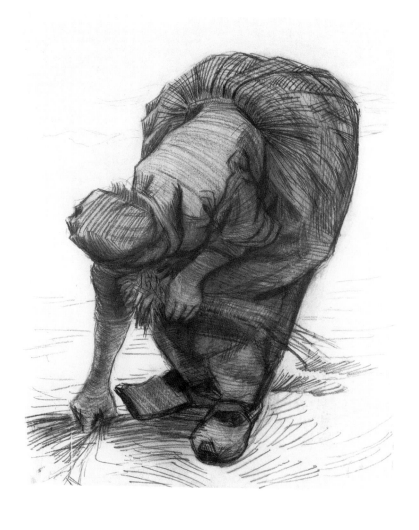

Peasant Woman, Stooping and Gleaning · July 1885
Museum Folkwang, Essen

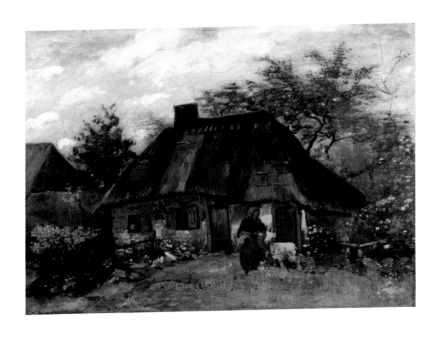

Cottage and Woman with a Goat · June–July 1885

Städelsches Kunstinstitut und Städtische Galerie, Frankfurt am Main

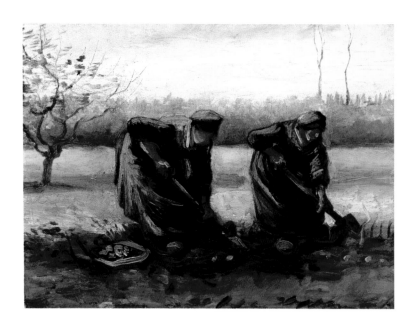

Two Peasant Women Digging Potatoes · August 1885
Kröller-Müller Museum, Otterlo

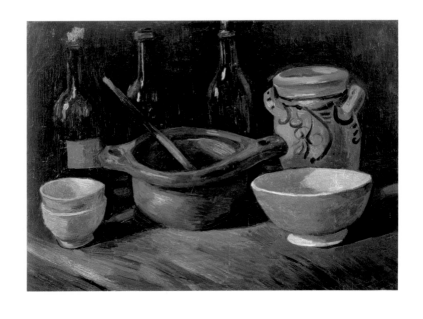

Still Life with Pottery and Three Bottles · November 1884
Van Gogh Museum, Amsterdam

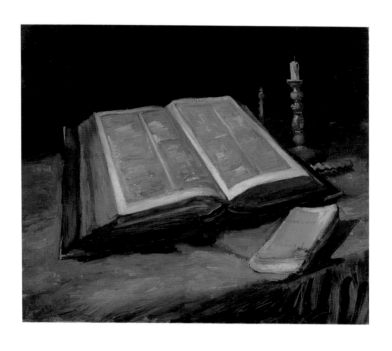

Still Life with Open Bible, Candlestick and Novel · October 1885
Van Gogh Museum, Amsterdam

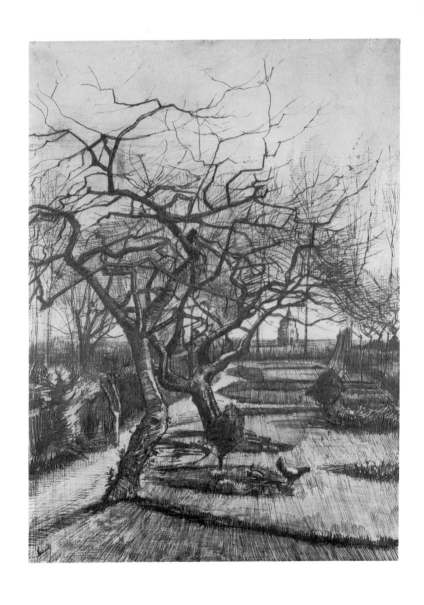

Parsonage Garden · March 1884

Kunstmuseum, Budapest

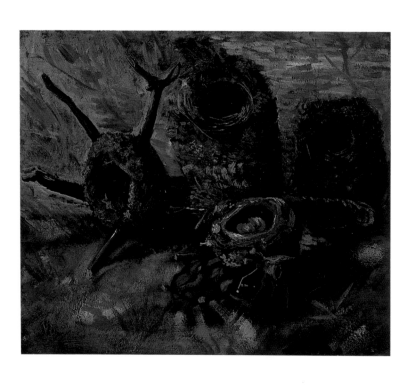

Still Life with Five Birds' Nests · September–October 1885
Van Gogh Museum, Amsterdam

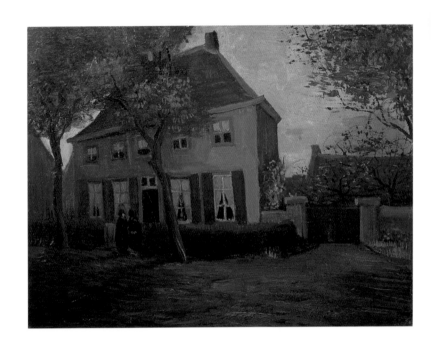

The Parsonage at Nuenen · October 1885
Van Gogh Museum, Amsterdam

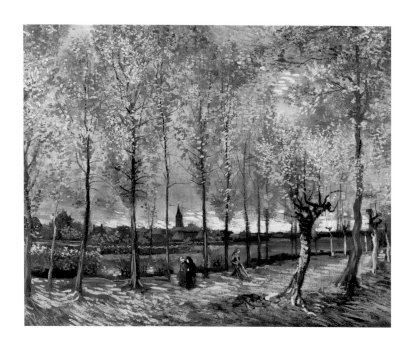

Lane with Poplars · November 1885
Museum Boijmans Van Beuningen, Rotterdam
> **The De Ruijterkade in Amsterdam** · October 1885
Van Gogh Museum, Amsterdam

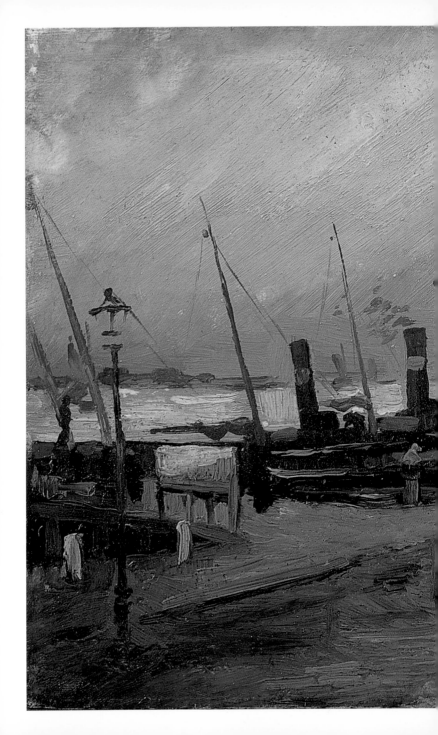

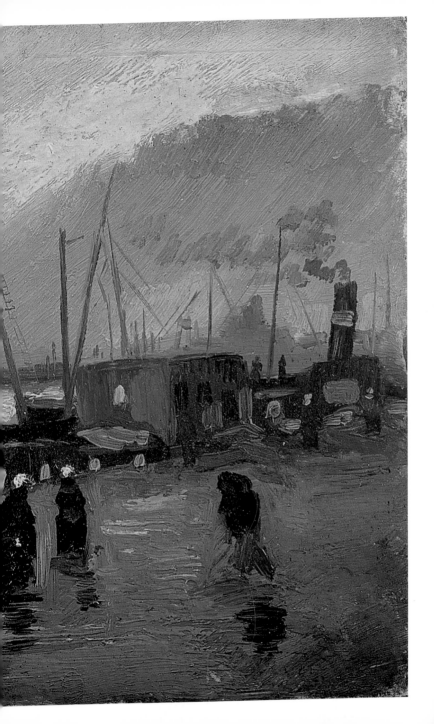

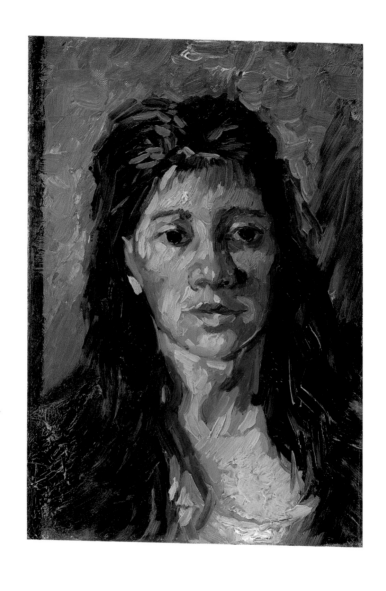

Head of a Woman with Her Hair Loose · December 1885
Van Gogh Museum, Amsterdam

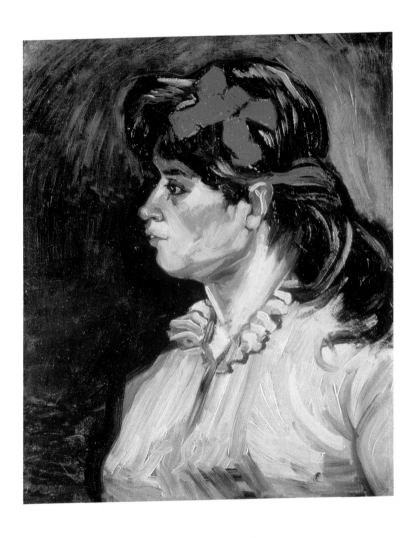

Portrait of a Woman with a Scarlet Bow in Her Hair · December 1885
Collection Alfred Wyler, New York

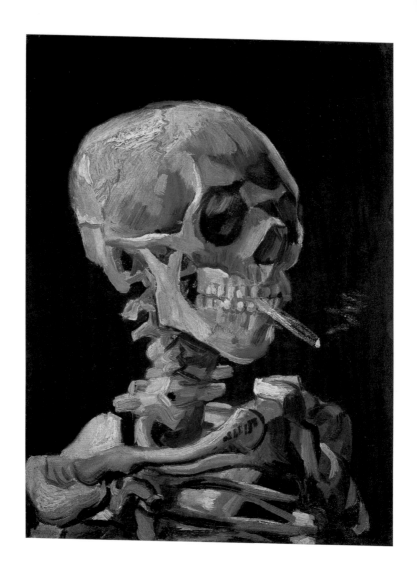

Skull with Burning Cigarette between the Teeth · February 1886
Van Gogh Museum, Amsterdam

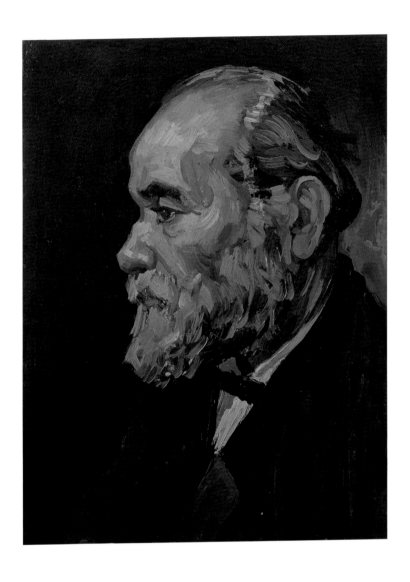

Portrait of an Old Man with Beard · December 1885
Van Gogh Museum, Amsterdam

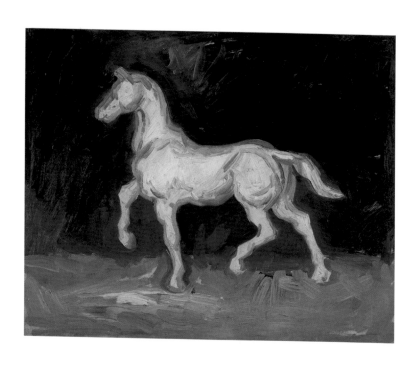

Plaster Statuette of a Horse · Spring 1886
Van Gogh Museum, Amsterdam

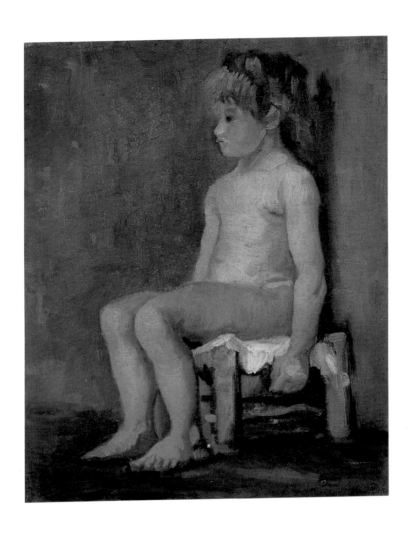

Nude Girl, Sitting · Spring 1886
Van Gogh Museum, Amsterdam

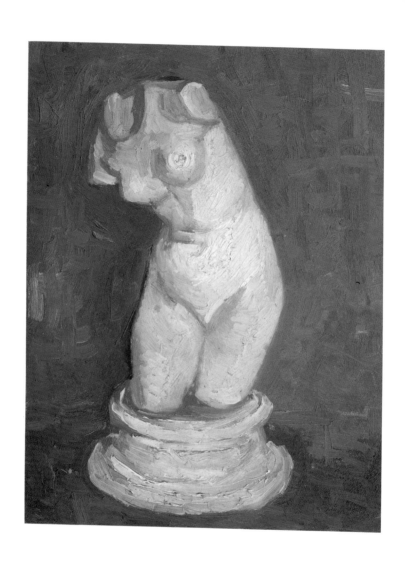

Plaster Statuette of a Female Torso · Spring 1886
Van Gogh Museum, Amsterdam

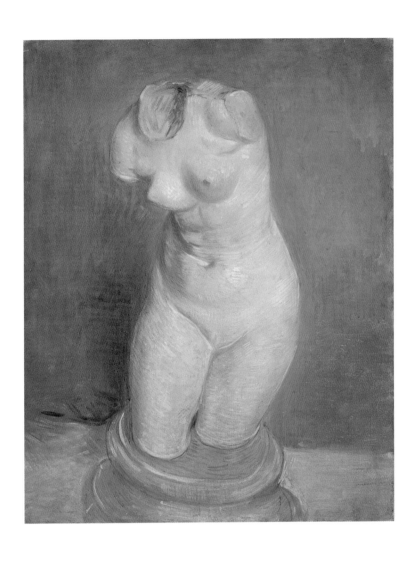

Plaster Statuette of a Female Torso · Spring 1886
Van Gogh Museum, Amsterdam

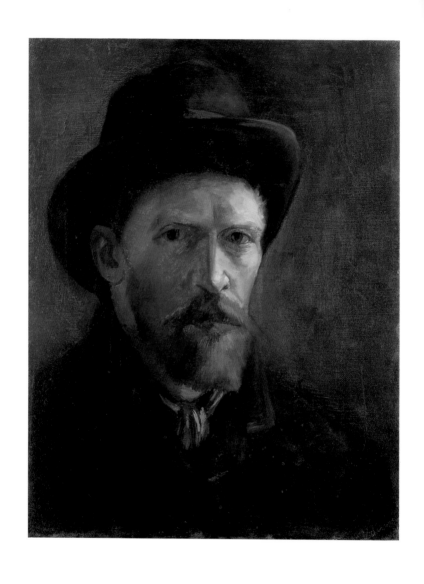

Self-Portrait with Dark Felt Hat · Spring 1886
Van Gogh Museum, Amsterdam

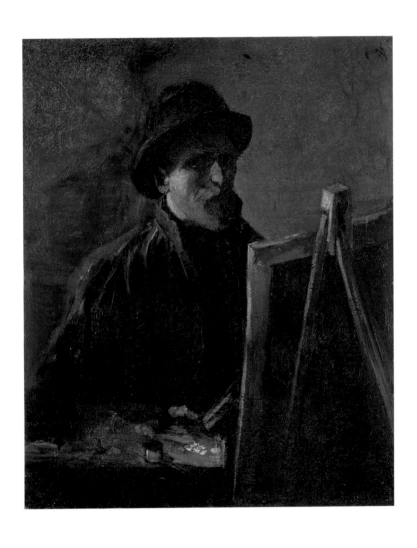

Self-Portrait with Dark Felt Hat in front of the Easel · Spring 1886
Van Gogh Museum, Amsterdam

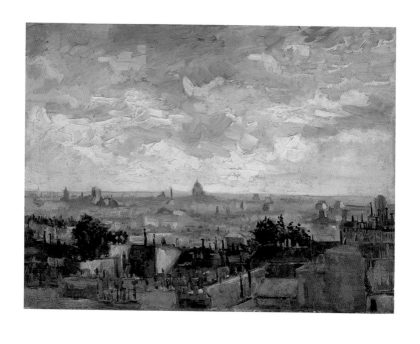

The Roofs of Paris · Spring 1886
Van Gogh Museum, Amsterdam

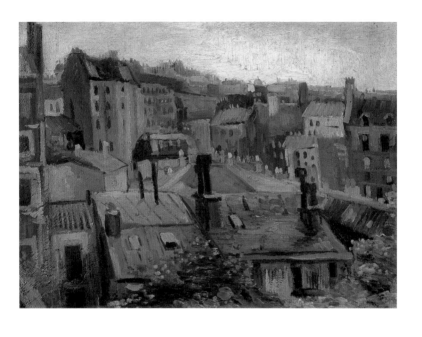

View of Roofs and Backs of Houses · Spring 1886
Van Gogh Museum, Amsterdam

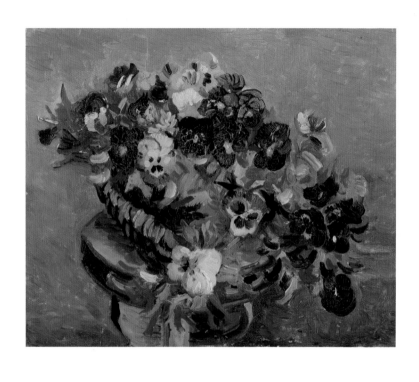

Bowl of Pansies · Spring 1886
Van Gogh Museum, Amsterdam

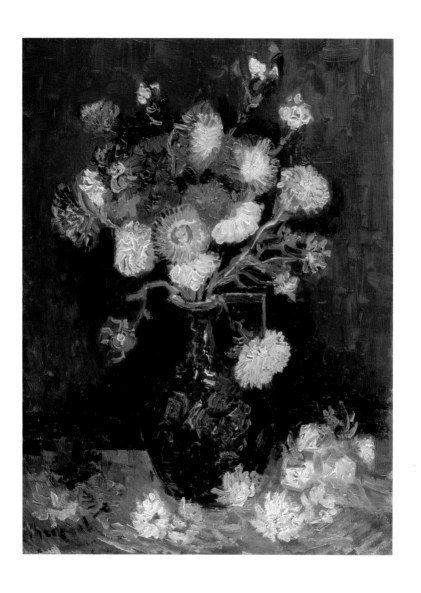

Vase with Asters and Phlox · Summer 1886

Van Gogh Museum, Amsterdam

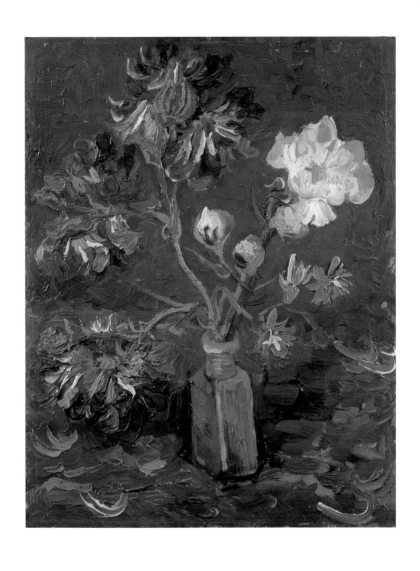

Vase with Myosotis and Peonies · Summer 1886

Van Gogh Museum, Amsterdam

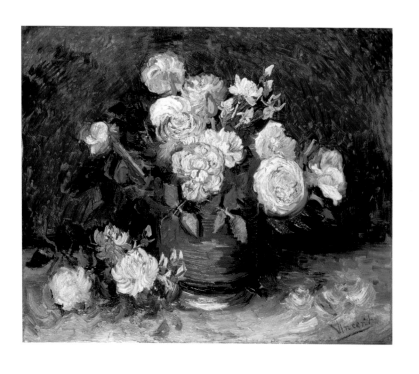

Vase with Peonies and Roses · Summer 1886
Kröller-Müller Museum, Otterlo

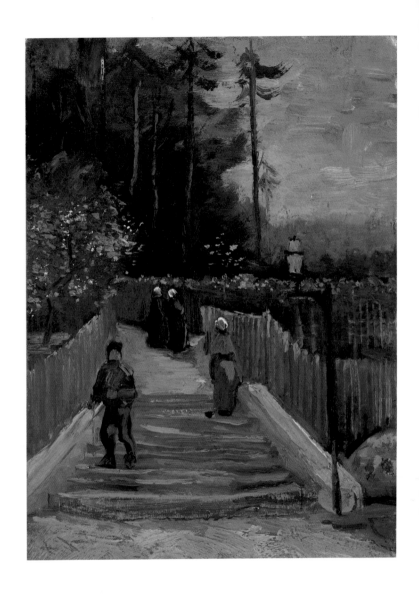

A Path in Montmartre · Summer 1886
Van Gogh Museum, Amsterdam

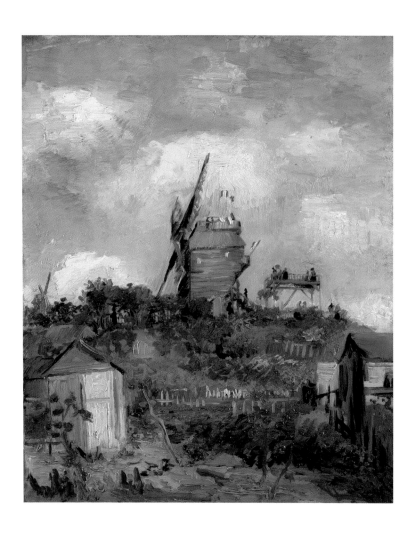

The Moulin de Blute-Fin · Summer 1886

Glasgow Museums: Art Gallery and Museum, Kelvingrove

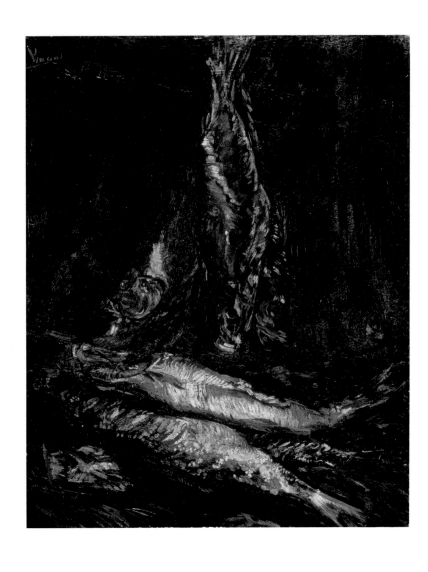

Still Life with Red Herrings · Summer 1886
Kröller-Müller Museum, Otterlo

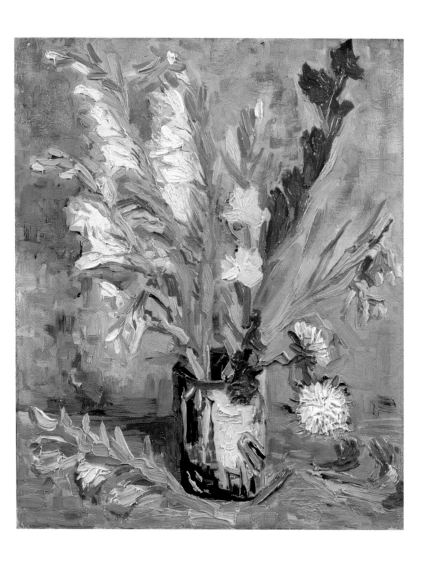

Vase with Gladioli · Summer 1886
Van Gogh Museum, Amsterdam

View of Paris with the Panthéon · Spring 1886
Van Gogh Museum, Amsterdam

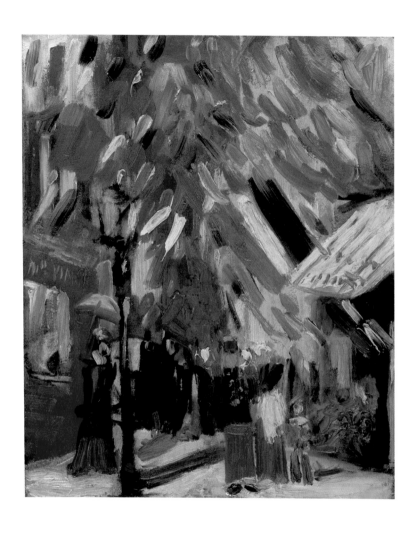

Street Scene, Celebration of Bastille Day · Summer 1886
Villa Flora, Winterthur

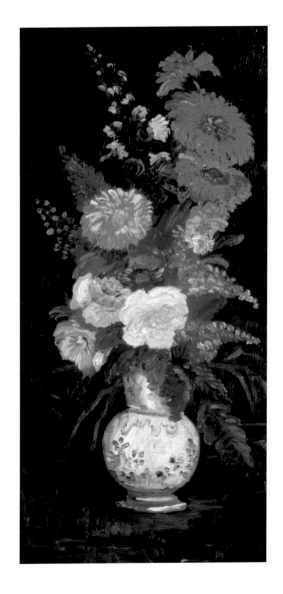

Vase with Asters and Other Flowers · Summer 1886
Haags Gemeentemuseum, The Hague

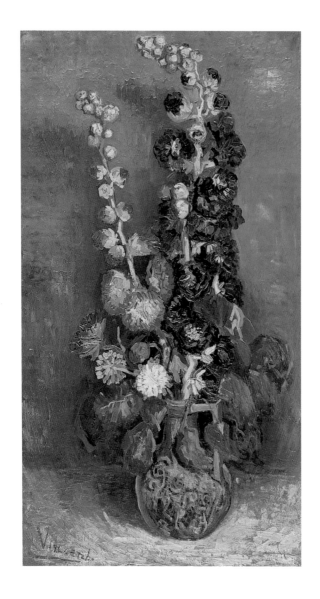

Vase with Hollyhocks · Summer 1886
Kunsthaus Zürich

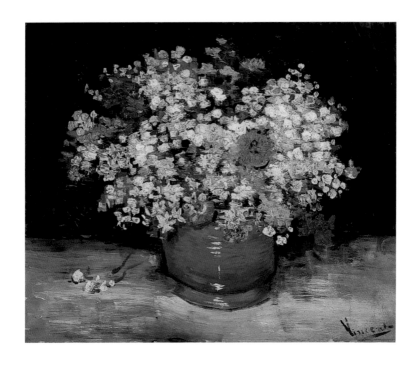

Bowl with Zinnias and Other Flowers · Summer 1886
National Gallery of Canada, Ottawa

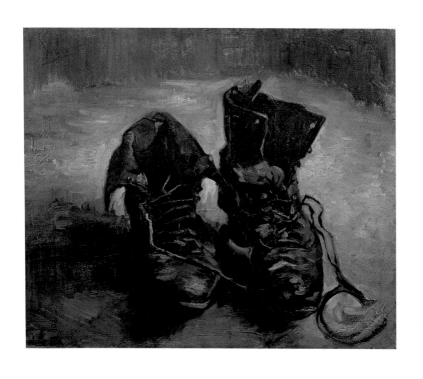

A Pair of Shoes · Summer 1886

Van Gogh Museum, Amsterdam

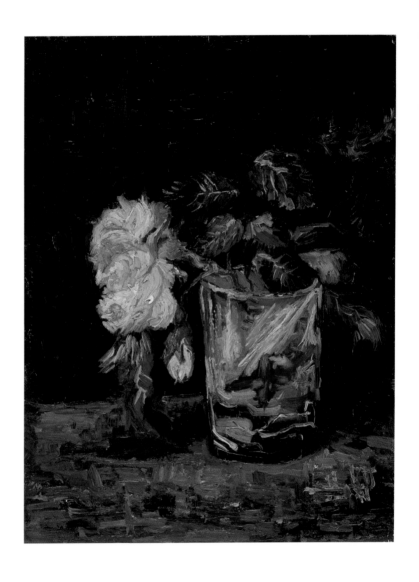

Glass with Roses · Summer 1886
Van Gogh Museum, Amsterdam

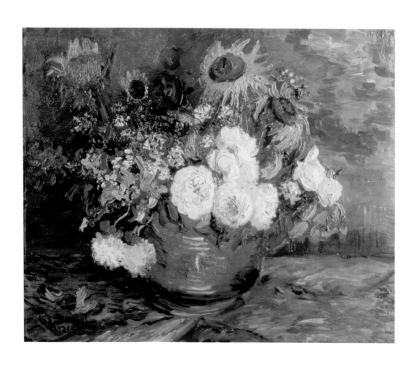

Bowl with Sunflowers, Roses and Other Flowers · Summer 1886
Städtische Kunsthalle, Mannheim

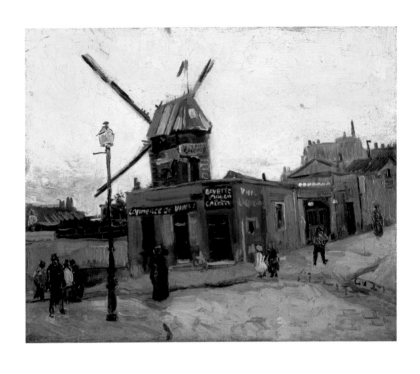

The Moulin de la Galette · Fall 1886

Kröller-Müller Museum, Otterlo

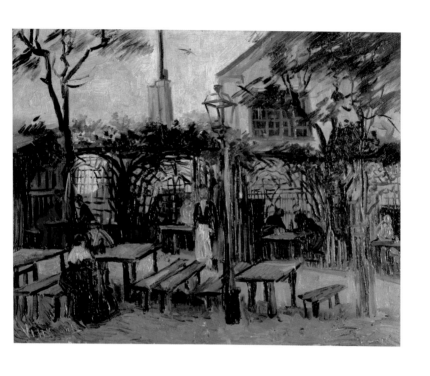

Terrace of a Café (La Guinguette) · Fall 1886

Musée d'Orsay, Paris

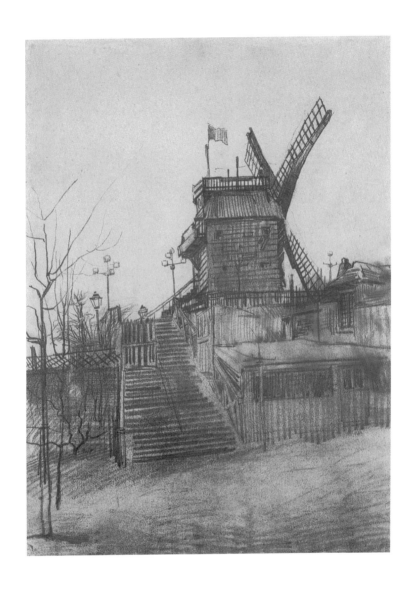

The Moulin de Blute-Fin · Fall 1886
The Phillips Collection, Washington

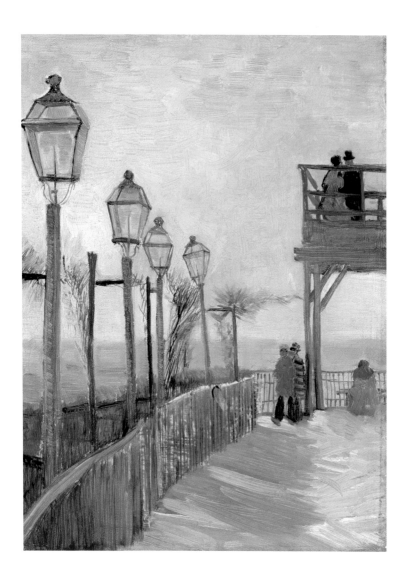

Belvedere Overlooking Montmartre · Fall 1886

The Art Institute of Chicago, Chicago

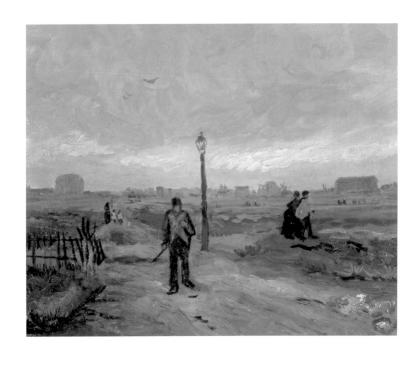

A Suburb of Paris · Fall 1886
Whereabouts unknown

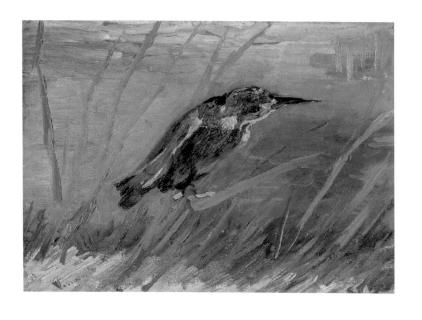

The Kingfisher · Fall 1886?
Van Gogh Museum, Amsterdam

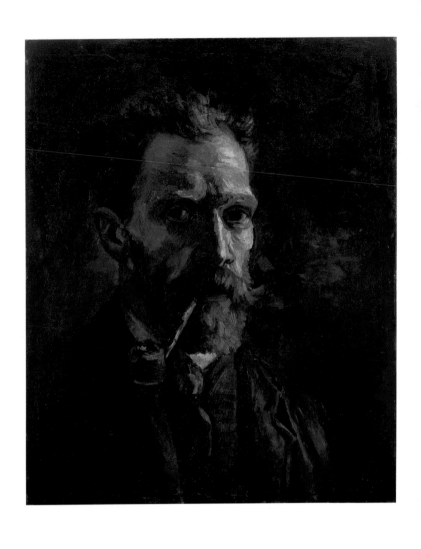

Self-Portrait with Pipe · Fall 1886

Van Gogh Museum, Amsterdam

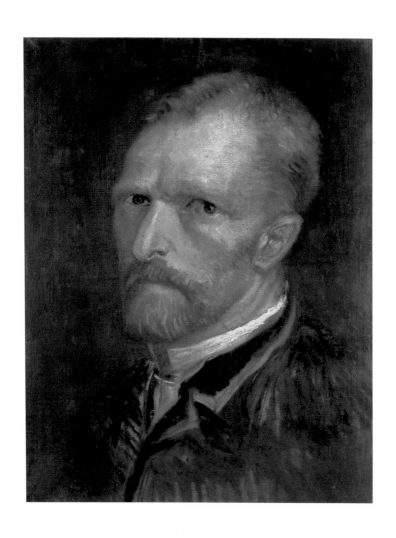

Self-Portrait · Fall 1886
Haags Gemeentemuseum, The Hague

Head of a Man, probably a portrait of Theo van Gogh · Summer 1886
Van Gogh Museum, Amsterdam

Two Self-Portraits and Several Details · Fall 1886
Van Gogh Museum, Amsterdam

Self-Portrait with Pipe · Fall 1886

Van Gogh Museum, Amsterdam

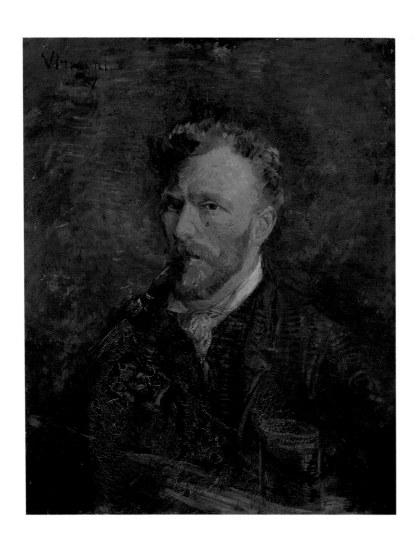

Self-Portrait with Pipe and Glass · Winter 1886/87
Van Gogh Museum, Amsterdam

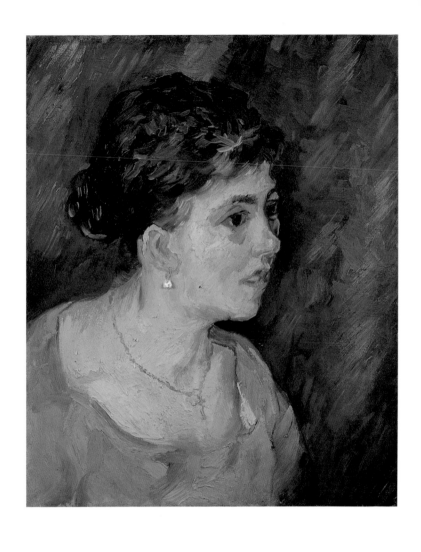

Portrait of Woman in Blue · Winter 1886/87
Van Gogh Museum, Amsterdam

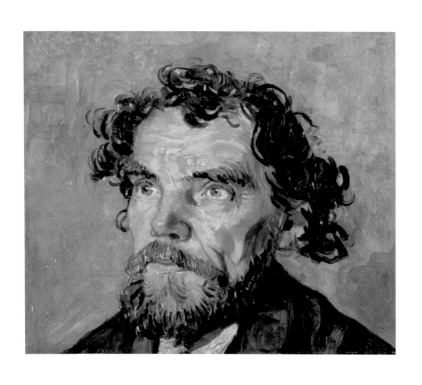

Portrait of a Man · Winter 1886/87
National Gallery of Victoria, Melbourne

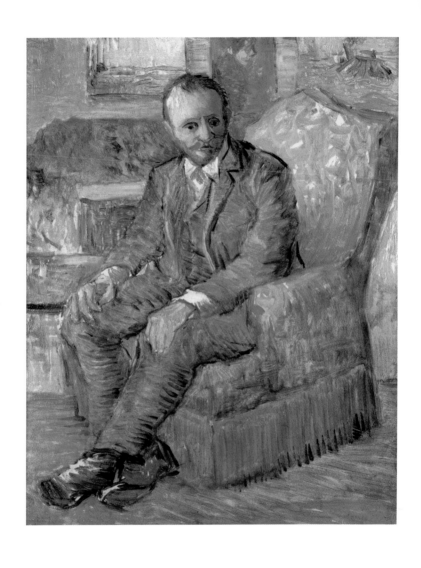

Portrait of Alexander Reid, Sitting in an Easy Chair · Winter 1886/87
Museum of Art of the University of Oklahoma, Norman, Oklahoma

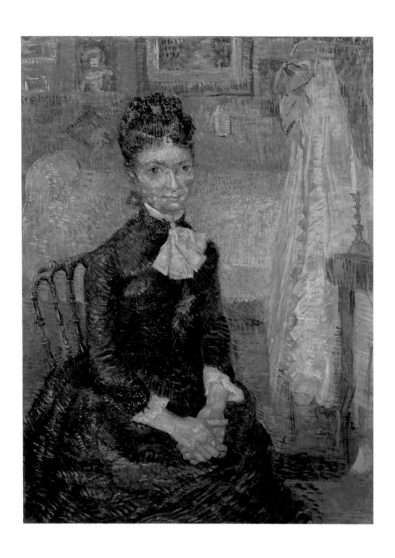

Lady, Sitting by a Cradle · Winter 1886/87

Van Gogh Museum, Amsterdam

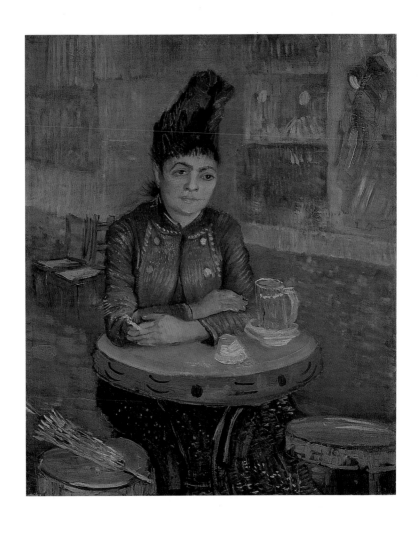

Woman at a Table in the Café du Tambourin · Winter 1886/87
Van Gogh Museum, Amsterdam

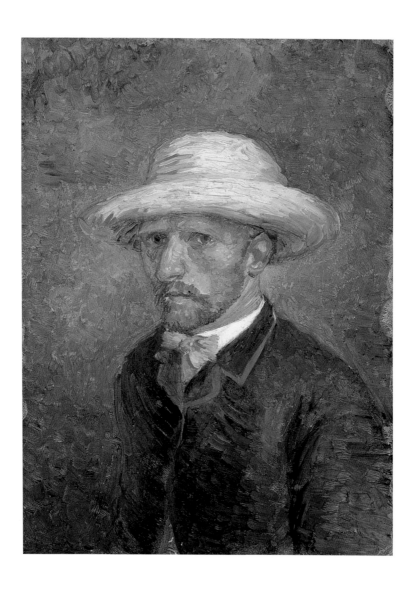

Self-Portrait with Straw Hat · Winter 1886/87
Van Gogh Museum, Amsterdam

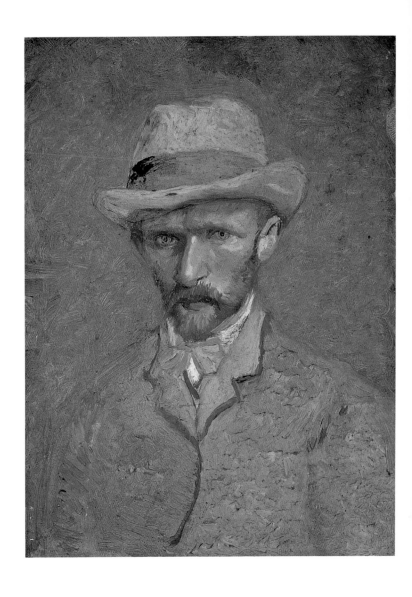

Self-Portrait with Grey Felt Hat · Winter 1886/87
Van Gogh Museum, Amsterdam

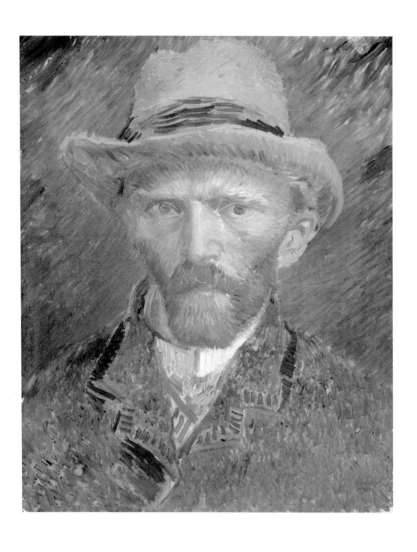

Self-Portrait with Grey Felt Hat · Winter 1886/87
Rijksmuseum Amsterdam

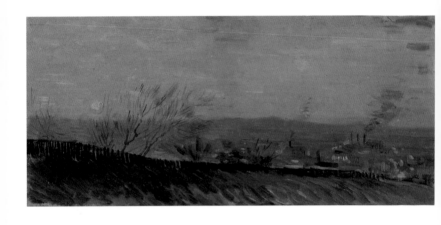

View of a Town with Factories · Winter 1886/87
Van Gogh Museum, Amsterdam

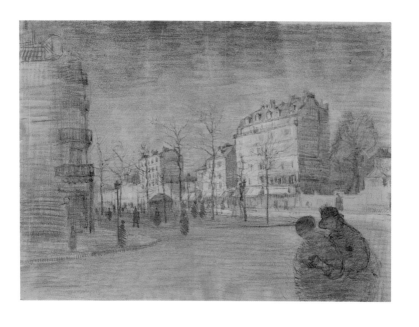

Street Scene (Boulevard de Clichy) · Winter 1886/87
Van Gogh Museum, Amsterdam
> **Street Scene (Boulevard de Clichy)** · Winter 1886/87
Van Gogh Museum, Amsterdam

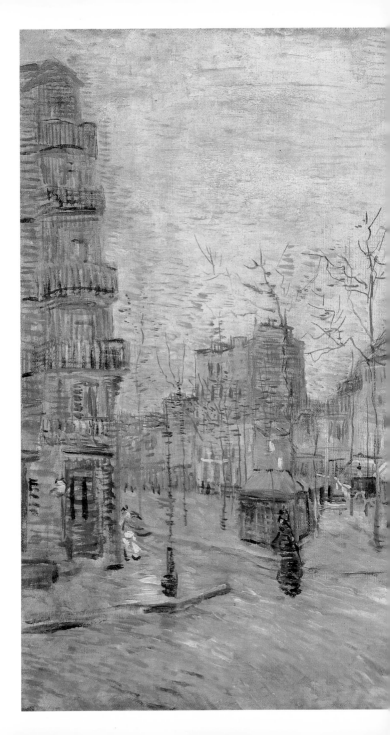

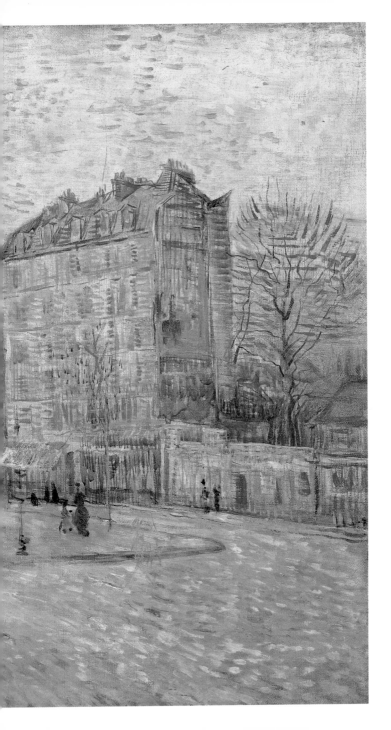

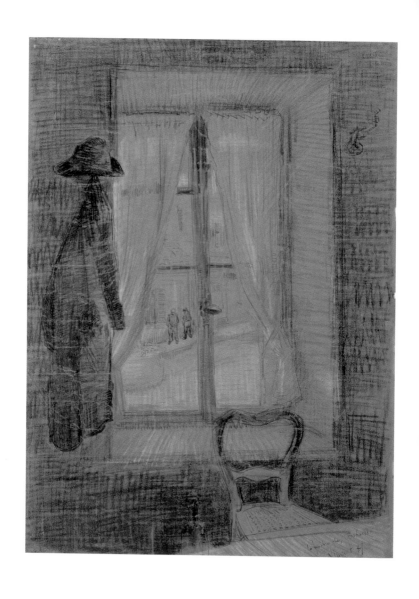

View from a Window (Restaurant Chez Bataille) · Winter 1886/87
Van Gogh Museum, Amsterdam

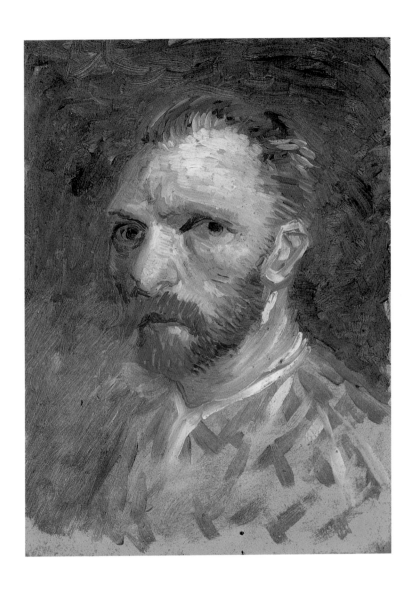

Self-Portrait · Spring 1887
Van Gogh Museum, Amsterdam

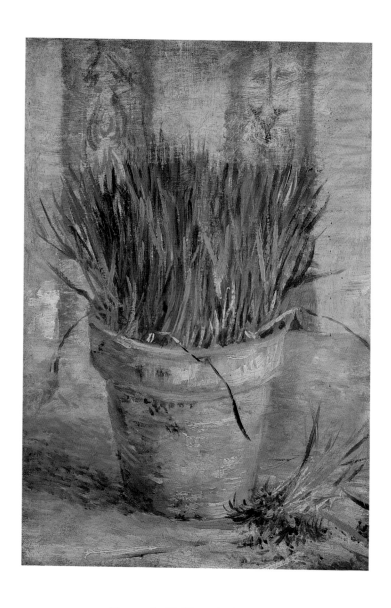

Flowerpot with Chives · Spring 1887

Van Gogh Museum, Amsterdam

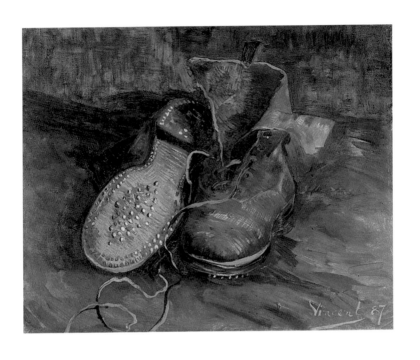

A Pair of Shoes, One Shoe Upside Down · Spring 1887

Baltimore Museum of Art, Baltimore

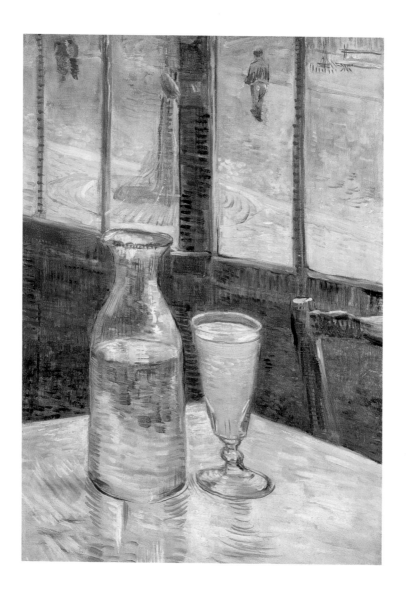

A Table in front of a Window with a Glass of Absinthe and a Carafe · Spring 1887
Van Gogh Museum, Amsterdam

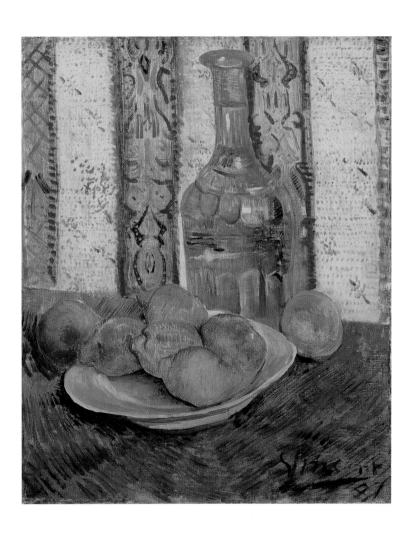

A Plate with Lemons and a Carafe · Summer 1887

Van Gogh Museum, Amsterdam

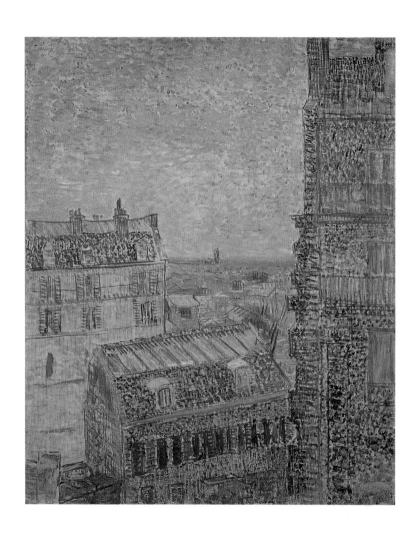

View from Vincent's Window · Spring 1887
Van Gogh Museum, Amsterdam

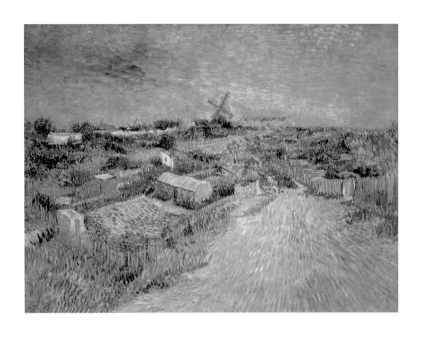

Vegetable Gardens in Montmartre · Spring 1887
Stedelijk Museum, Amsterdam

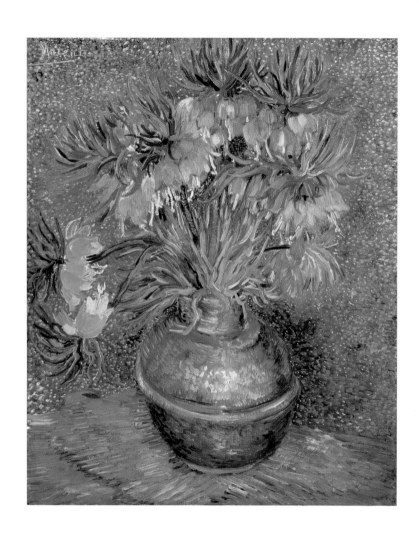

Fritillaries in a Copper Vase · Spring 1887
Musée d'Orsay, Paris

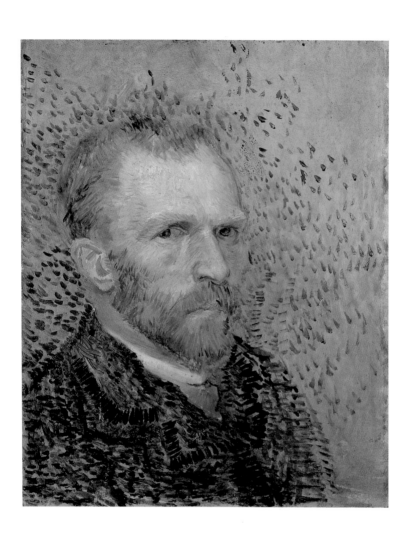

Self-Portrait · Spring 1887
Van Gogh Museum, Amsterdam

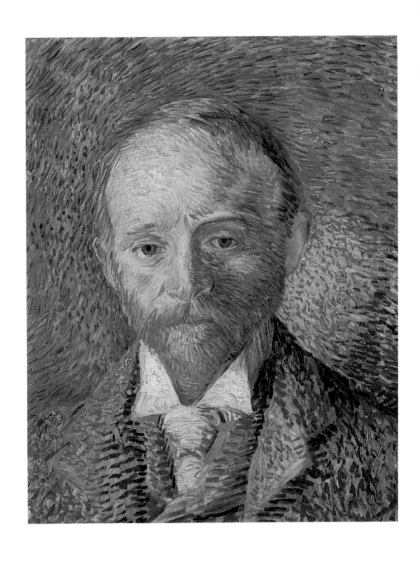

Portrait of Alexander Reid · Spring 1887
Glasgow Museums: Art Gallery and Museum, Kelvingrove

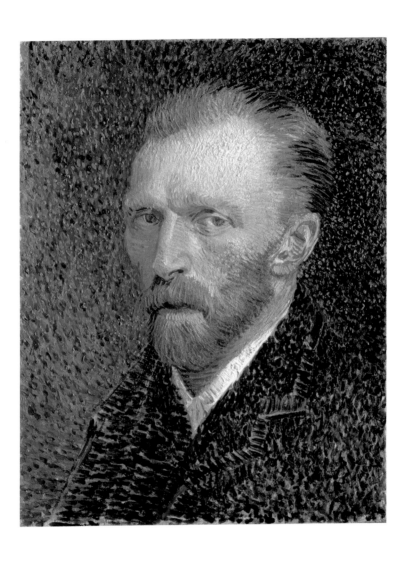

Self-Portrait · Spring 1887
The Art Institute of Chicago, Chicago

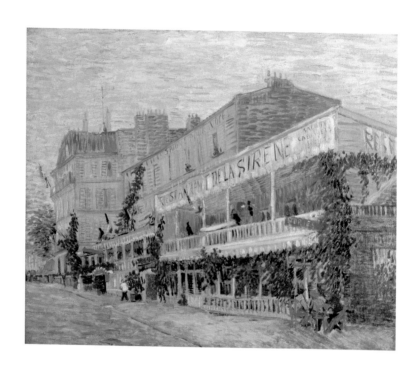

Restaurant de la Sirène at Asnières · Spring 1887

Musée d'Orsay, Paris

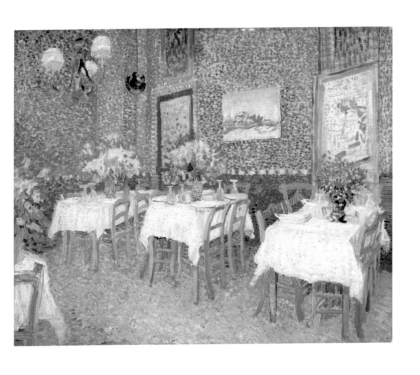

Interior of a Restaurant · Spring 1887
Kröller-Müller Museum, Otterlo

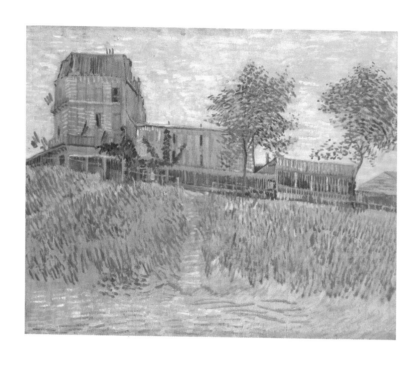

Restaurant de la Sirène at Asnières · Spring 1887
Ashmolean Museum, Oxford

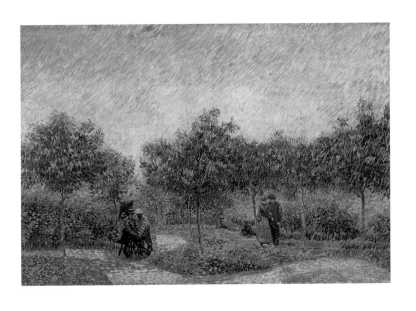

People Walking in a Public Garden at Asnières · Spring 1887
Van Gogh Museum, Amsterdam

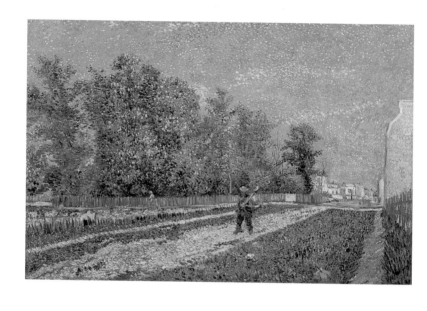

A Suburb of Paris with a Man Carrying a Spade · Spring 1887
Private collection

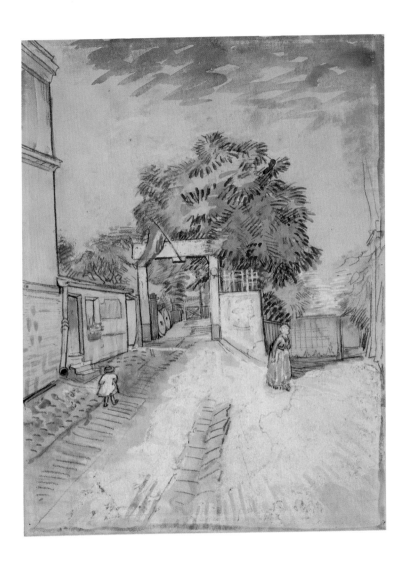

Path to the Entrance of a Belvedere · Spring 1887

Van Gogh Museum, Amsterdam

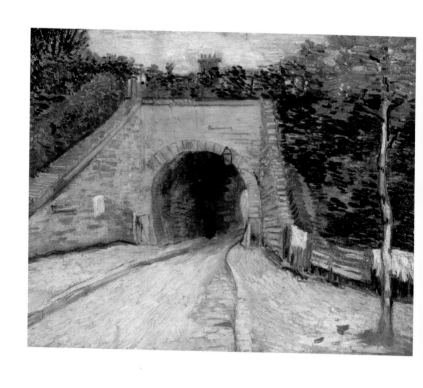

Viaduct · Spring 1887

The Solomon R. Guggenheim Museum, Justin K. Thannhauser Collection, New York

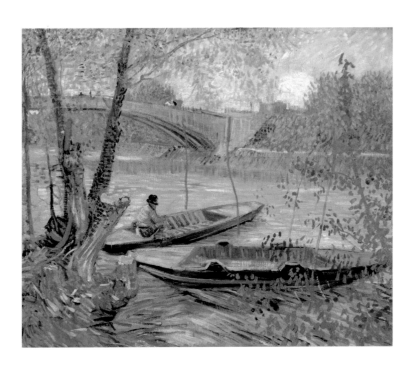

Two Boats near a Bridge across the Seine · Spring 1887
The Art Institute of Chicago, Chicago

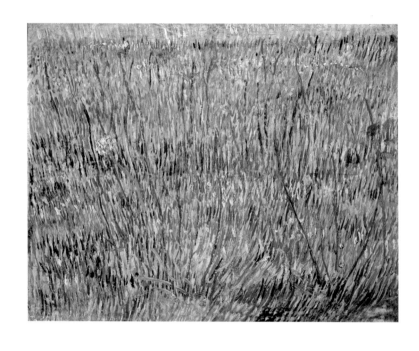

Pasture in Bloom · Spring 1887
Kröller-Müller Museum, Otterlo

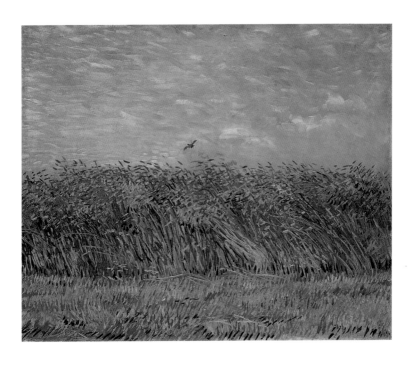

Edge of a Wheat Field with Poppies and a Lark · Spring 1887
Van Gogh Museum, Amsterdam

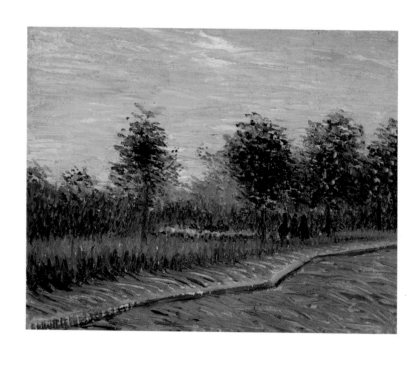

Lane in a Public Garden at Asnières · Spring 1887
Van Gogh Museum, Amsterdam

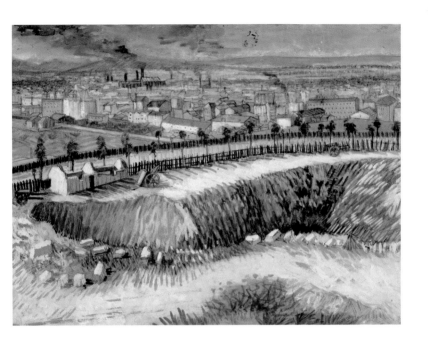

A Suburb of Paris, Seen from a Height · Summer 1887

Stedelijk Museum, Amsterdam

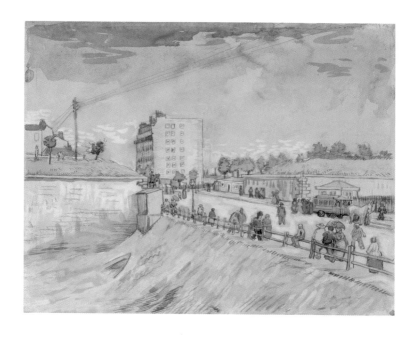

Street with People Walking and a Horsecar near the Ramparts · Summer 1887

Van Gogh Museum, Amsterdam

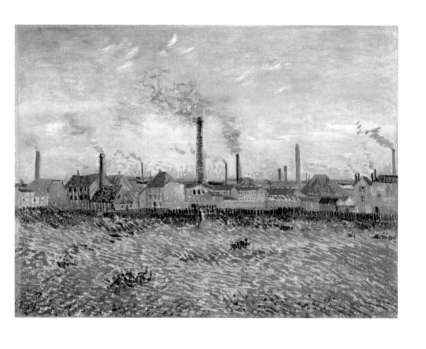

Factories at Asnières · Summer 1887
The Saint Louis Art Museum, Saint Louis

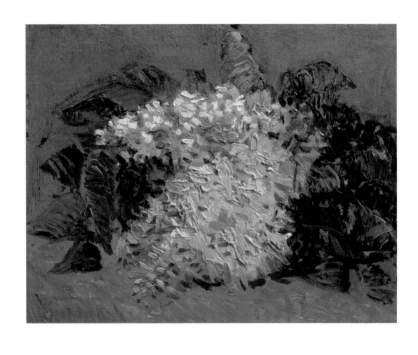

Lilacs · Summer 1887
UCLA Hammer Museum, Los Angeles;
The Armand Hammer Collection, gift of the Armand Hammer Foundation

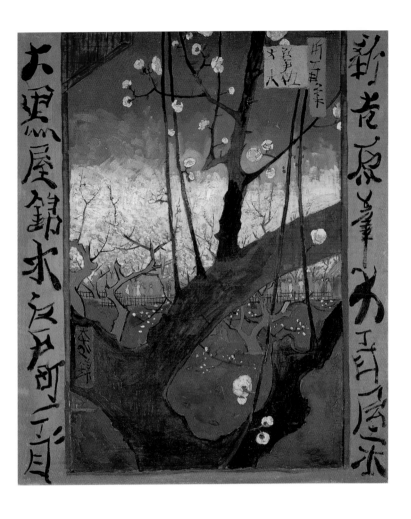

Japonaiserie: Flowering Plum Tree (after Hiroshige) · Summer 1887

Van Gogh Museum, Amsterdam

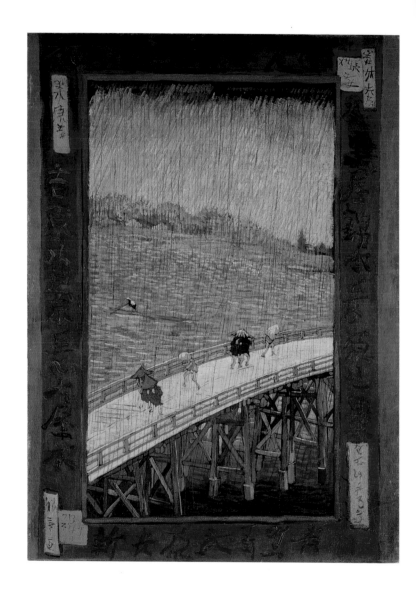

Japonaiserie: Bridge in the Rain (after Hiroshige) · Summer 1887
Van Gogh Museum, Amsterdam

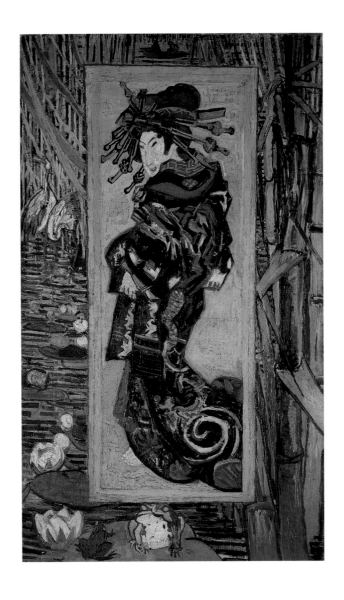

Japonaiserie: Oiran (after Kesaï Eisen) · Summer 1887

Van Gogh Museum, Amsterdam

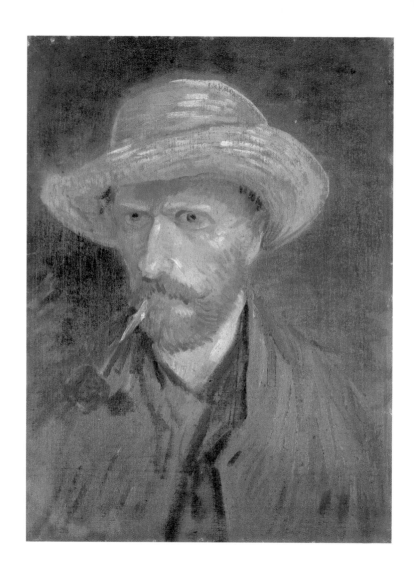

Self-Portrait with Straw Hat and Pipe · Summer 1887

Van Gogh Museum, Amsterdam

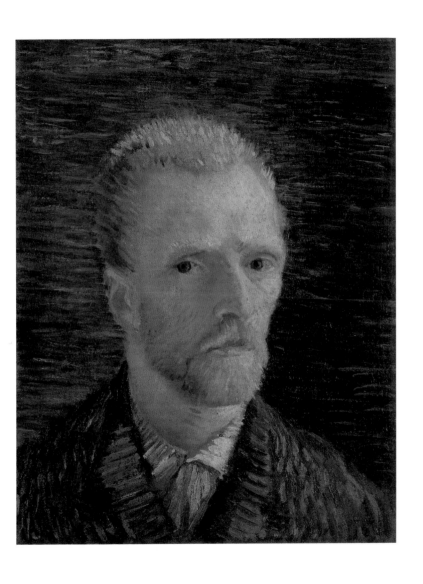

Self-Portrait · Summer 1887

Van Gogh Museum, Amsterdam

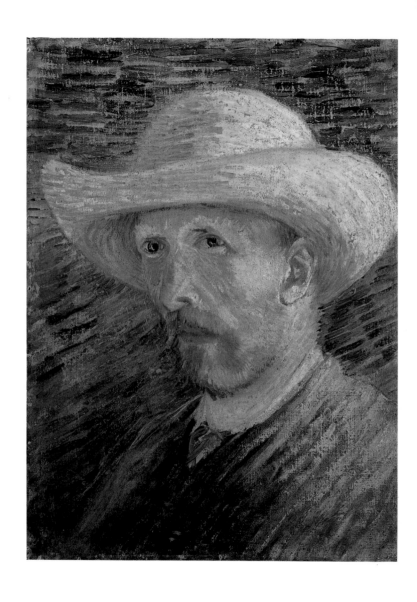

Self-Portrait with Straw Hat · Summer 1887

Van Gogh Museum, Amsterdam

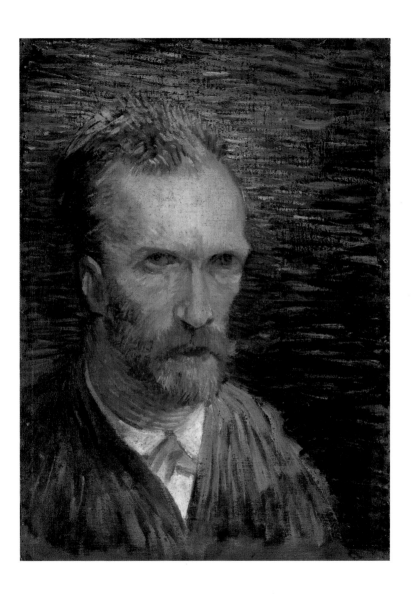

Self-Portrait · Summer 1887
Van Gogh Museum, Amsterdam

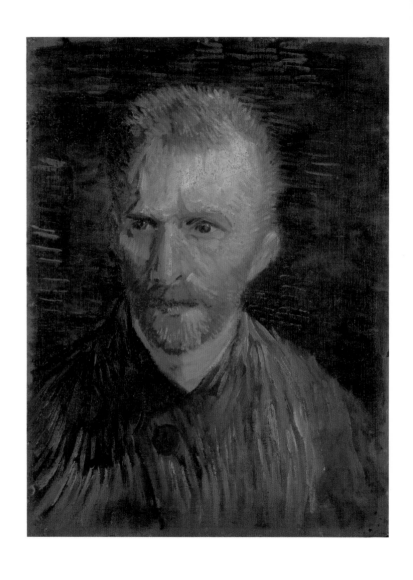

Self-Portrait · Summer 1887
Van Gogh Museum, Amsterdam

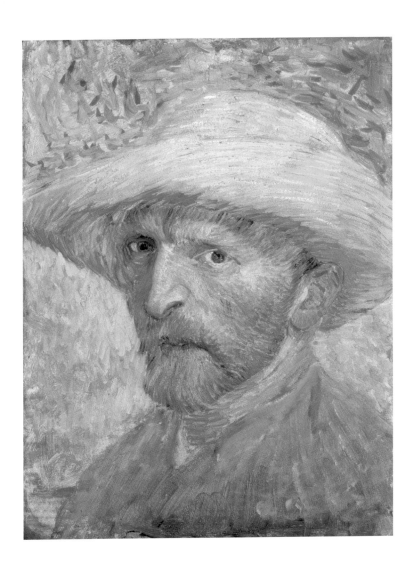

Self-Portrait with Straw Hat · Summer 1887

The Detroit Institute of Arts, Detroit

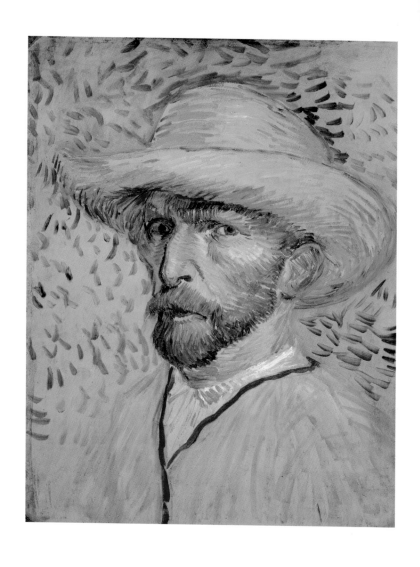

Self-Portrait with Straw Hat · Summer 1887

Van Gogh Museum, Amsterdam

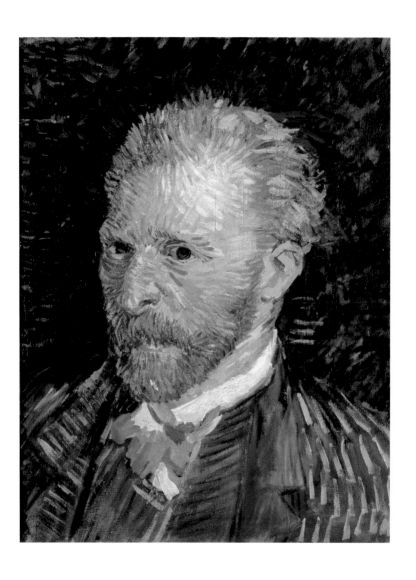

Self-Portrait · Winter 1887/88
Musée d'Orsay, Paris

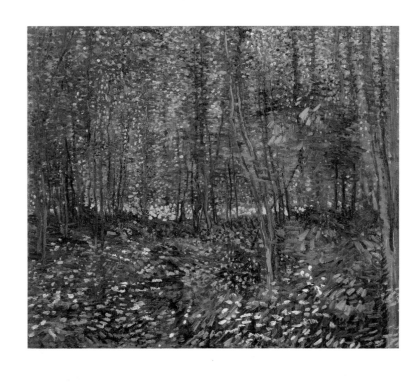

Undergrowth · Summer 1887
Van Gogh Museum, Amsterdam

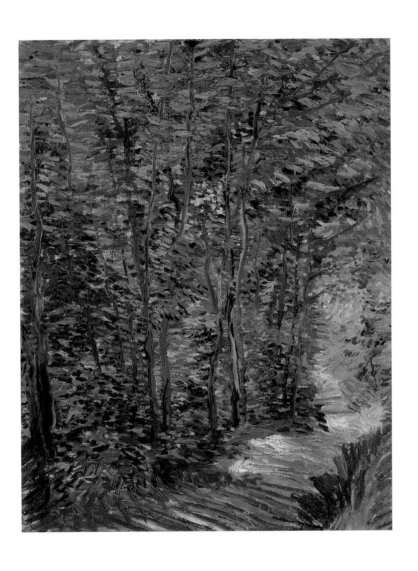

A Path in the Woods · Summer 1887
Van Gogh Museum, Amsterdam

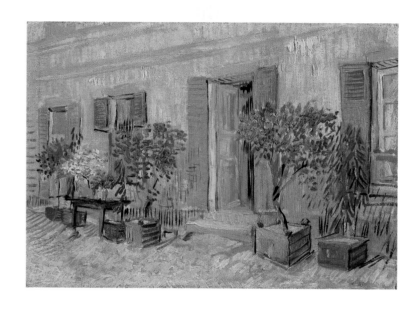

Exterior of a Restaurant with Oleanders in Pots · Summer 1887

Van Gogh Museum, Amsterdam

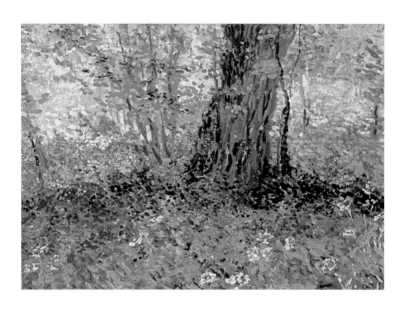

Undergrowth · Summer 1887
Centraal Museum, Utrecht (on loan from the Van Baaren Museum Foundation, Utrecht)

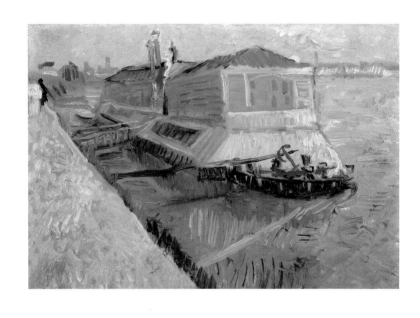

Bathing Boat on the Seine · Summer 1887
Virginia Museum of Fine Arts, Richmond

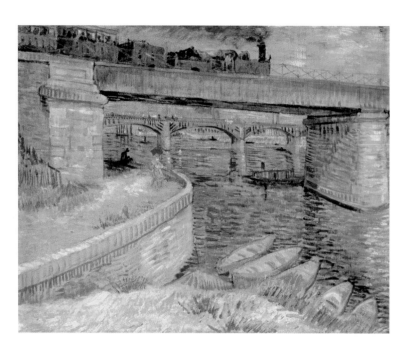

Bridges across the Seine at Asnières · Summer 1887
Foundation E.G. Bührle, Zurich
> **Two Cut Sunflowers, One Upside Down** · Summer 1887
The Metropolitan Museum of Art, New York

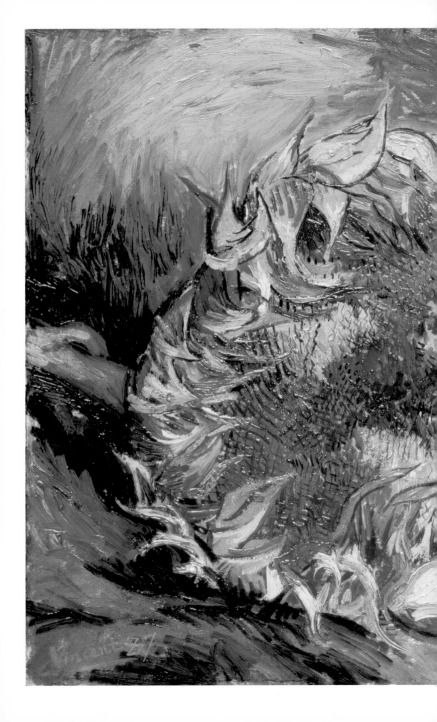

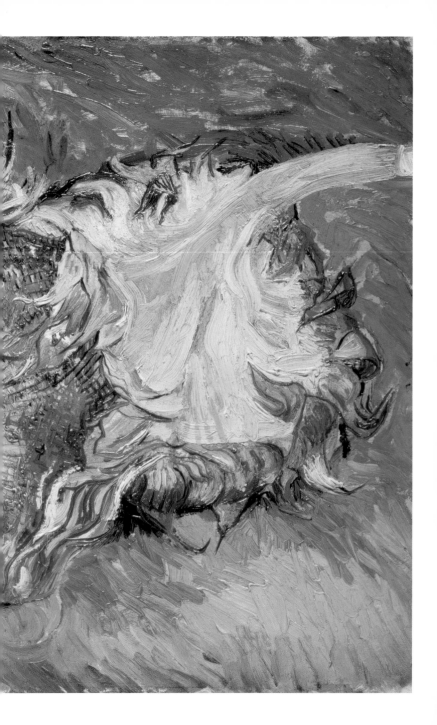

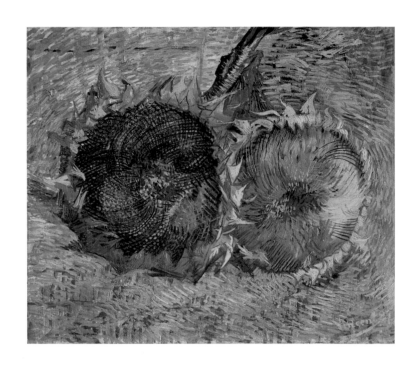

Two Cut Sunflowers · Summer 1887
Kunstmuseum Bern

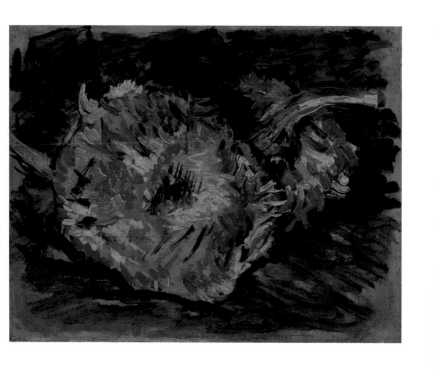

Two Cut Sunflowers, One Upside Down · Summer 1887

Van Gogh Museum, Amsterdam

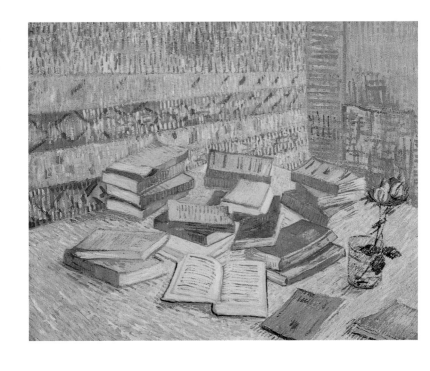

Piles of French Novels and a Glass with a Rose (Romans parisiens) · Winter 1887/88
Private collection

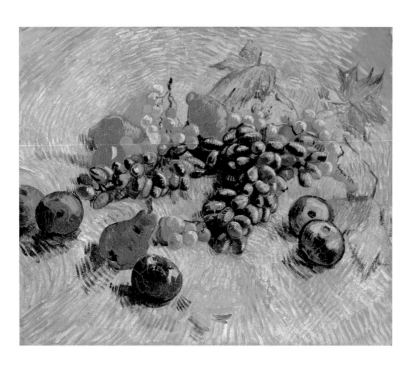

Blue and White Grapes, Apples, Pears and Lemons · Winter 1887/88
The Art Institute of Chicago, Chicago

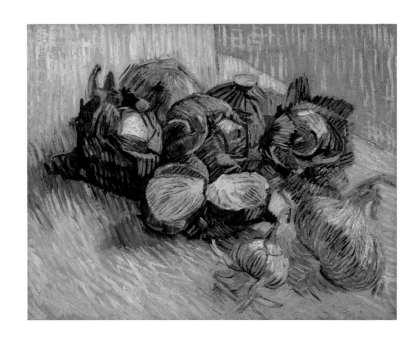

Red Cabbages and Onions · Winter 1887/88
Van Gogh Museum, Amsterdam

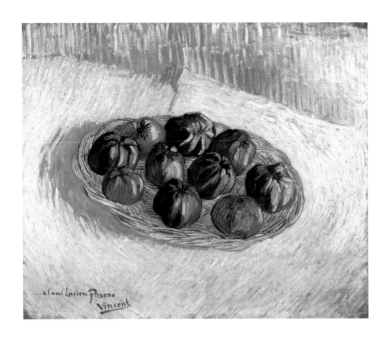

Basket with Apples (Dedicated to Lucien Pissarro) · Winter 1887/88
Kröller-Müller Museum, Otterlo

185

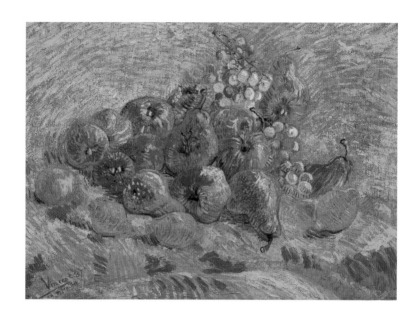

White Grapes, Apples, Pears, Lemons and Orange (Dedicated to Theo van Gogh) · Winter 1887/88
Van Gogh Museum, Amsterdam

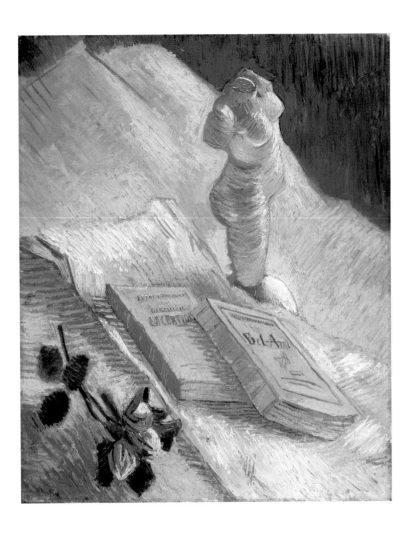

Still Life with Plaster Statuette, a Rose and Two Novels · Winter 1887/88

Kröller-Müller Museum, Otterlo

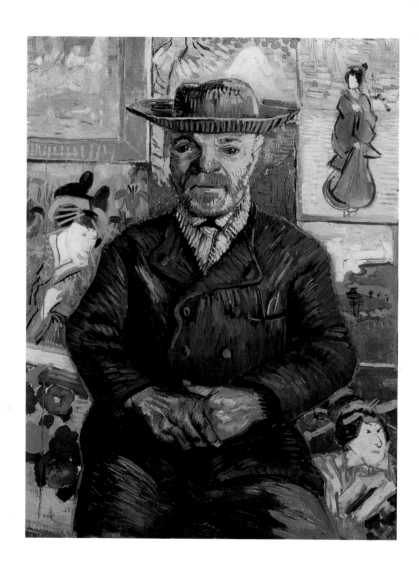

Portrait of Père Tanguy · Winter 1887/88
Collection Stavros S. Niarchos

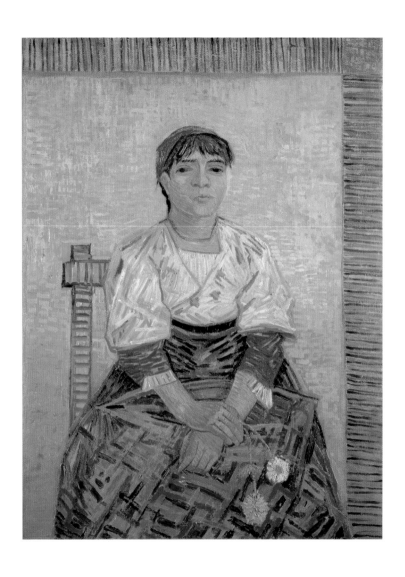

Portrait of a Woman with Carnations (Agostina Segatori?) · Winter 1887/88

Musée d'Orsay, Paris

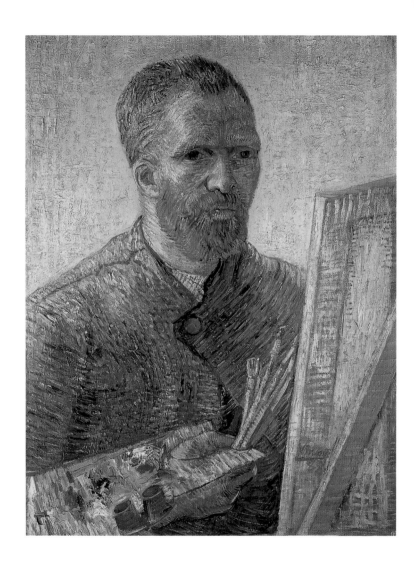

Self-Portrait in Front of the Easel · Winter 1887/88
Van Gogh Museum, Amsterdam

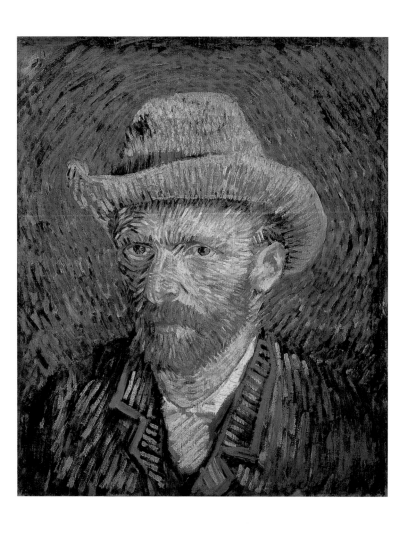

Self-Portrait with Grey Felt Hat · Winter 1887/88
Van Gogh Museum, Amsterdam

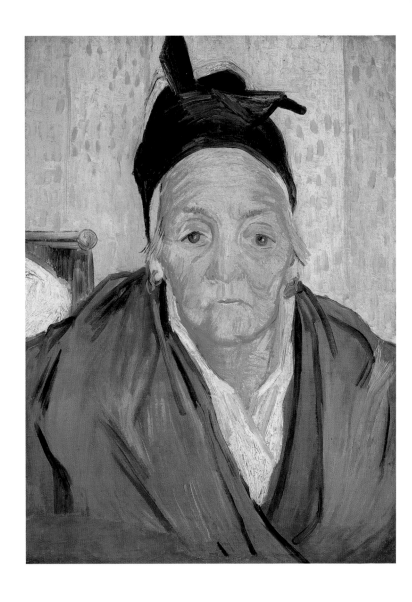

An Old Woman of Arles · February 1888
Van Gogh Museum, Amsterdam

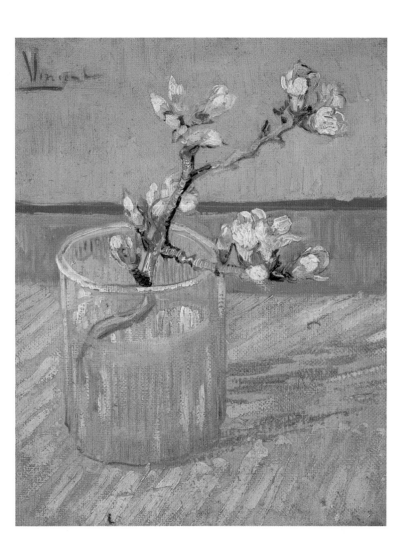

Blossoming Almond Branch in a Glass · March 1888
Van Gogh Museum, Amsterdam

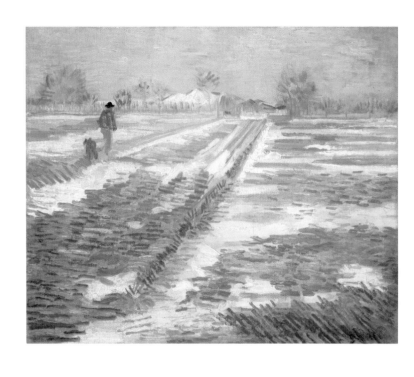

Landscape with Snow · March 1888

The Solomon R. Guggenheim Museum, Justin K. Thannhauser Collection, New York

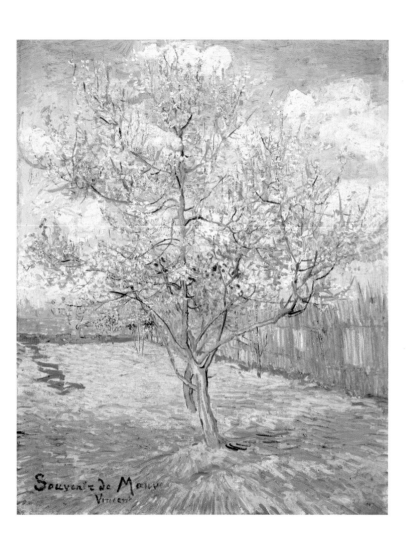

Pink Peach Trees · March 1888

Kröller-Müller Museum, Otterlo

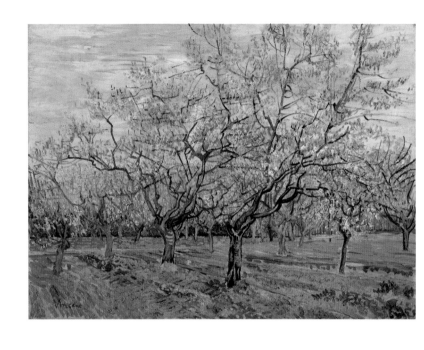

Orchard with Blossoming Plum Trees · April 1888
Van Gogh Museum, Amsterdam

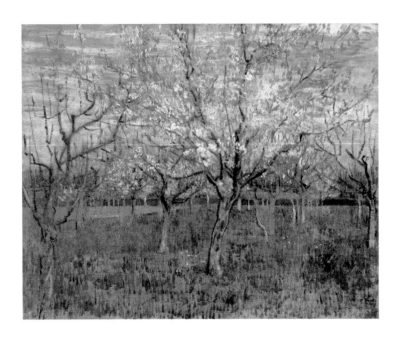

Orchard with Blossoming Apricot Trees · March 1888
Van Gogh Museum, Amsterdam
> **Drawbridge with Carriage** · March 1888
Kröller-Müller Museum, Otterlo

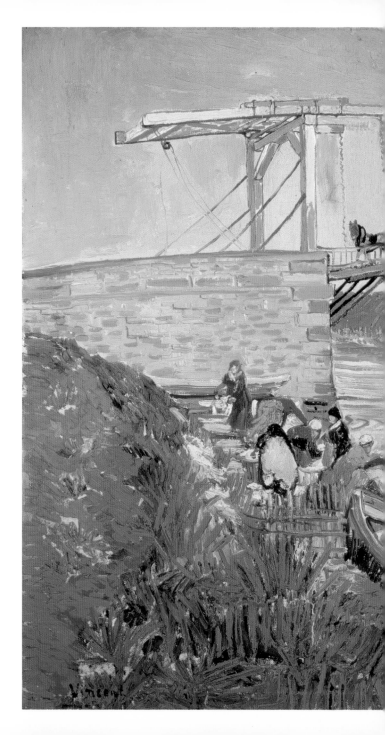

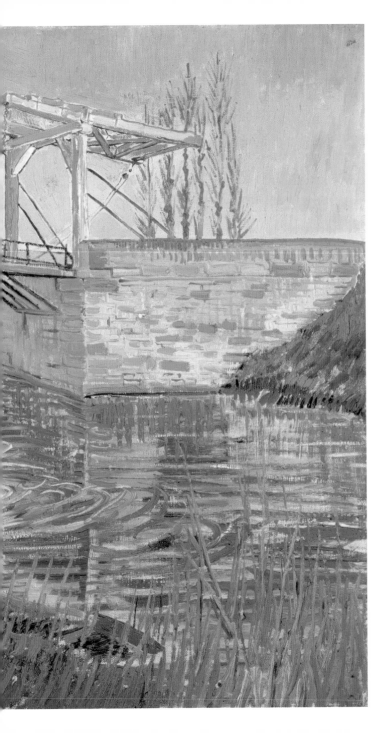

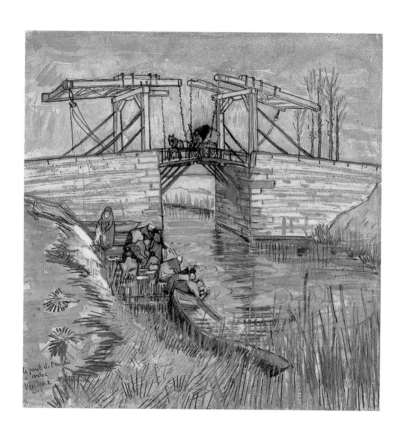

Drawbridge with Carriage · April 1888

Private collection

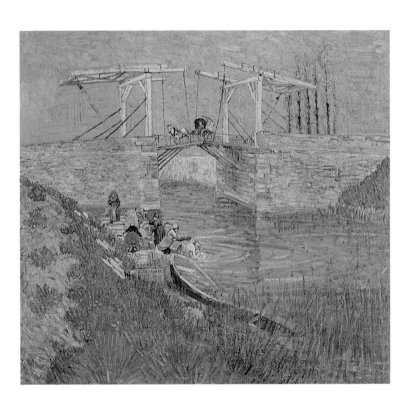

Drawbridge with Carriage · April 1888
Private collection

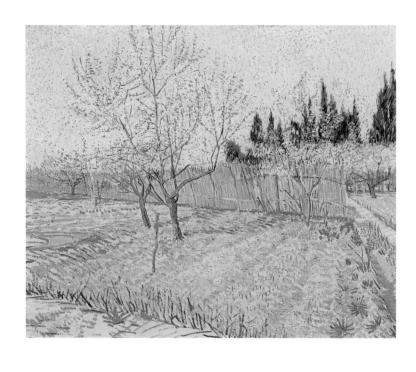

Orchard with Cypresses · April 1888
Private collection

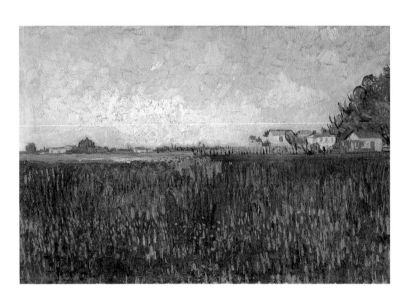

Meadow with Poppies · May 1888
Van Gogh Museum, Amsterdam
> **Harvest Landscape** · June 1888
Van Gogh Museum, Amsterdam

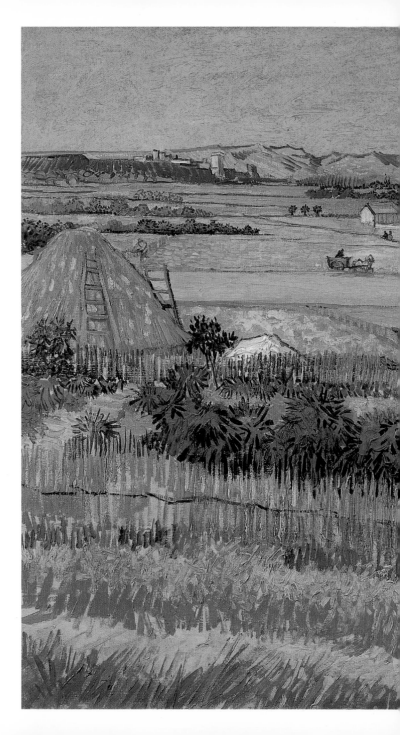

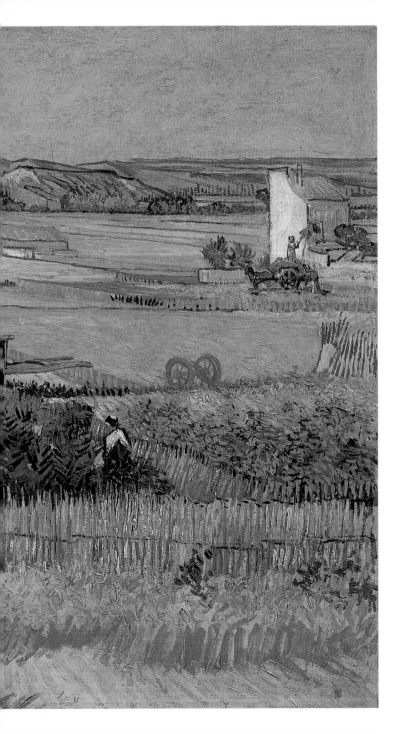

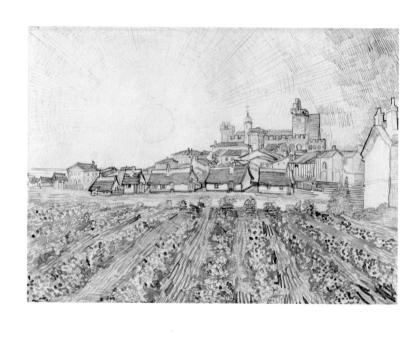

View of Saintes-Maries · May–June 1888

Collection Oskar Reinhart "Am Römerholz," Winterthur

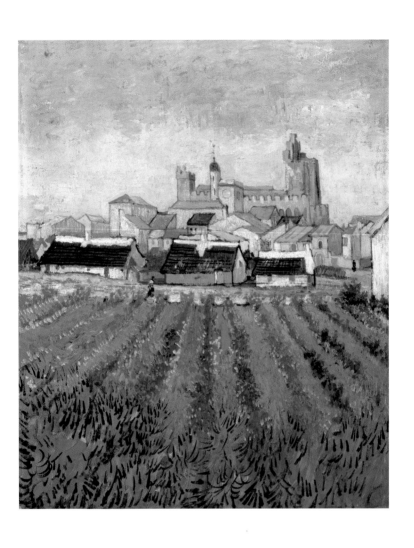

View of Saintes-Maries · May–June 1888
Kröller-Müller Museum, Otterlo

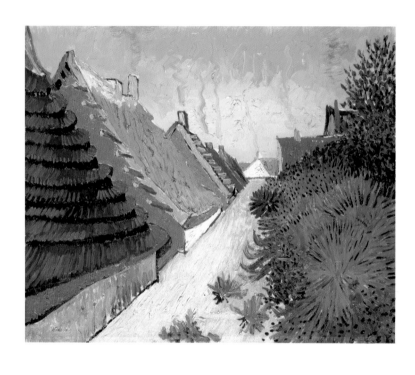

Street in Saintes-Maries · June 1888
Private collection

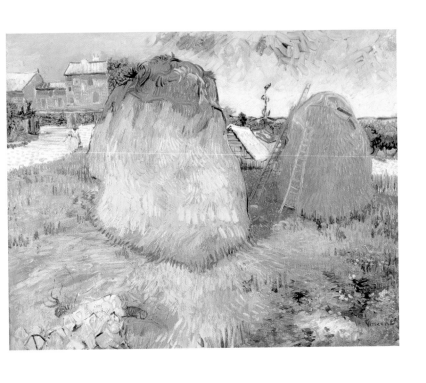

Haystacks near a Farm · June 1888
Kröller-Müller Museum, Otterlo

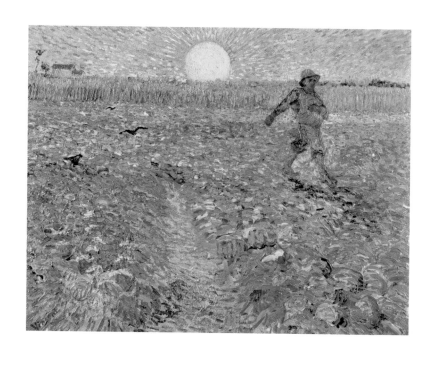

Sower with Setting Sun · June 1888
Kröller-Müller Museum, Otterlo

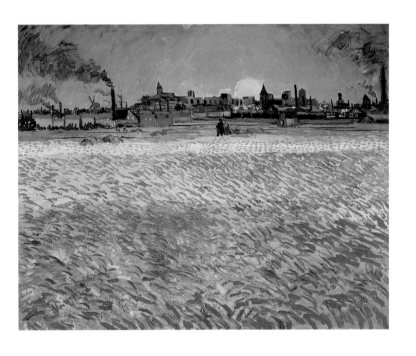

Wheat Field with Setting Sun · June 1888
Collection Oskar Reinhart, Winterthur
> **Fishing Boats on the Beach** · June 1888
Van Gogh Museum, Amsterdam

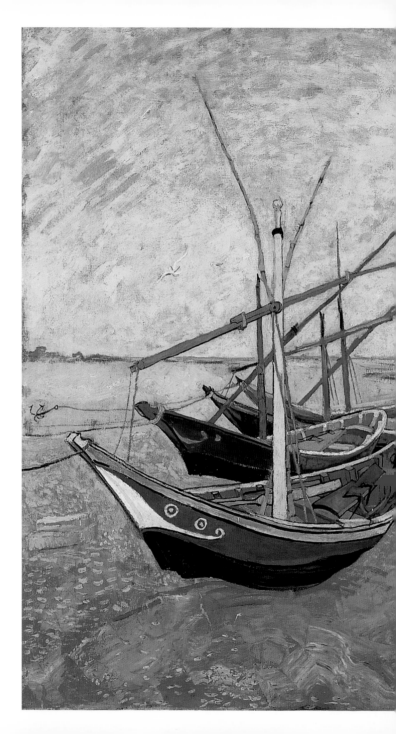

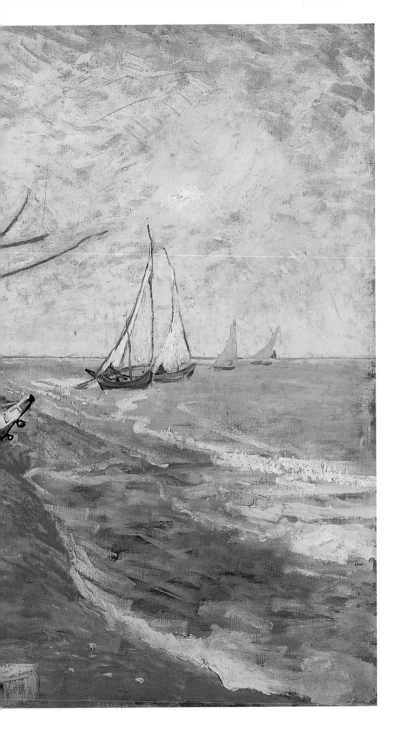

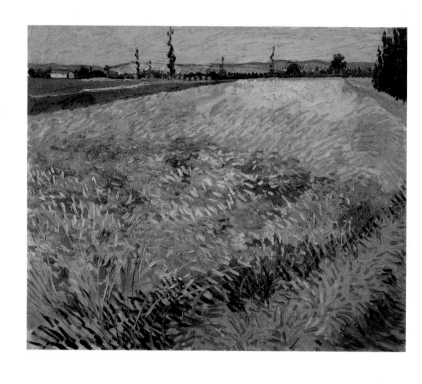

Wheat Field · June 1888
Van Gogh Museum, Amsterdam

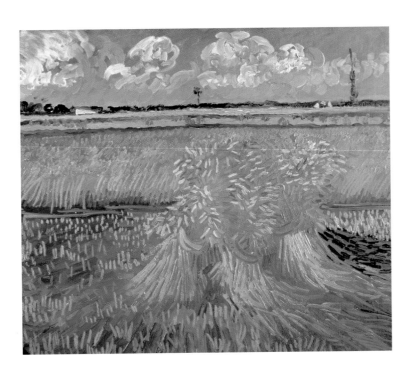

Wheat Field with Sheaves · June 1888
Honolulu Academy of Arts, Honolulu

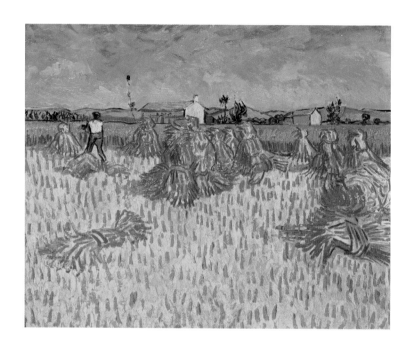

Wheat Field with Sheaves · June 1888
The Israel Museum, Jerusalem

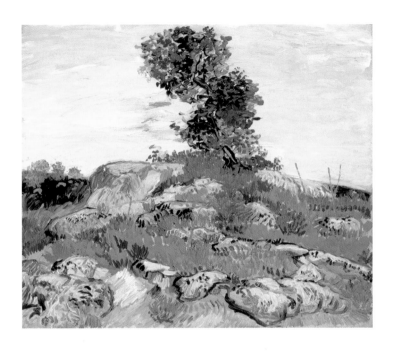

Rocks with Tree · July 1888

Museum of Fine Arts, Houston

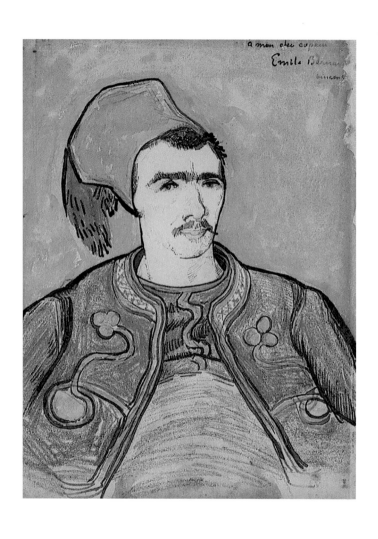

Zouave, Half-Figure · June 1888

The Metropolitan Museum of Art, New York

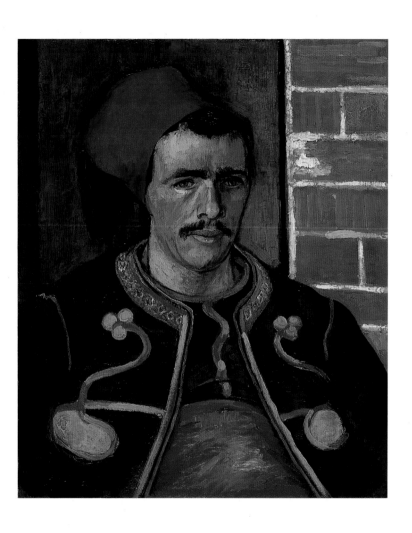

Zouave, Half-Figure · June 1888

Van Gogh Museum, Amsterdam

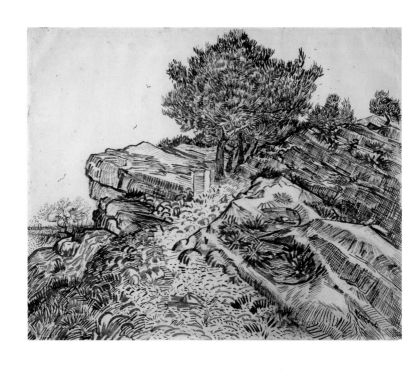

Rocks with Trees · July 1888
Van Gogh Museum, Amsterdam

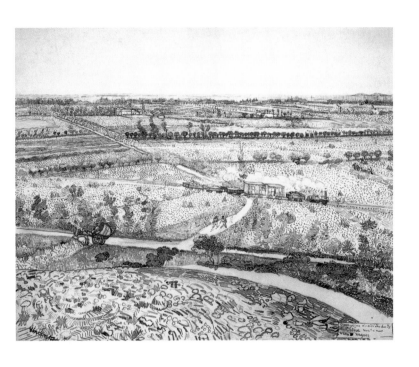

Landscape near Montmajour with Train · July 1888
British Museum, London
> **Garden with Flowers** · July 1888
Haags Gemeentemuseum, The Hague (on loan)

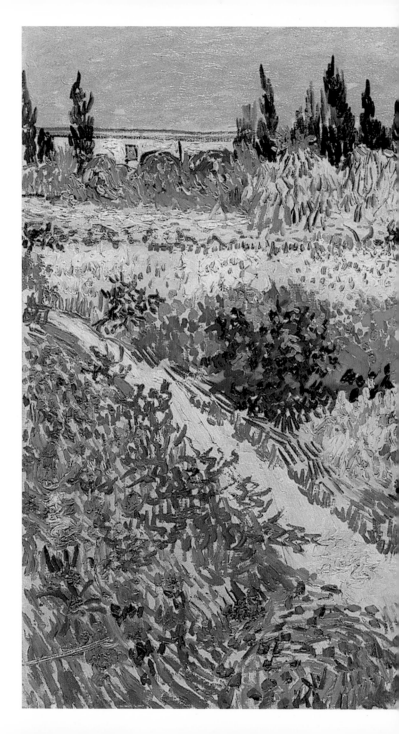

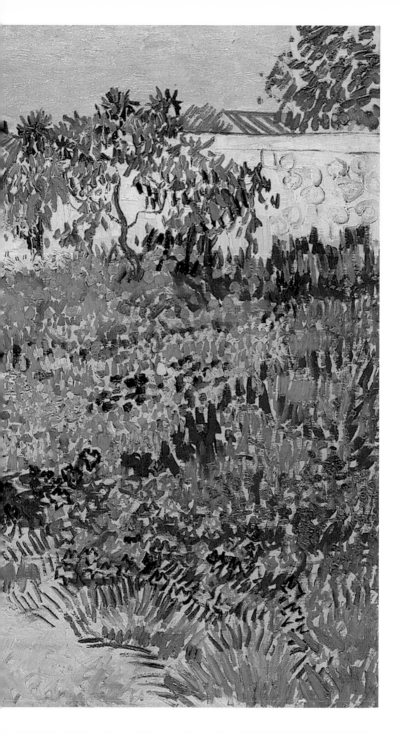

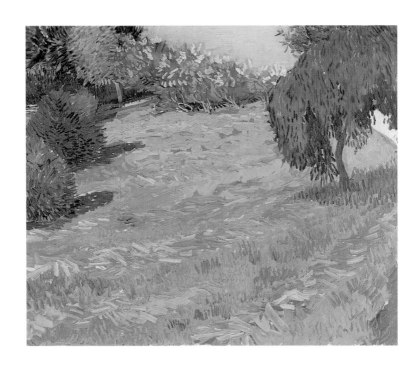

Newly Mowed Lawn with Weeping Tree · July 1888
Private collection

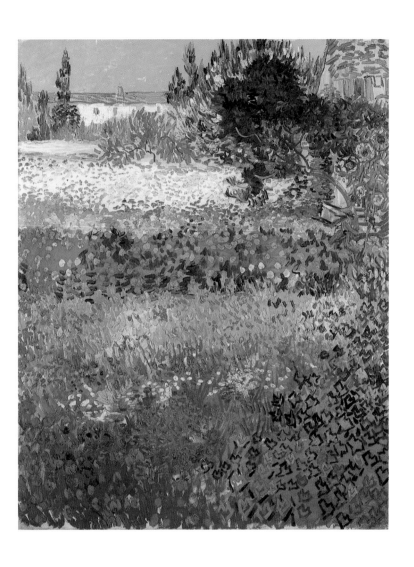

Garden with Flowers · July 1888
Private collection

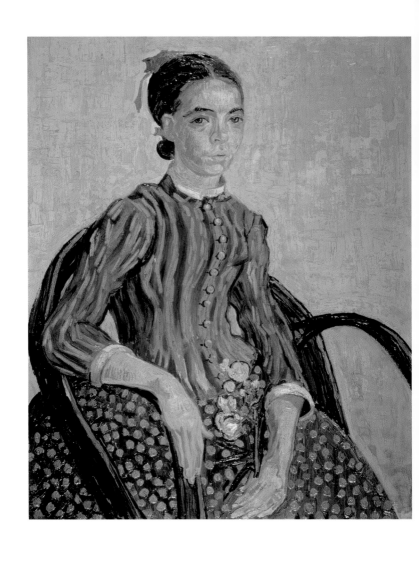

Mousmé, Sitting in a Cane Chair · July 1888
National Gallery of Art, Washington

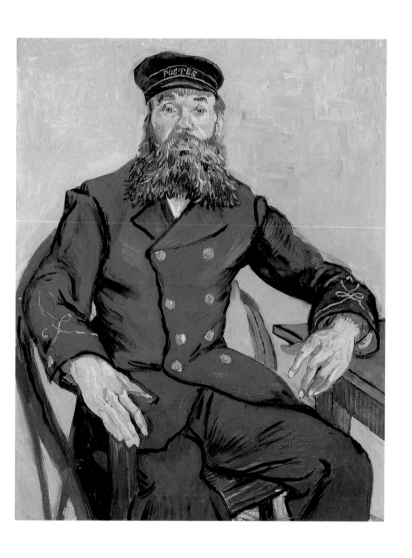

Joseph Roulin, Sitting in a Cane Chair · July–August 1888

Museum of Fine Arts, Boston

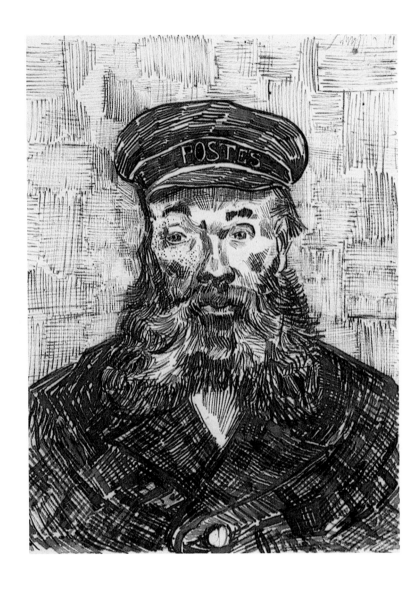

Joseph Roulin, Head · July–August 1888
J. Paul Getty Museum, Malibu

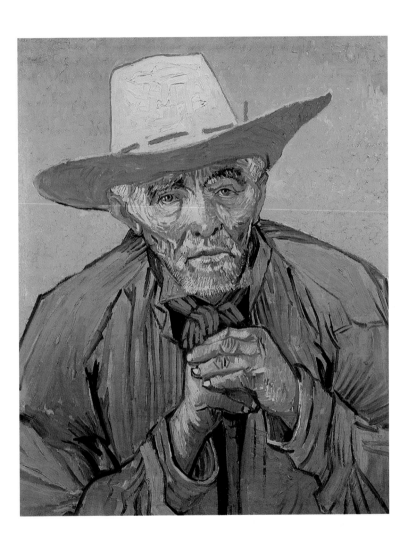

The Old Peasant Patience Escalier with Walking Stick · August 1888

Collection Stavros S. Niarchos

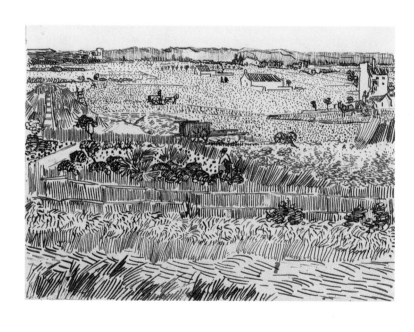

Harvest Landscape · August 1888
Nationalgalerie, Berlin

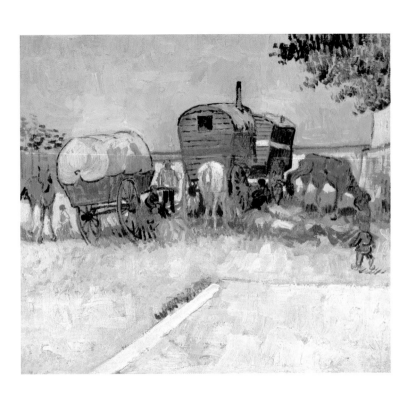

Traveling Artist's Caravans · August 1888
Musée d'Orsay, Paris

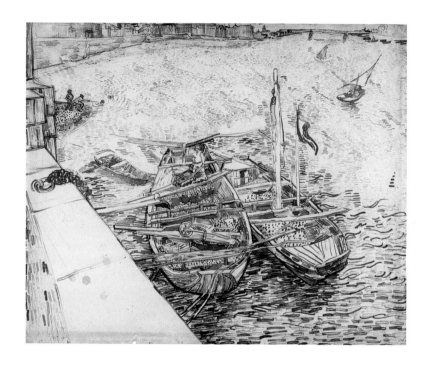

Quay with Men Unloading Sand Barges · August 1888
The Cooper Hewitt Museum, New York

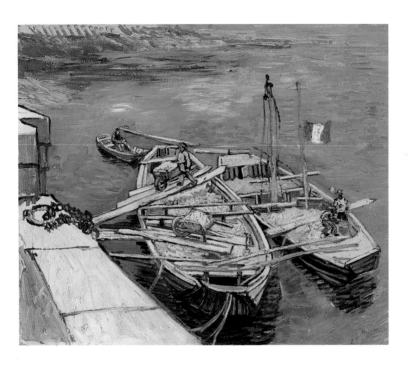

Quay with Men Unloading Sand Barges · August 1888
Museum Folkwang, Essen

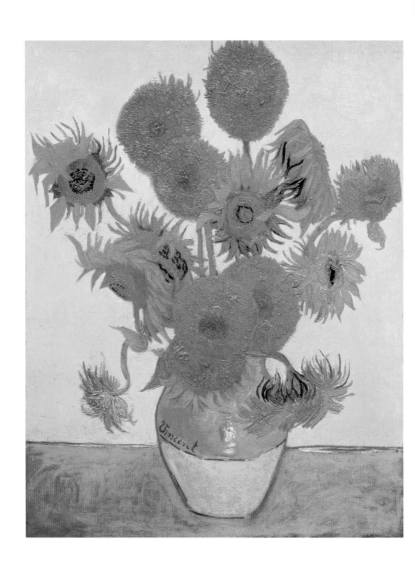

Fourteen Sunflowers in a Vase · August 1888
National Gallery, London

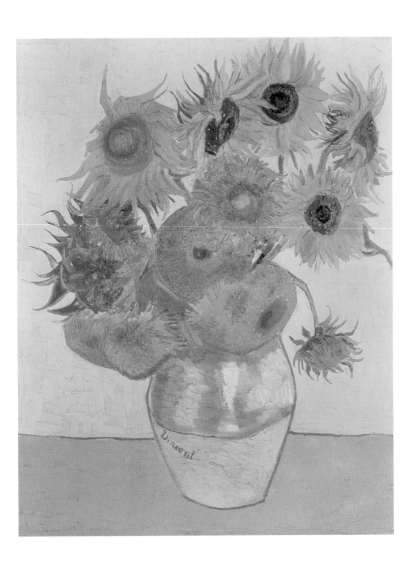

Twelve Sunflowers in a Vase · August 1888

Neue Pinakothek, Munich

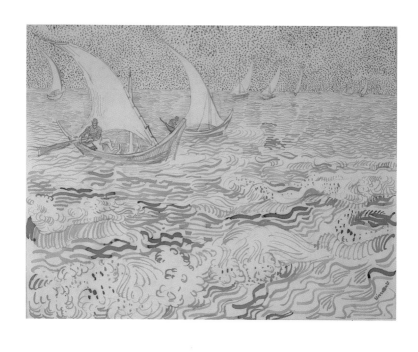

Fishing Boats at Sea · August 1888
Royal Museums of Fine Arts of Belgium, Brussels

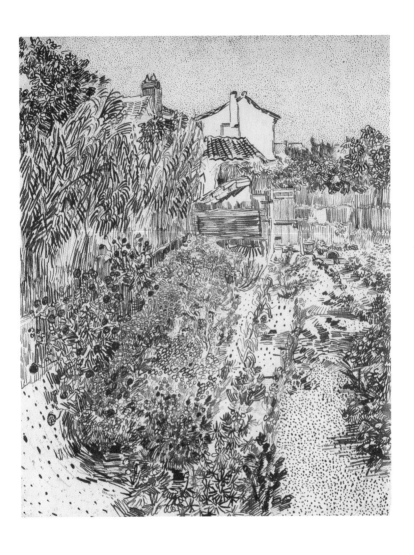

Garden with Flowers · August 1888
Private collection

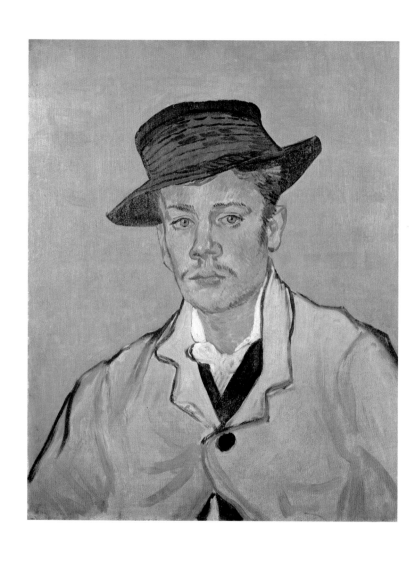

Portrait of Armand Roulin · December 1888
Museum Folkwang, Essen

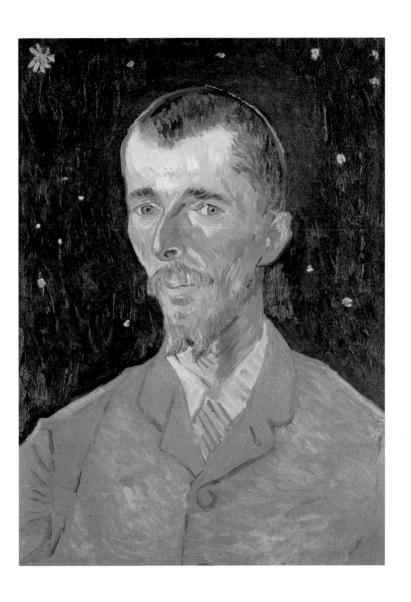

Portrait of Eugène Boch · September 1888

Musée d'Orsay, Paris

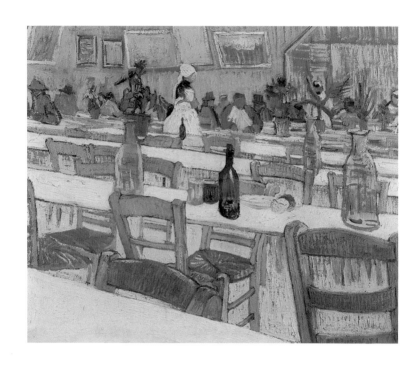

Interior of a Restaurant · August 1888
Private collection

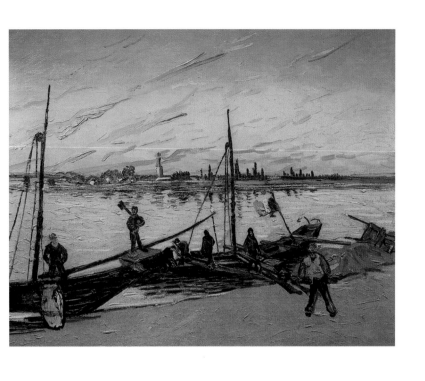

Coal Barges · August 1888

Collection Mr. and Mrs. Carleton Mitchell, Annapolis, Maryland

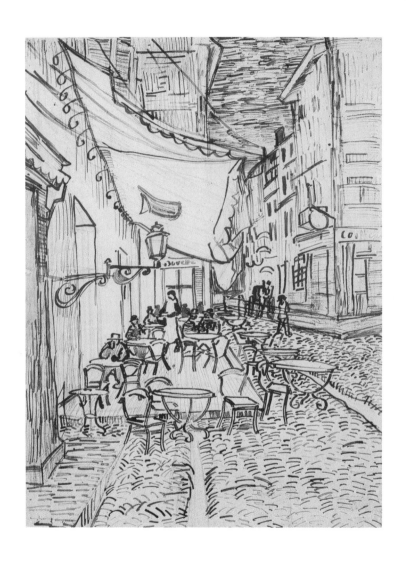

Café Terrace at Night · September 1888
Dallas Museum of Art, Dallas

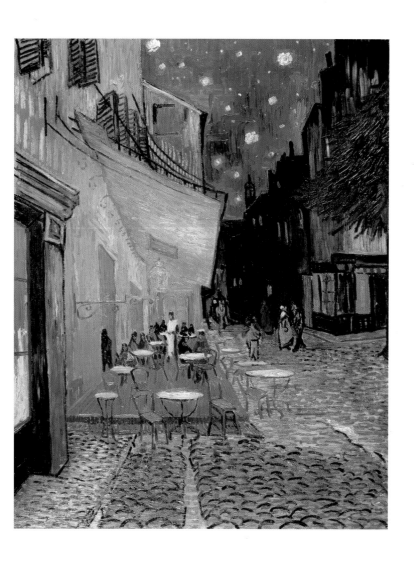

Café Terrace at Night · September 1888
Kröller-Müller Museum, Otterlo
> **The Night Café** · September 1888
Yale University Art Gallery, New Haven

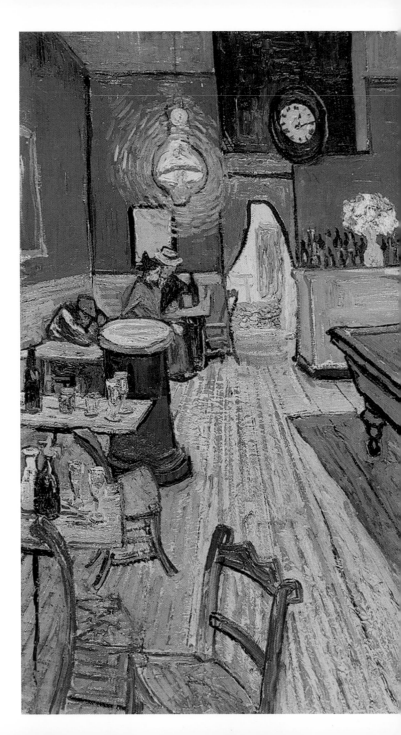

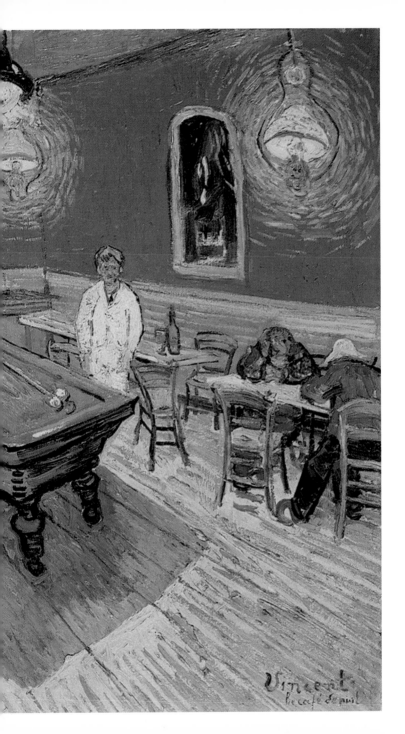

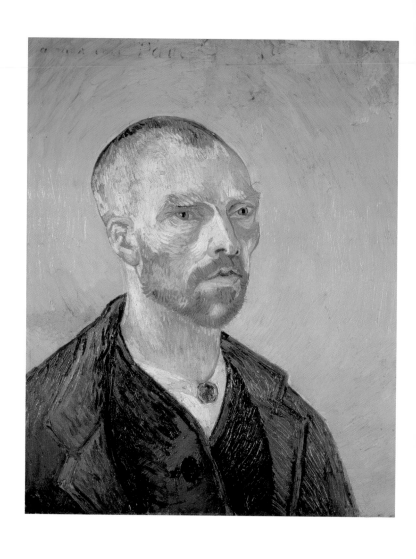

Self-Portrait · September 1888
Fogg Art Museum, Harvard University, Cambridge (Mass.)

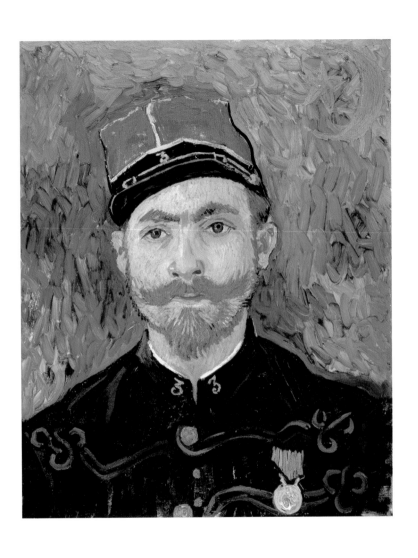

Lieutenant Milliet · September 1888
Kröller-Müller Museum, Otterlo

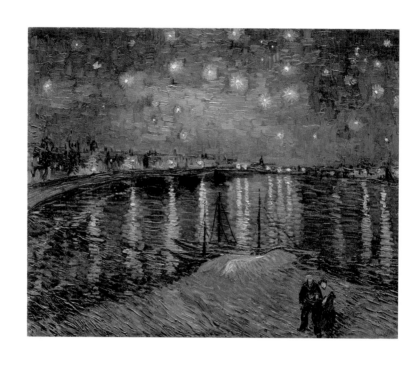

The Starry Night · September 1888
Musée d'Orsay, Paris

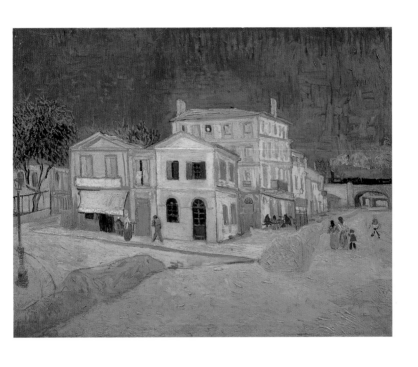

Vincent's House · September 1888
Van Gogh Museum, Amsterdam

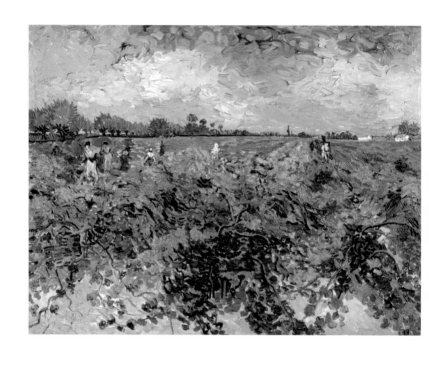

The Green Vineyard · October 1888
Kröller-Müller Museum, Otterlo

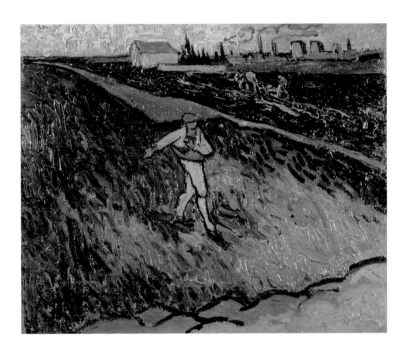

Sower · November–December 1888
The Armand Hammer Museum of Art, Los Angeles

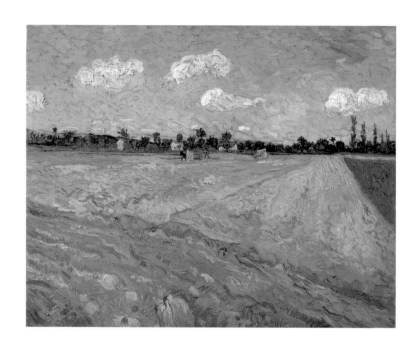

Plowed Field · September 1888
Van Gogh Museum, Amsterdam

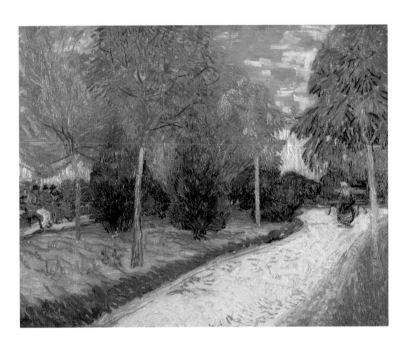

Public Garden · October 1888
Private collection

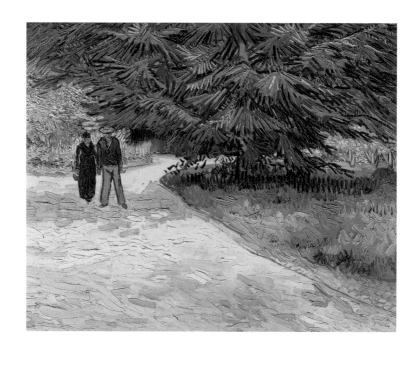

Public Garden with a Couple and a Blue Fir Tree · October 1888
Private collection

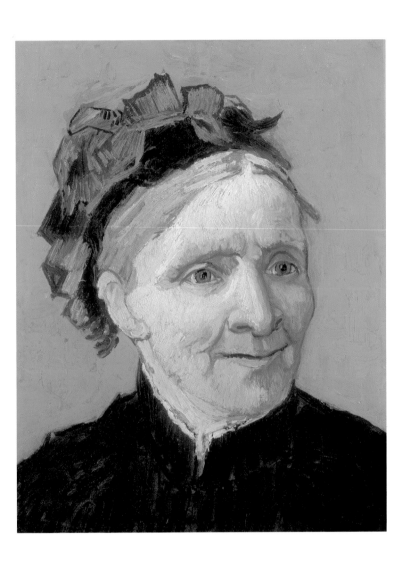

Portrait of Van Gogh's Mother · October 1888
The Norton Simon Museum, Pasadena

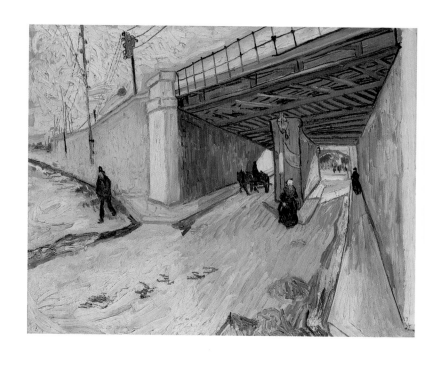

The Viaduct · October 1888

Kunsthaus Zürich (on loan)

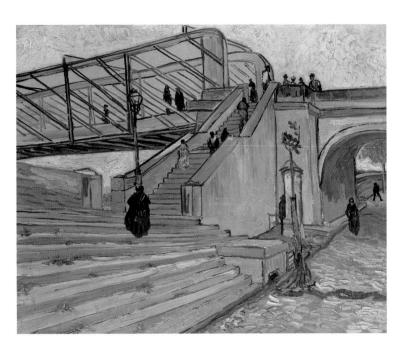

The Trinquetaille Bridge · October 1888
Kunsthaus Zürich (on loan)

Interior of a Restaurant (with Motifs of Bedroom) · October 1888

Van Gogh Museum, Amsterdam

Vincent's Bedroom · October 1888

Van Gogh Museum, Amsterdam

> **Vincent's Bedroom** · October 1888

Van Gogh Museum, Amsterdam

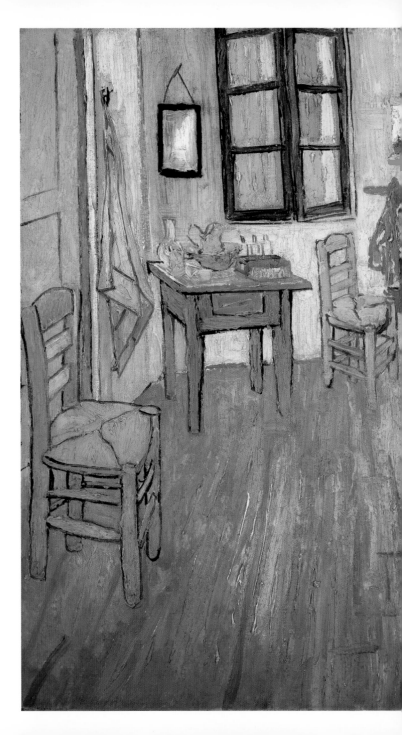

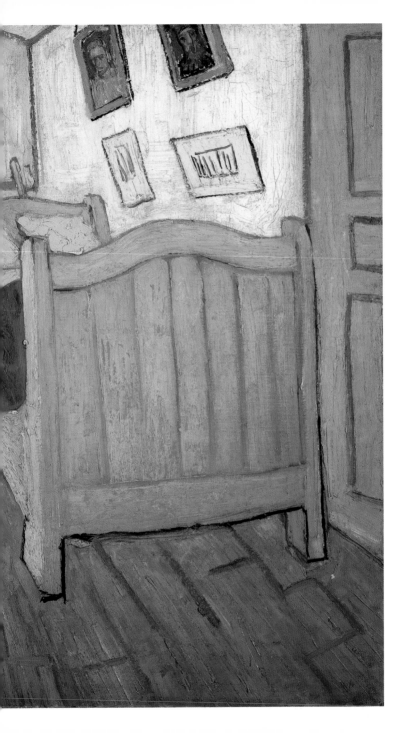

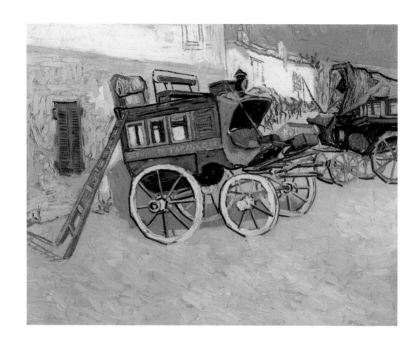

The Tarascon Stagecoach · October 1888
The Art Museum, Princeton

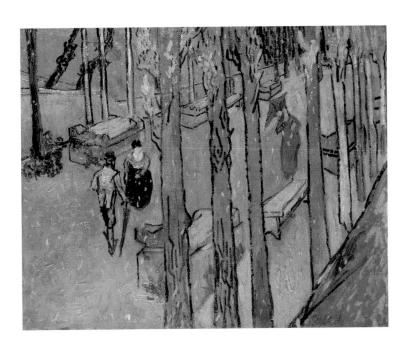

The Alyscamps, Avenue at Arles · November 1888
Kröller-Müller Museum, Otterlo

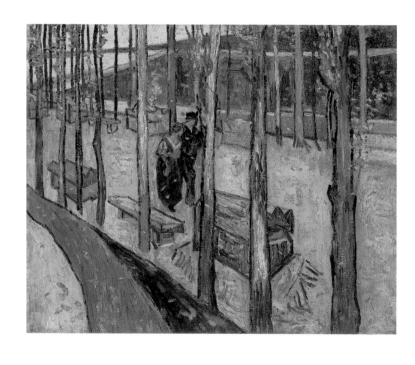

The Alyscamps, Avenue at Arles · October 1888
Collection Stavros S. Niarchos

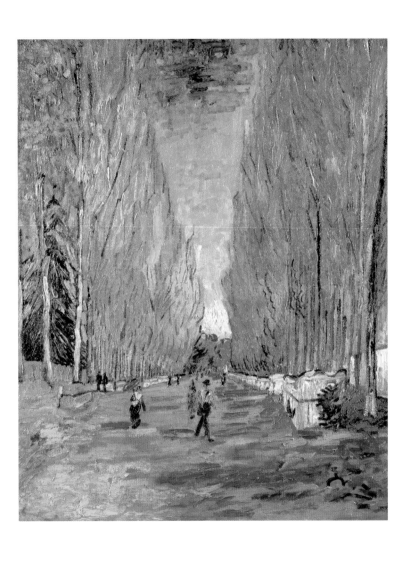

The Alyscamps, Avenue at Arles · November 1888
Private collection

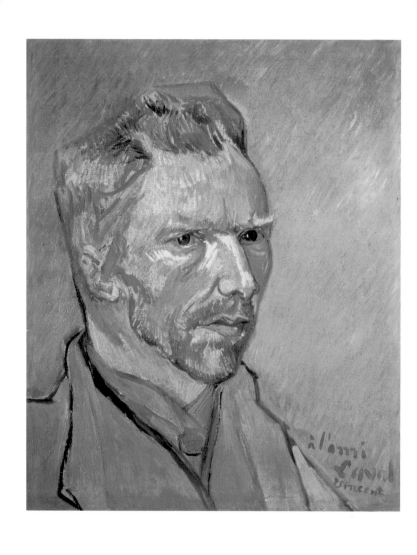

Self-Portrait · November–December 1888
Private collection

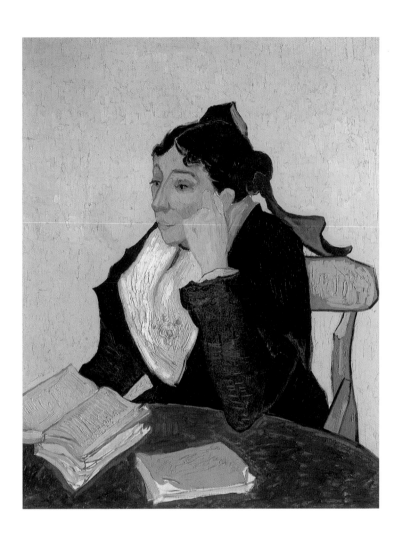

The Arlésienne (Madame Ginoux) · November 1888?
The Metropolitan Museum of Art, New York

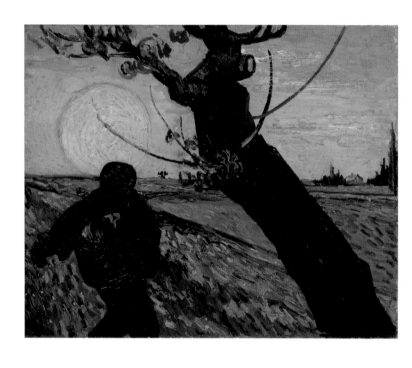

Sower with Setting Sun · November 1888
Van Gogh Museum, Amsterdam

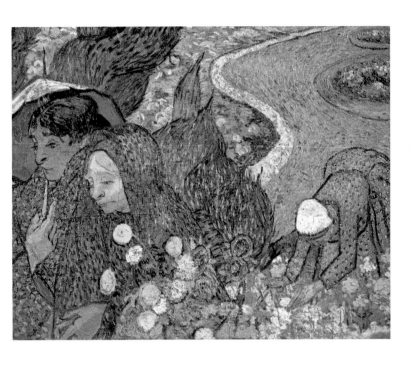

Memory of the Garden at Etten · November 1888
Hermitage, Saint Petersburg

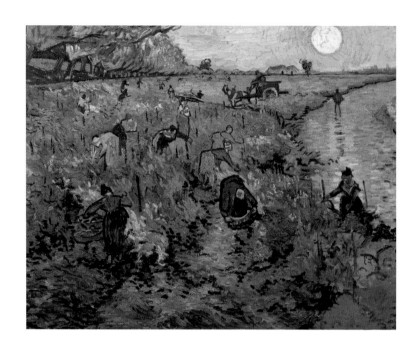

The Red Vineyard · November 1888

Pushkin Museum, Moscow

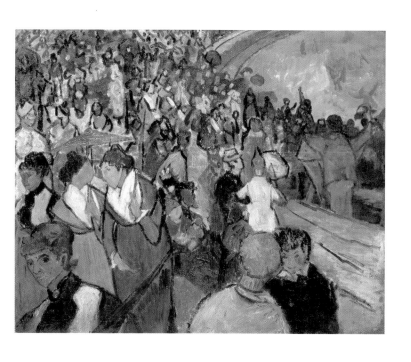

Spectators in the Arena · December 1888
Hermitage, Saint Petersburg

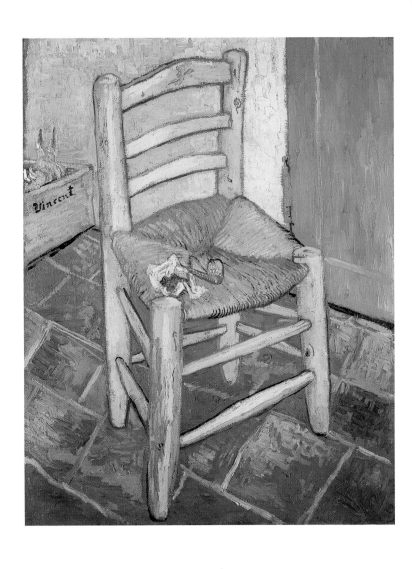

Vincent's Chair · November 1888
National Gallery, London

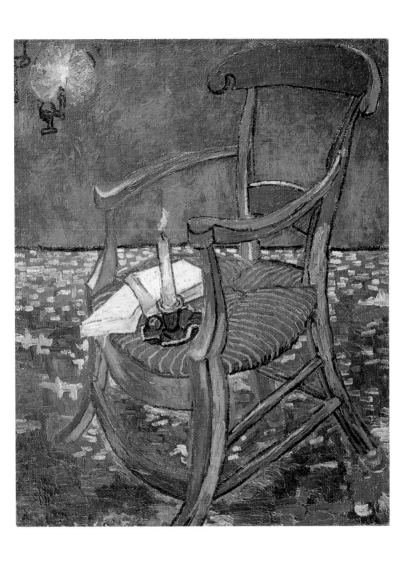

Gauguin's Chair · November 1888

Van Gogh Museum, Amsterdam

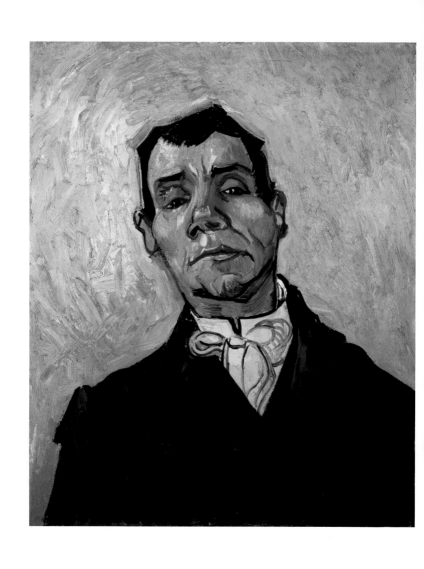

Portrait of a Man · December 1888
Kröller-Müller Museum, Otterlo

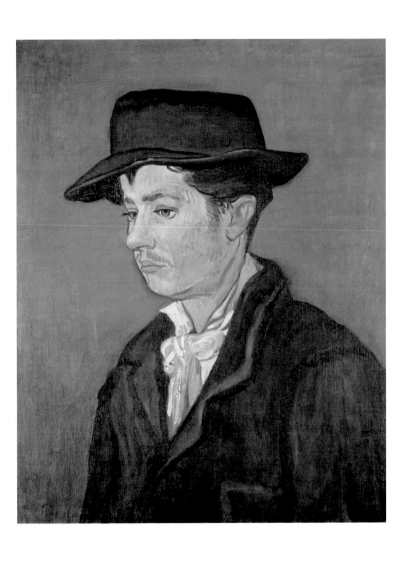

Portrait of Armand Roulin · December 1888
Museum Boijmans Van Beuningen, Rotterdam

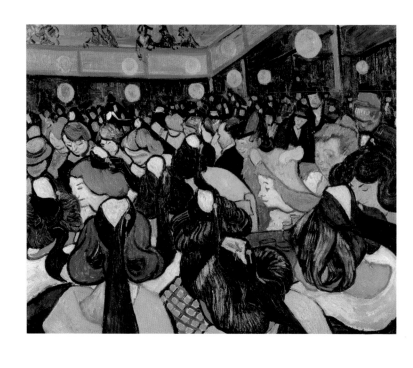

The Dance Hall · December 1888

Musée d'Orsay, Paris

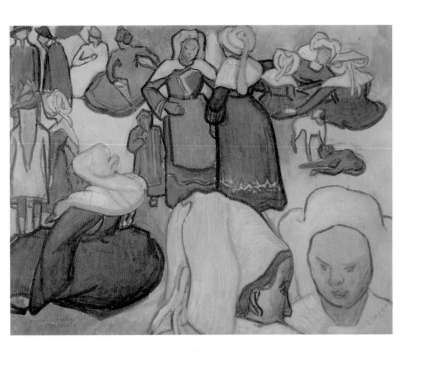

Breton Women (after Emile Bernard) · December 1888
Civica Galleria d'Arte Moderna, Milan

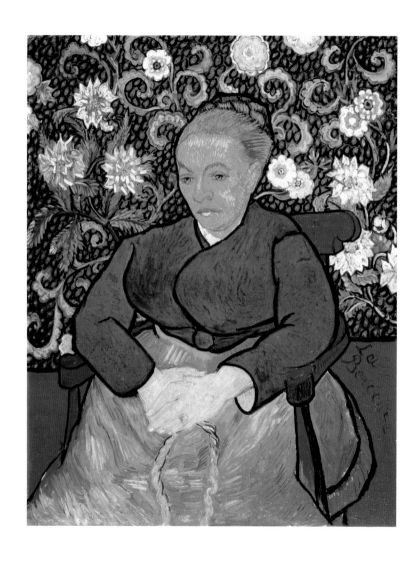

Augustine Roulin (La Berceuse) · March 1889
Kröller-Müller Museum, Otterlo

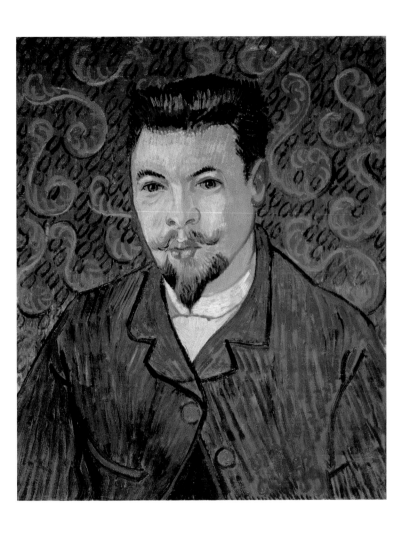

Doctor Felix Rey · January 1889
Pushkin Museum, Moscow

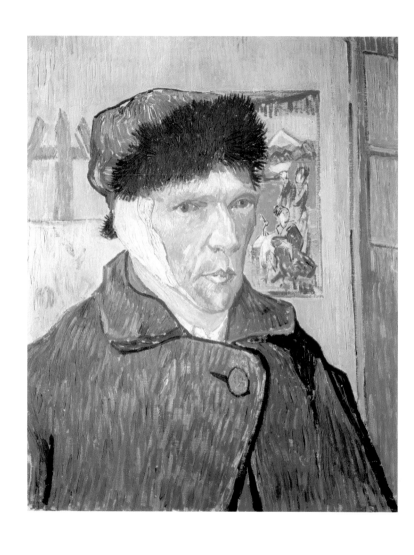

Self-Portrait with Bandaged Ear · January 1889
Courtauld Institute Galleries, London

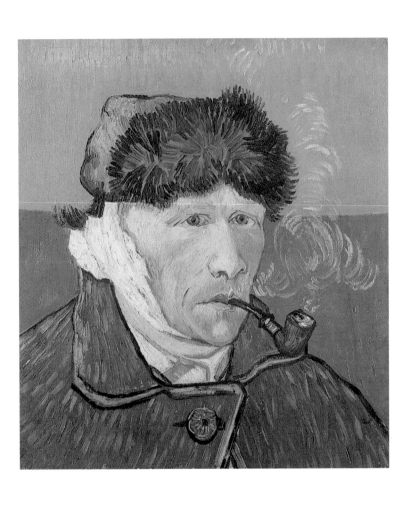

Self-Portrait with Bandaged Ear and Pipe · January 1889
Private collection

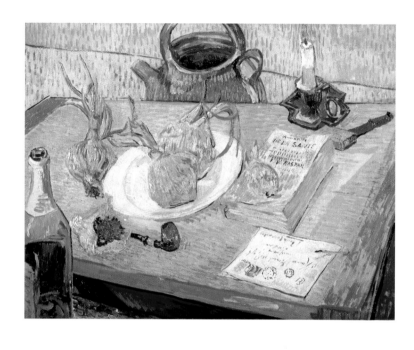

Plate with Onions, Annuaire de la Santé and Other Objects · January 1889
Kröller-Müller Museum, Otterlo

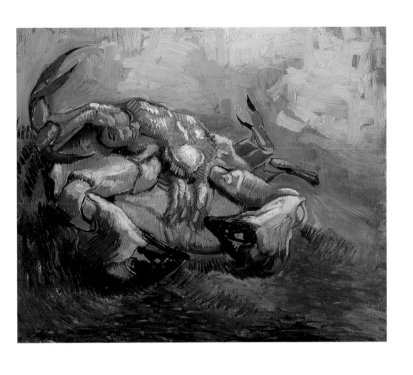

A Crab Upside Down · January–February 1889
Van Gogh Museum, Amsterdam

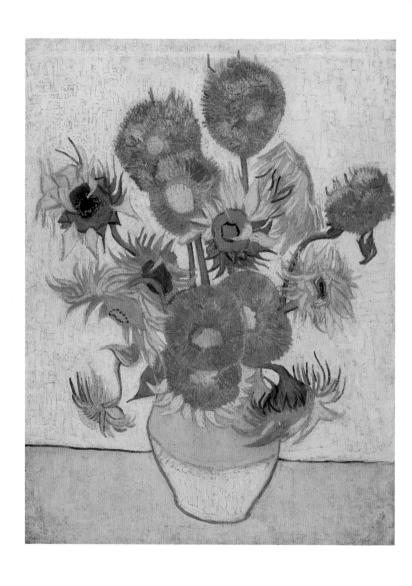

Vase with Fourteen Sunflowers · January 1889
Van Gogh Museum, Amsterdam

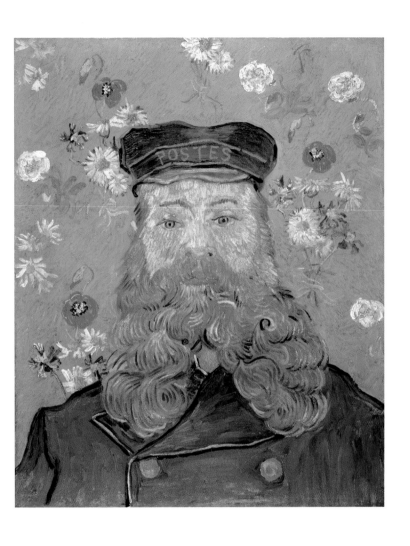

Joseph Roulin, Bust · February–April 1889
Kröller-Müller Museum, Otterlo

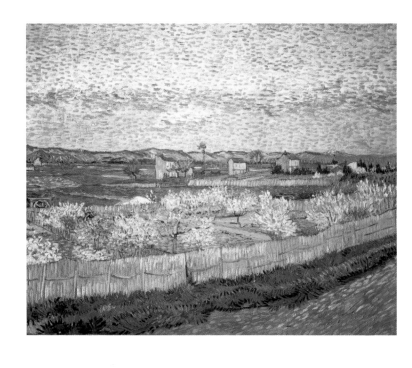

"La Crau" with Peach Trees in Blossom · April 1889
Courtauld Institute Galleries, London

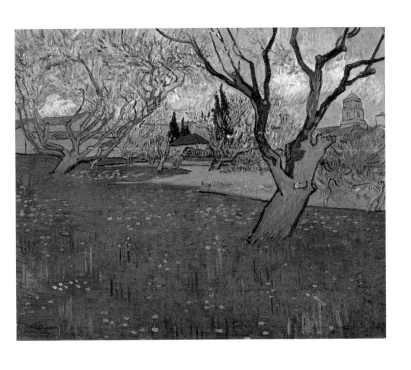

Orchard in Bloom with View of Arles · April 1889
Van Gogh Museum, Amsterdam

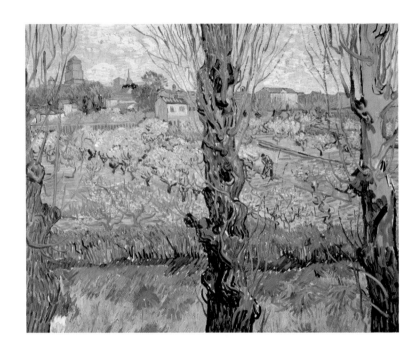

Orchard in Bloom with Poplars in the Foreground · April 1889
Neue Pinakothek, Munich

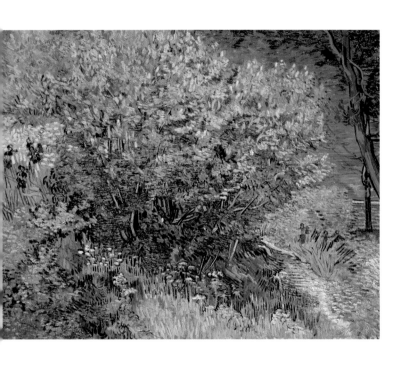

Lilacs · May 1889
Hermitage, Saint Petersburg

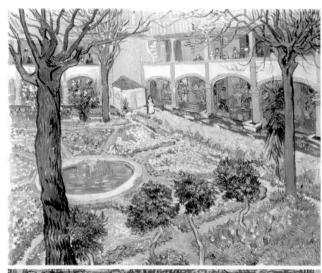

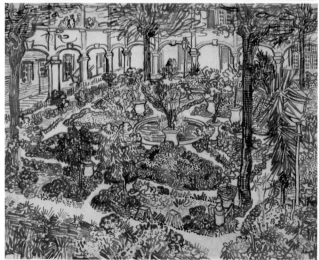

The Courtyard of the Hospital · April 1889
Collection Oskar Reinhart, Winterthur
Van Gogh Museum, Amsterdam

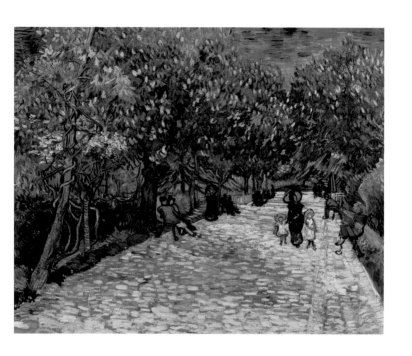

Lane with Chestnut Trees in Bloom · May 1889
Private collection
> **Irises** · May 1889
Getty Center, Los Angeles

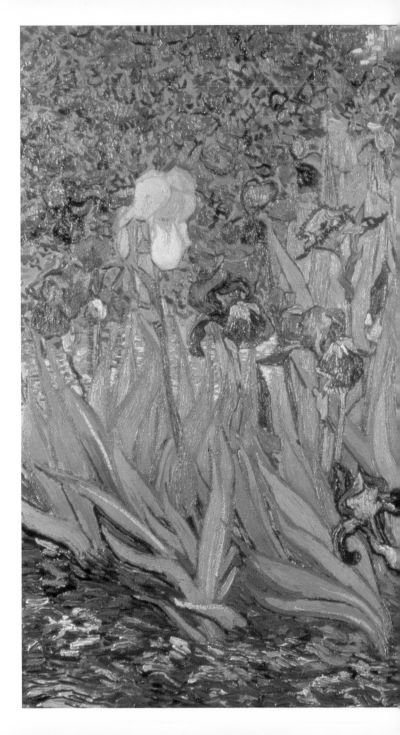

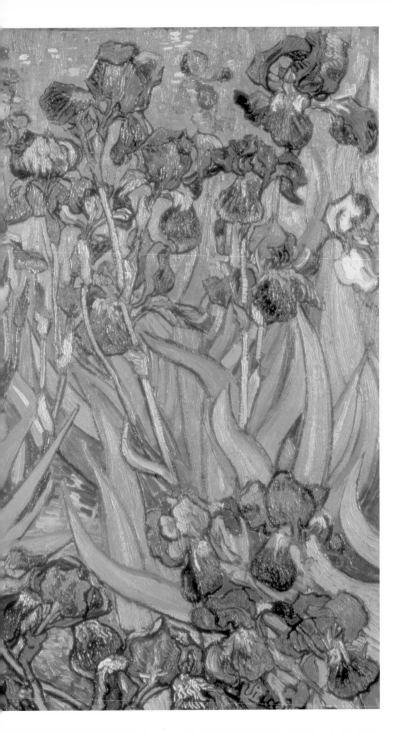

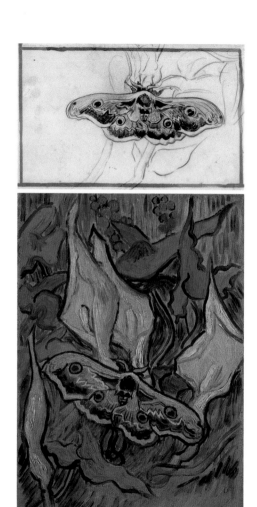

Death's-Head Moth
Death's-Head Moth on an Arum · May 1889
Van Gogh Museum, Amsterdam

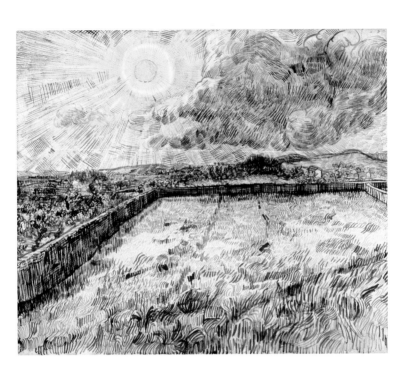

Sun over Walled Wheat Field · May 1889

Kröller-Müller Museum, Otterlo

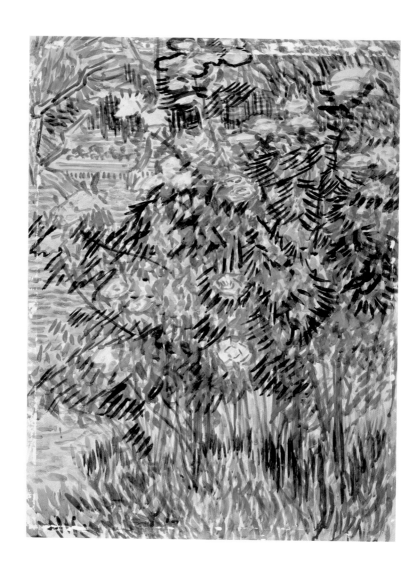

Flowering Shrubs · May 1889
Kröller-Müller Museum, Otterlo

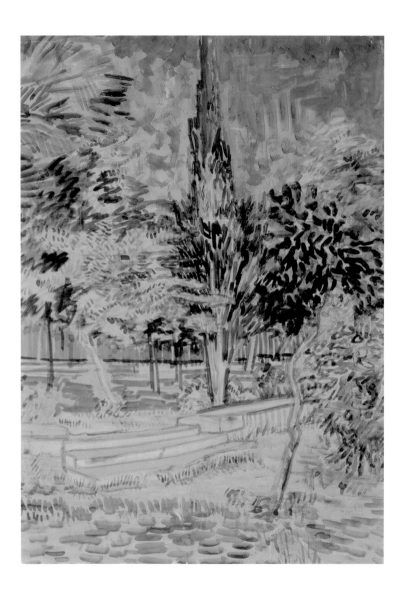

Stone Steps in the Garden of the Asylum · May 1889?
Van Gogh Museum, Amsterdam

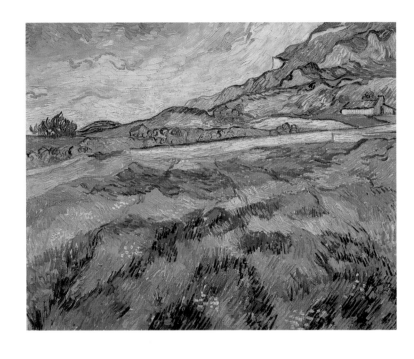

Mountain Landscape Seen across the Walls; Green Field · June 1889
Kunsthaus Zürich (on loan)

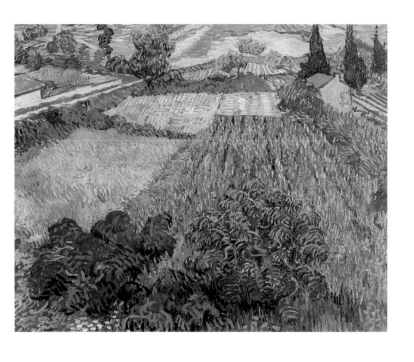

Fields with Poppies · June 1889

Kunsthalle, Bremen

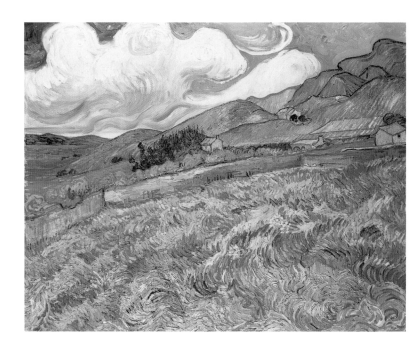

Mountain Landscape Seen across the Walls · June 1889
Ny Carlsberg Glyptotek, Copenhagen

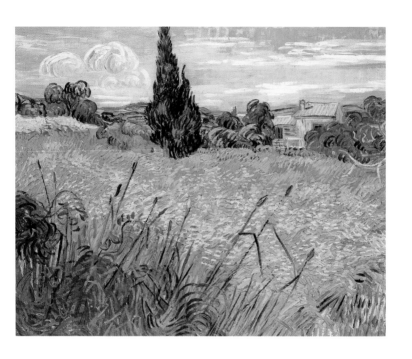

Green Wheat Field with Cypress · June 1889
Narodni Galerie, Prague
> **The Starry Night** · June 1889
The Museum of Modern Art, New York

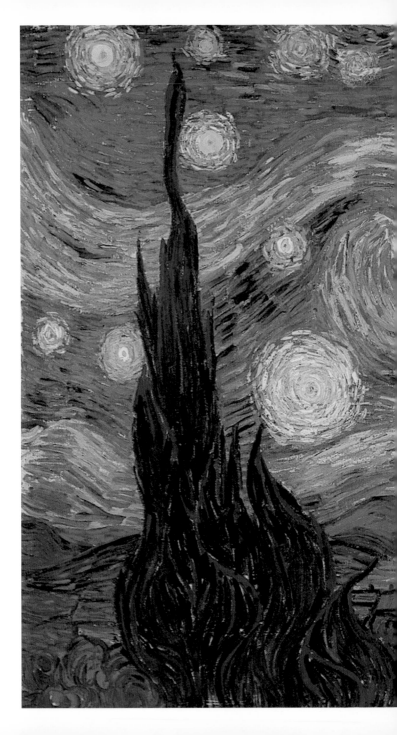

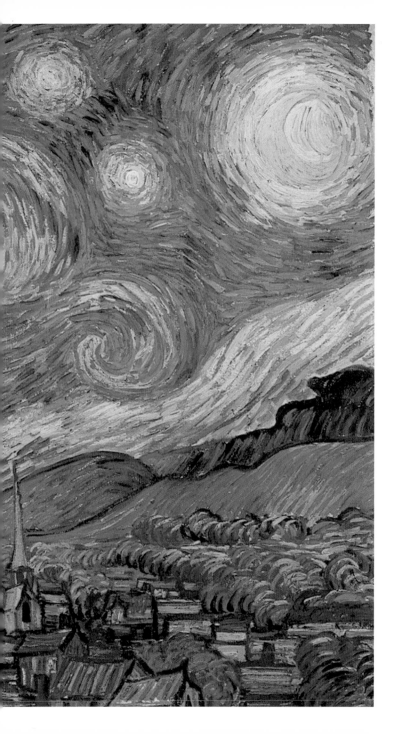

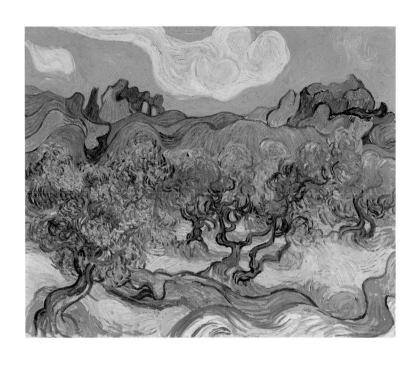

Olive Trees in a Mountain Landscape · June 1889
Collection Mrs. John Hay Whitney, New York

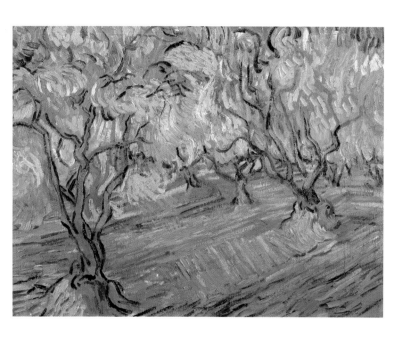

Olive Orchard · June 1889

Van Gogh Museum, Amsterdam

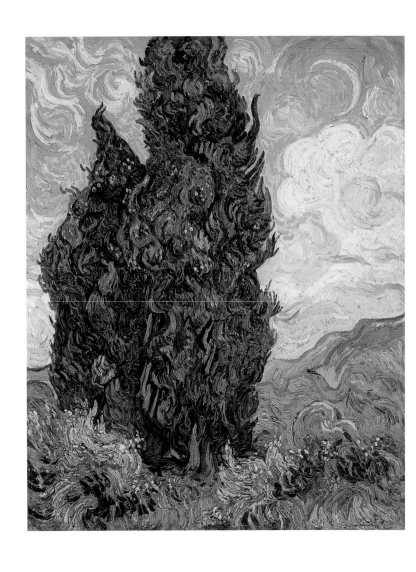

Cypresses · June 1889
The Metropolitan Museum of Art, New York

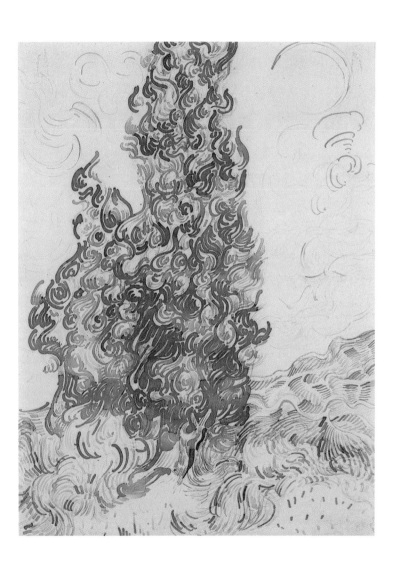

Cypresses · June 1889
Brooklyn Museum, New York

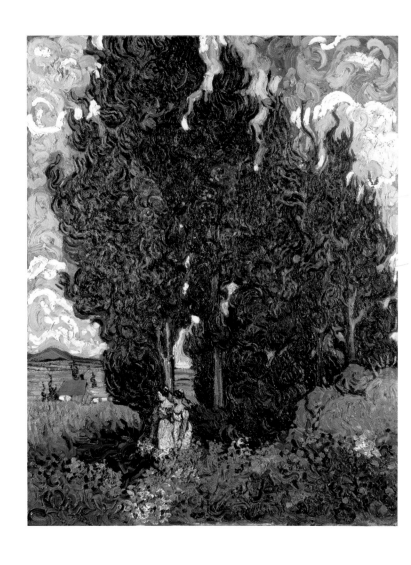

Cypresses · June 1889
Kröller-Müller Museum, Otterlo

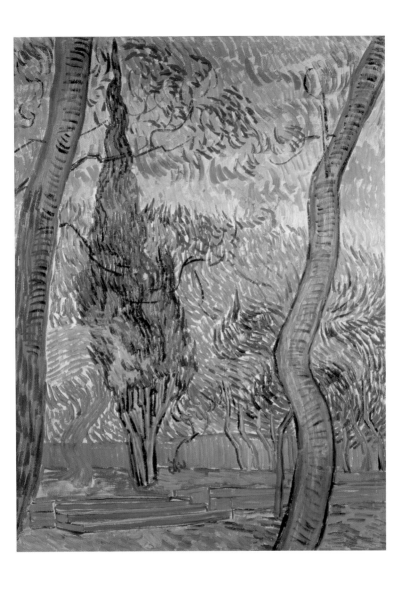

Trees in the Garden of the Asylum · June 1889

Private collection

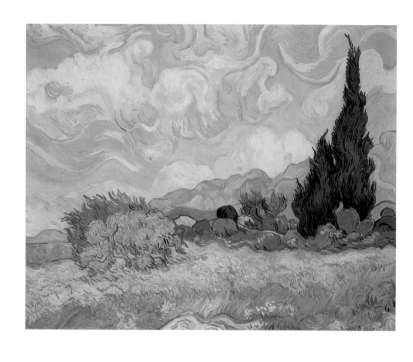

Wheat Field with Cypresses · June 1889
National Gallery, London

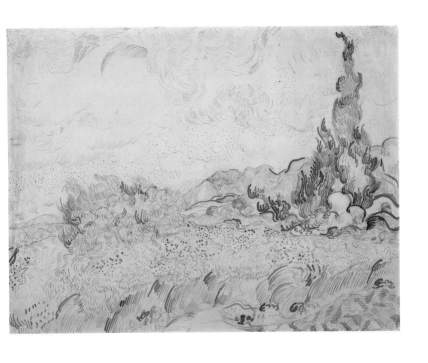

Wheat Field with Cypresses · June 1889
Van Gogh Museum, Amsterdam

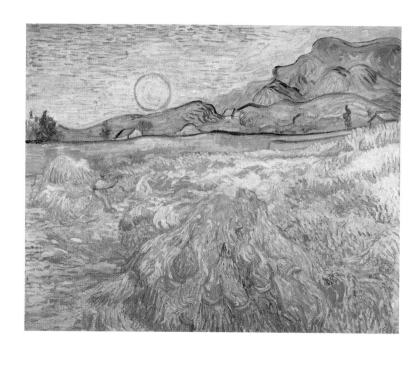

Enclosed Wheat Field with Reaper · June and September 1889
Kröller-Müller Museum, Otterlo

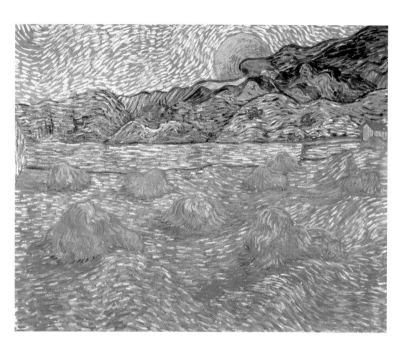

Enclosed Field with Sheaves and Rising Moon · July 1889
Kröller-Müller Museum, Otterlo

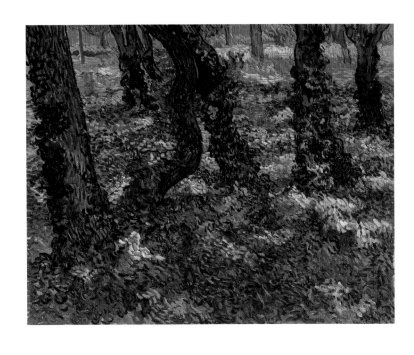

Trunks of Trees with Ivy · July 1889

Van Gogh Museum, Amsterdam

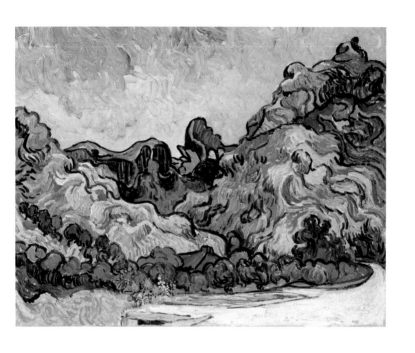

Mountains with Dark Hut · July 1889

The Solomon R. Guggenheim Museum, Justin K. Thannhauser Collection, New York

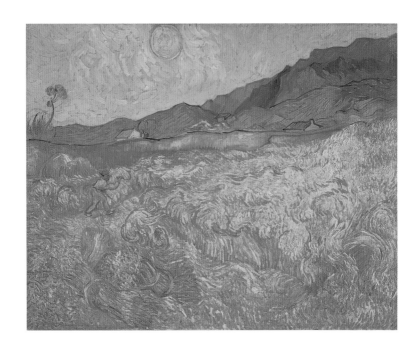

Wheat Fields with Reaper at Sunrise · September 1889
Van Gogh Museum, Amsterdam

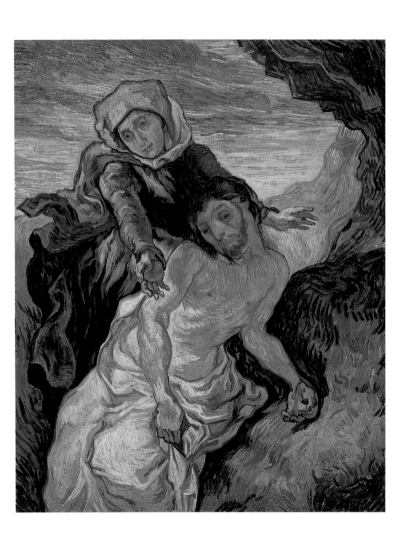

Pietà (after Delacroix) · September 1889
Van Gogh Museum, Amsterdam

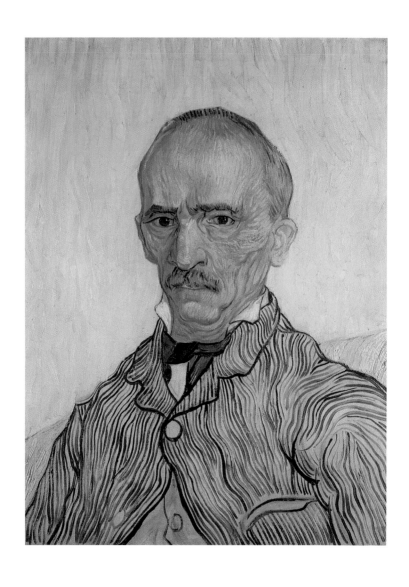

Portrait of the Chief Orderly (Trabuc) · September 1889
Kunstmuseum Solothurn, Dubi-Muller Foundation, Solothurn

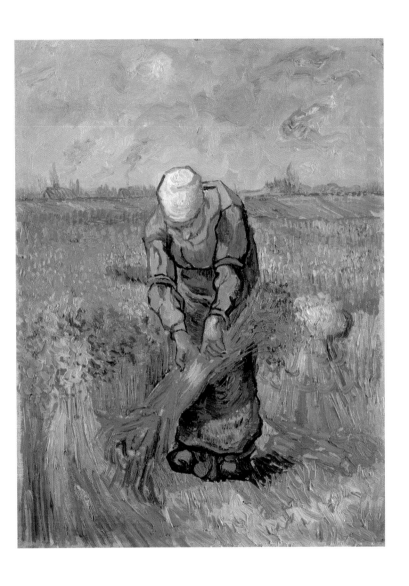

Woman Binding Sheaves · September 1889

Van Gogh Museum, Amsterdam

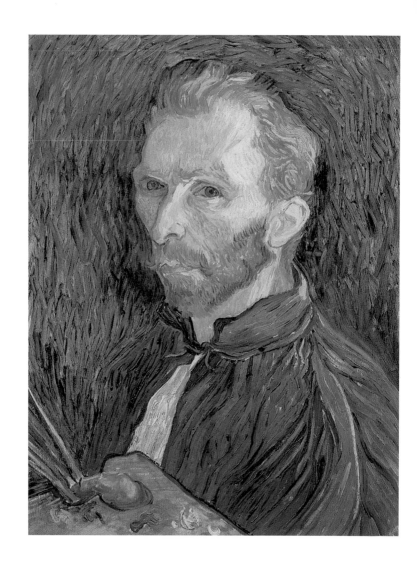

Self-Portrait · September 1889
National Gallery of Art, Washington

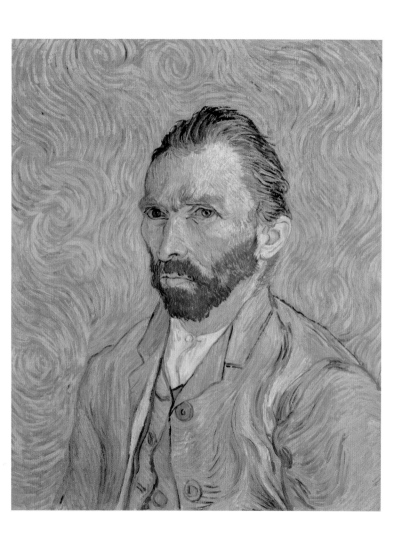

Self-Portrait · September 1889
Musée d'Orsay, Paris

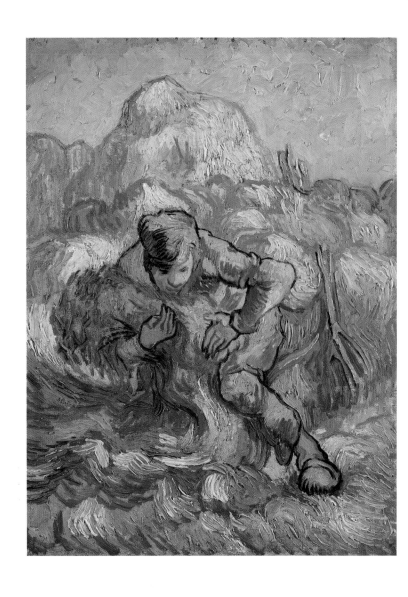

Sheaf-Binder (after Millet) · September 1889
Van Gogh Museum, Amsterdam

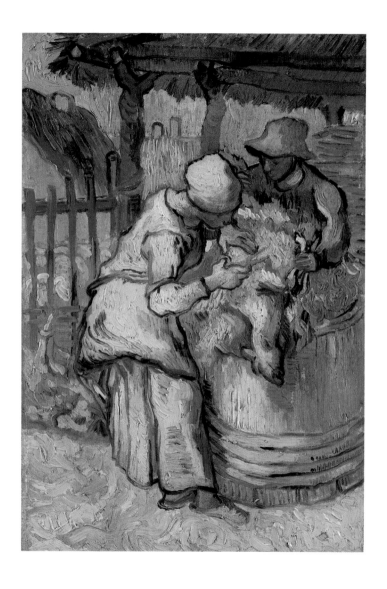

Sheep-Shearers (after Millet) · September 1889
Van Gogh Museum, Amsterdam

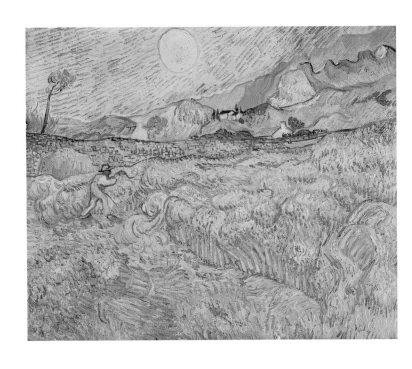

Enclosed Field with Reaper at Sunrise · September 1889
Museum Folkwang, Essen

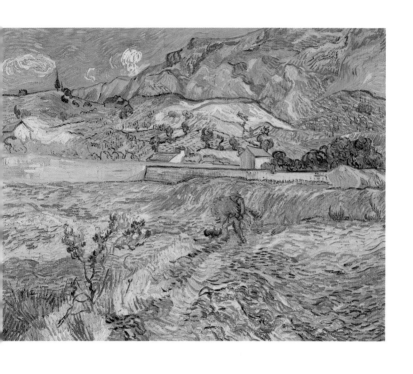

Enclosed Field with Farmer Carrying a Bundle of Straw · October 1889
Indianapolis Museum of Art, Indianapolis

Entrance to a Quarry · July 1889
Van Gogh Museum, Amsterdam

A Small Stream in the Mountains · October 1889

Van Gogh Museum, Amsterdam

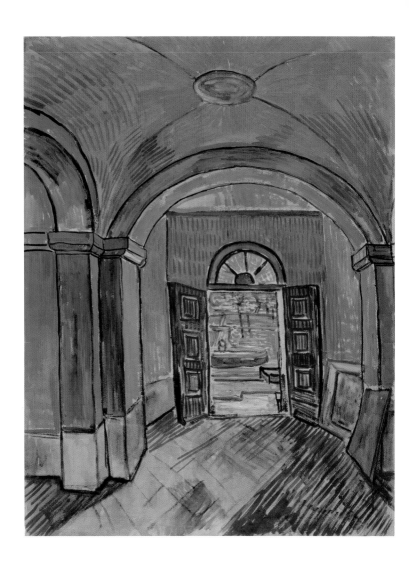

The Vestibule of the Asylum · October 1889
Van Gogh Museum, Amsterdam

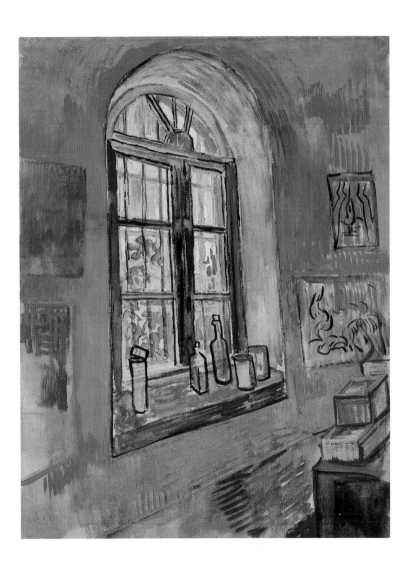

Window of Vincent's Studio at the Asylum · October 1889
Van Gogh Museum, Amsterdam

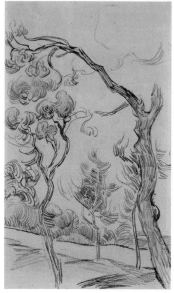

Trees and a Stone Bench in the Garden of the Asylum
Pine Trees Seen against the Wall of the Asylum · October 1889
Van Gogh Museum, Amsterdam

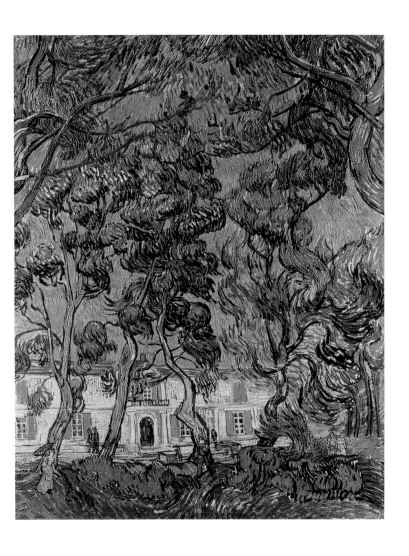

Trees in Front of the Entrance of the Asylum · October 1889
The Armand Hammer Museum of Art, Los Angeles

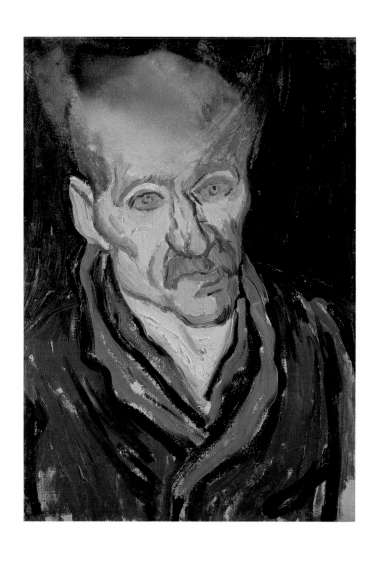

Portrait of a Patient · October 1889
Van Gogh Museum, Amsterdam

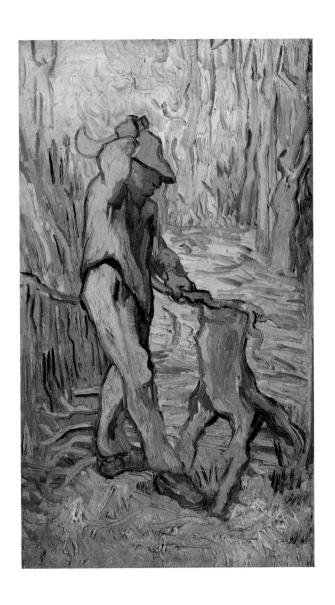

The Woodcutter (after Millet) · October 1889
Van Gogh Museum, Amsterdam

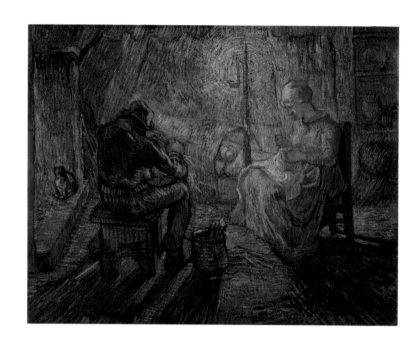

The Family at Night (after Millet) · October 1889
Van Gogh Museum, Amsterdam

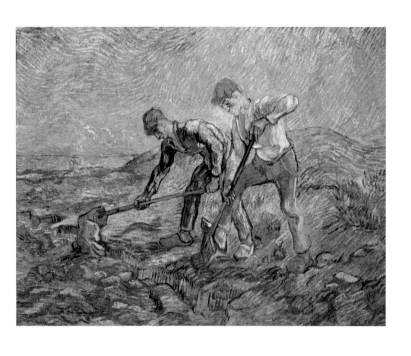

Two Diggers (after Millet) · October–December 1889
Stedelijk Museum, Amsterdam

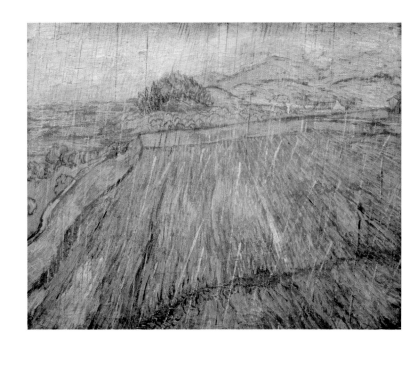

Enclosed Field in the Rain · November 1889
Museum of Art, Philadelphia

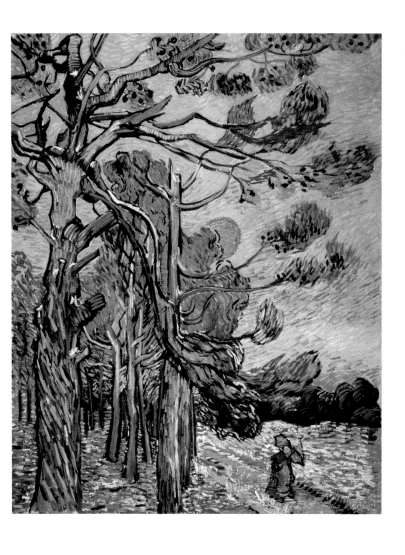

Storm-Beaten Pine Trees against the Setting Sun · December 1889
Kröller-Müller Museum, Otterlo

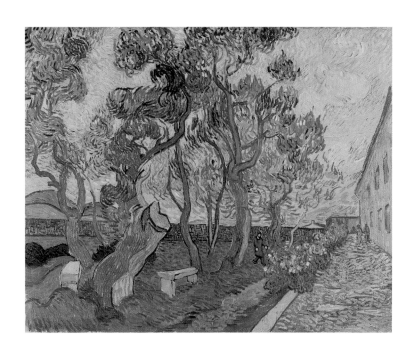

**Corner of the Asylum and the Garden with a Heavy,
Sawn-Off Tree** · October–November 1889

Museum Folkwang, Essen

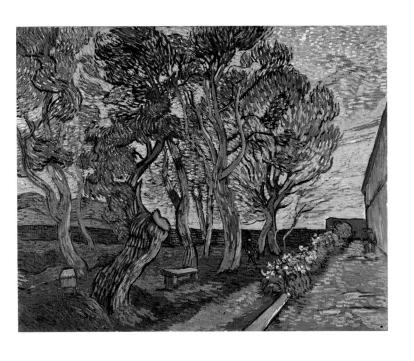

**Corner of the Asylum and the Garden with a Heavy,
Sawn-Off Tree** · November–December 1889
Van Gogh Museum, Amsterdam

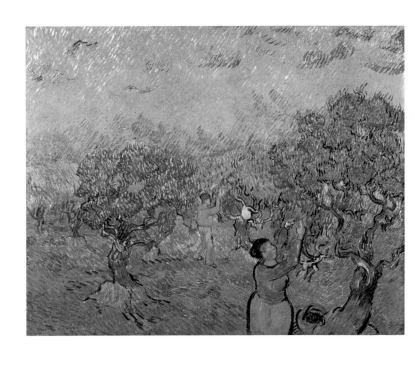

Olive Orchard with a Man and a Woman Picking Olives · November 1889
Kröller-Müller Museum, Otterlo

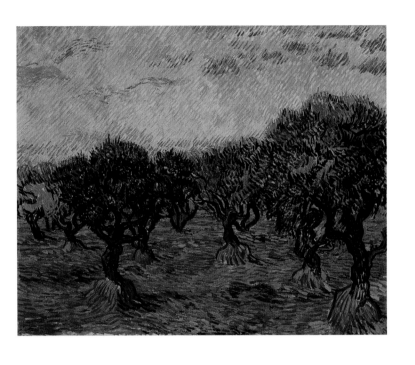

Olive Orchard · November 1889
Konstmuseum, Göteborg

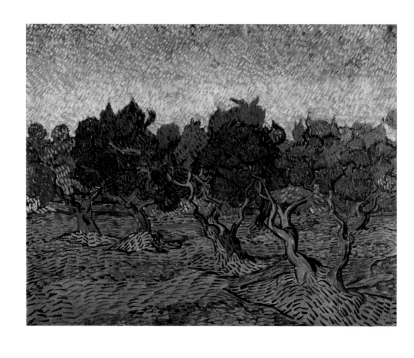

Olive Orchard · November 1889
Van Gogh Museum, Amsterdam

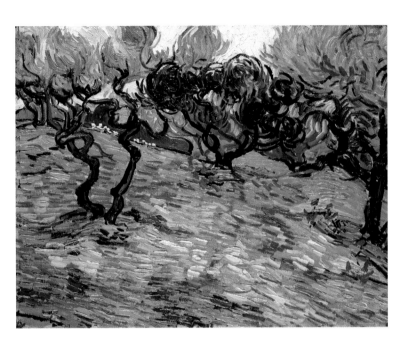

Olive Orchard · November 1889
National Gallery of Scotland, Edinburgh

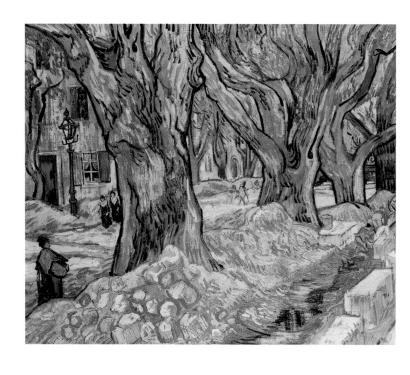

Road Menders in a Lane with Massive Plane Trees · December 1889

The Cleveland Museum of Art, Cleveland

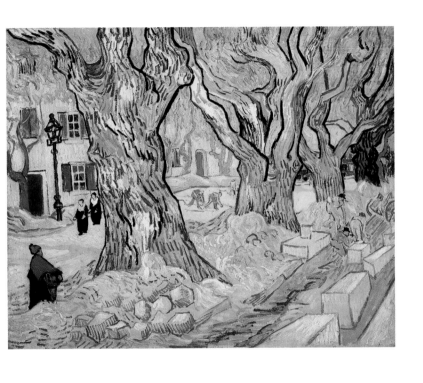

Road Menders in a Lane with Massive Plane Trees · December 1889
The Phillips Collection, Washington

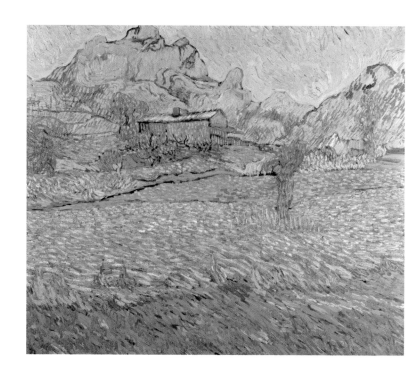

Fields with Pollard Tree and Mountainous Background · December 1889
Kröller-Müller Museum, Otterlo

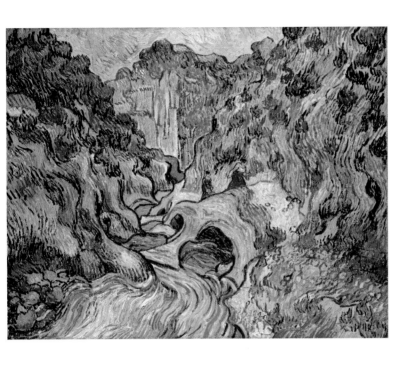

A Path through the Ravine · December 1889

Kröller-Müller Museum, Otterlo

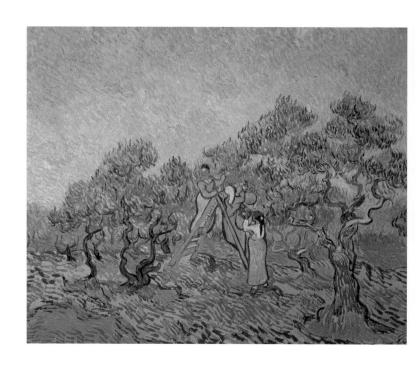

Women Picking Olives · December 1889
National Gallery of Art, Washington

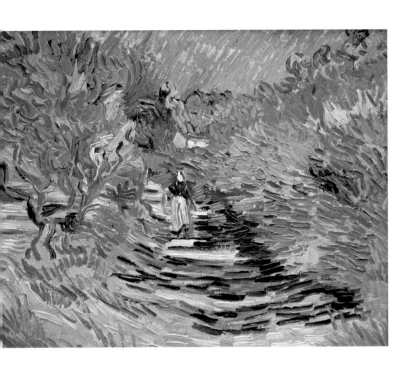

Woman on a Road among Trees · December 1889
Kasama Nichido Museum of Art, Kasama

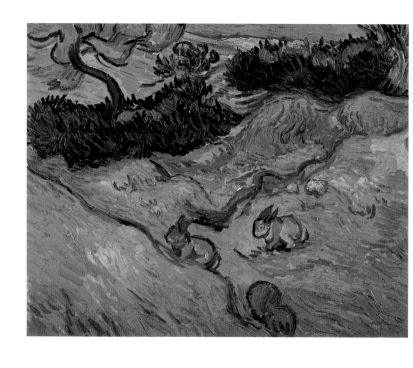

Field with Two Rabbits · December 1889

Van Gogh Museum, Amsterdam

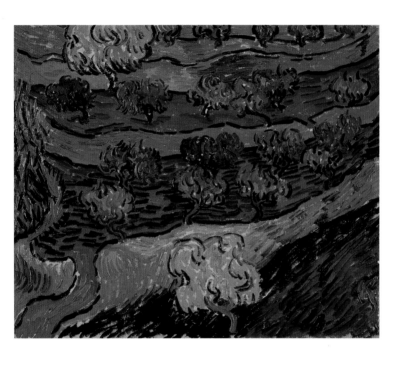

Olive Orchard (Bird's-Eye View) · December 1889
Van Gogh Museum, Amsterdam

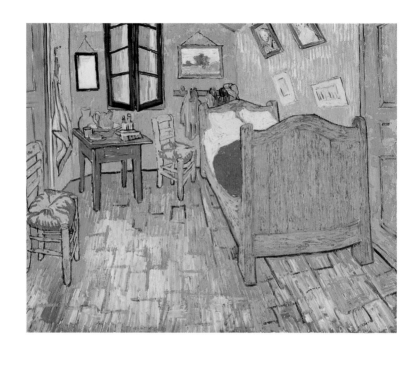

Vincent's Bedroom · September 1889
The Art Institute of Chicago, Chicago

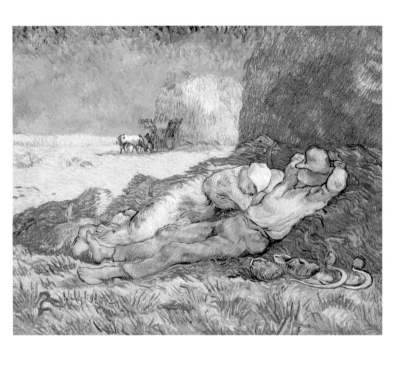

Noon: Rest (after Millet) · January 1890
Musée d'Orsay, Paris

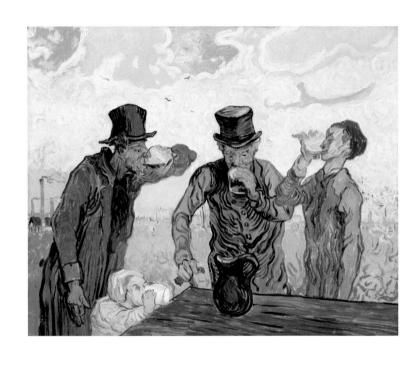

Men Drinking (after Daumier) · February 1890
The Art Institute of Chicago, Chicago

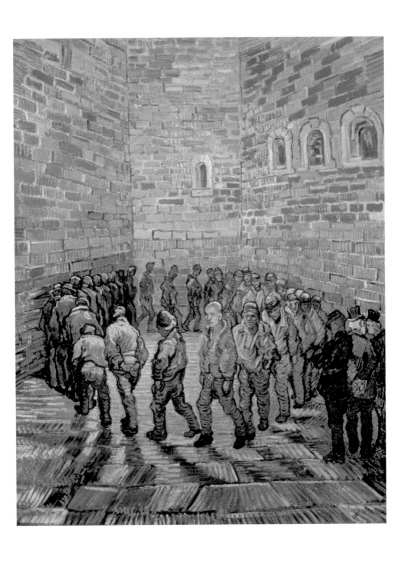

Prisoners Round (after Gustave Doré) · February 1890

Pushkin Museum, Moscow

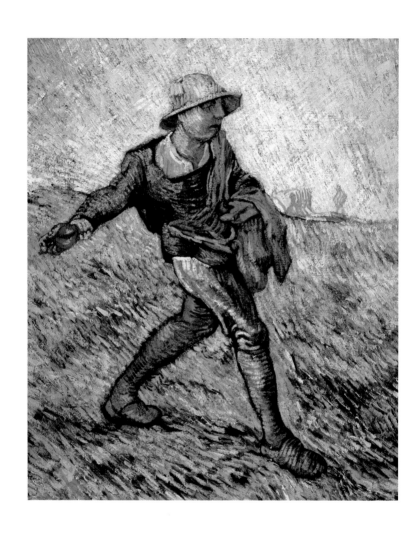

The Sower (after Millet) · February 1890

Kröller-Müller Museum, Otterlo

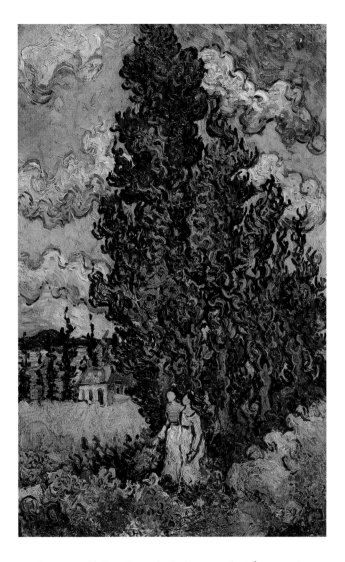

Cypresses with Two Women in the Foreground · February 1890
Van Gogh Museum, Amsterdam
> **Branches of a Blossoming Almond Tree** · February 1890
Van Gogh Museum, Amsterdam

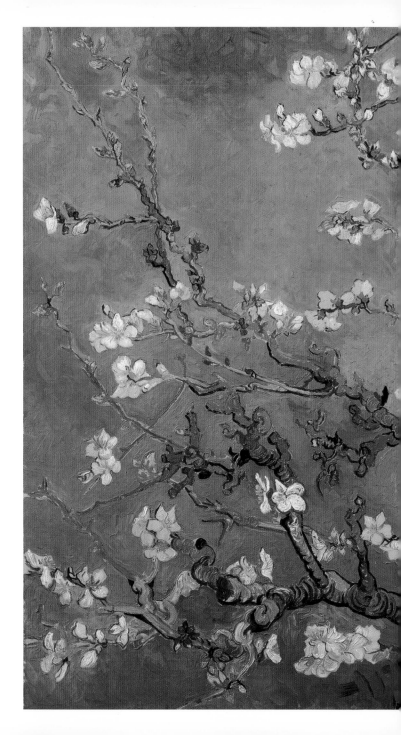

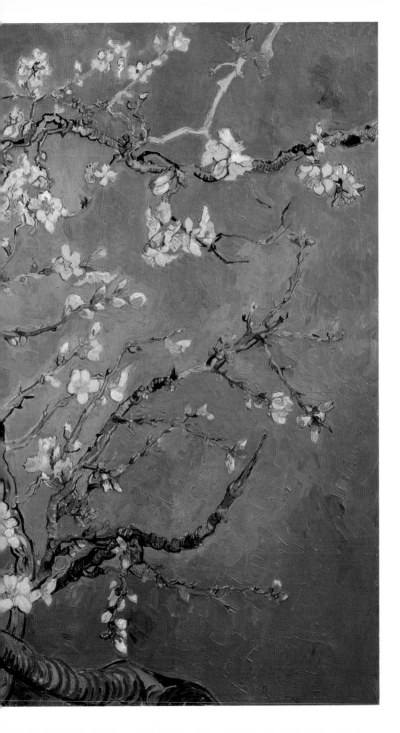

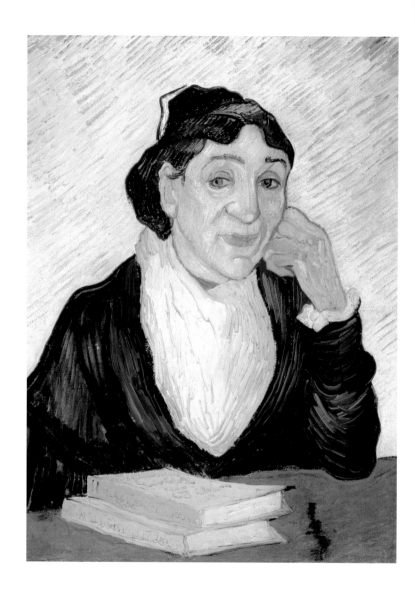

The Arlésienne (Madame Ginoux), with Pink Background · February 1890
Kröller-Müller Museum, Otterlo

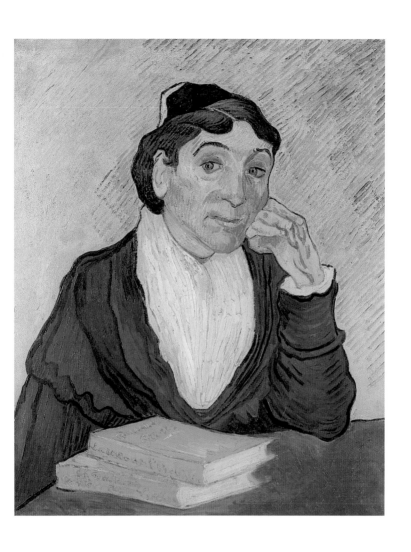

The Arlésienne (Madame Ginoux), with Pink Background · February 1890
Museu de Arte de São Paulo, São Paulo

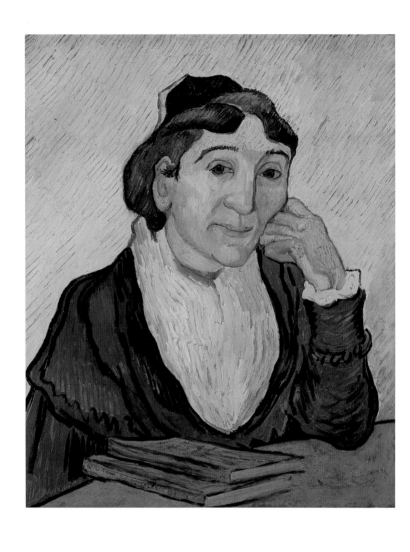

The Arlésienne (Madame Ginoux), with Cherry-Colored Background · February 1890
Galleria Nazionale d'Arte Moderna, Rome

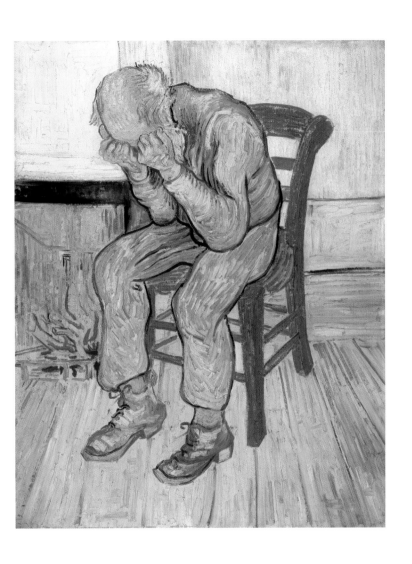

**Old Man with His Head in His Hands
(after the lithograph "At Eternity's Gate")** · Spring 1890
Kröller-Müller Museum, Otterlo

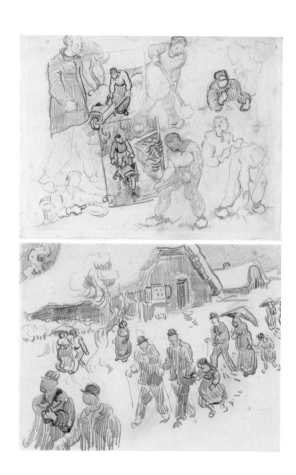

Sheet with Sketches of Working People
People Walking in Front of Snow-Covered Cottage · March–April 1890
Van Gogh Museum, Amsterdam

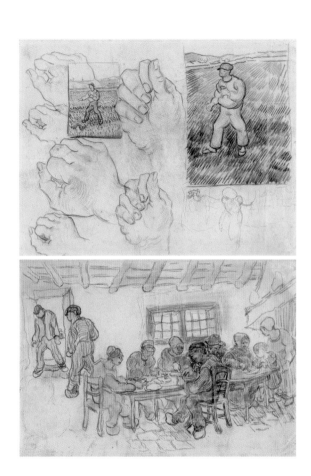

Sheet with Two Sowers and Hands
Sheet with Two Groups of Peasants at a Meal and Other Figures · March–April 1890
Van Gogh Museum, Amsterdam

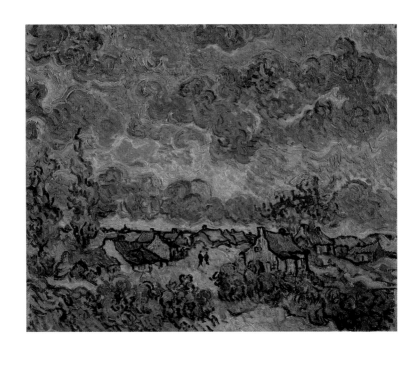

Cottages and Cypresses at Sunset with Stormy Sky · March–April 1890
Van Gogh Museum, Amsterdam

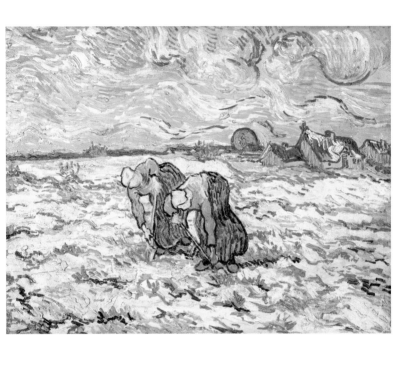

Two Peasant Women Digging in a Snow-Covered Field at Sunset · March–April 1890
Foundation E.G. Bührle, Zurich

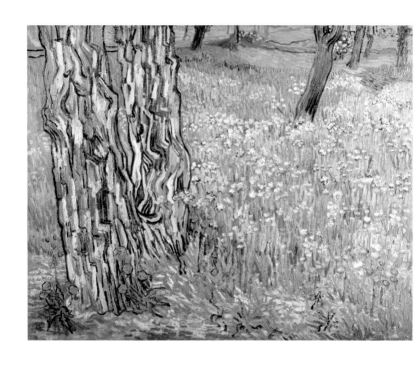

Field of Grass with Dandelions and Tree Trunks · April 1890
Kröller-Müller Museum, Otterlo

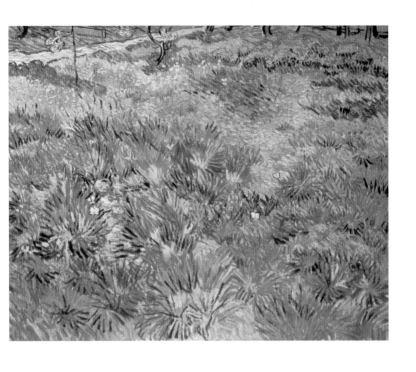

Field of Grass with Flowers and Butterflies · May 1890

National Gallery, London

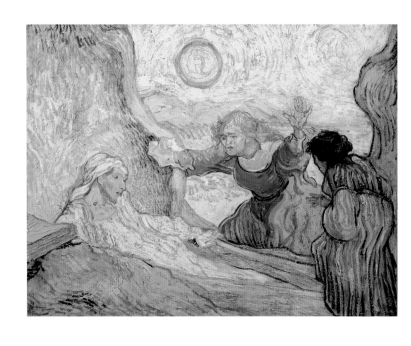

The Raising of Lazarus (after Rembrandt) · May 1890
Van Gogh Museum, Amsterdam

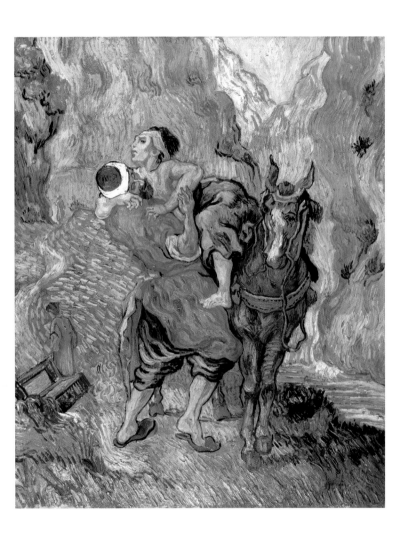

The Good Samaritan (after Delacroix) · May 1890
Kröller-Müller Museum, Otterlo

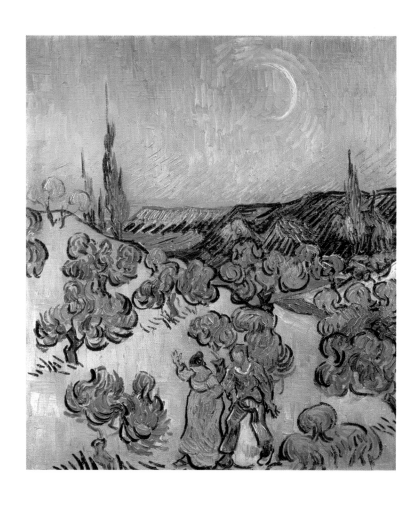

**Couple Walking among Olive Trees in Mountainous Landscape
with Crescent Moon** · May 1890

Museu de Arte de São Paulo, São Paulo

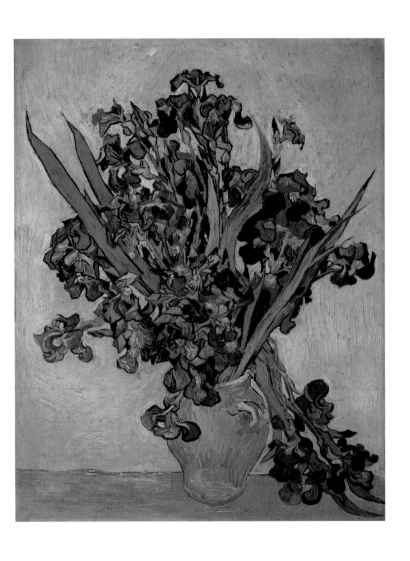

Vase with Violet Irises against a Yellow Background · May 1890
Van Gogh Museum, Amsterdam

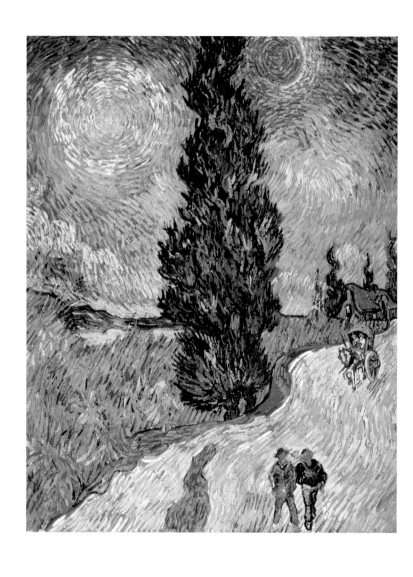

Road with Men Walking, Carriage, Cypress, Star, and Crescent Moon · May 1890
Kröller-Müller Museum, Otterlo

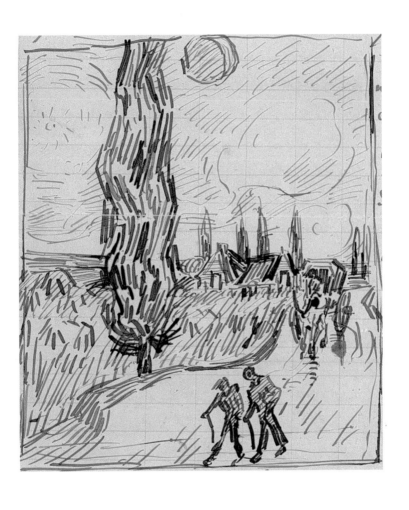

Road with Men Walking, Carriage, Cypress, Star, and Crescent Moon · June 1890
Van Gogh Museum, Amsterdam

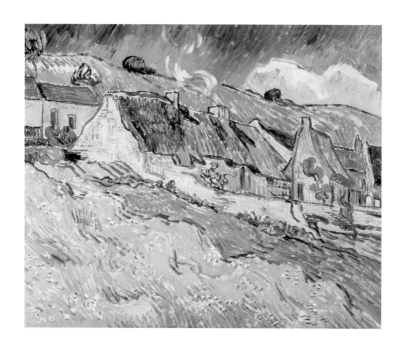

A Group of Cottages · May 1890

Hermitage, Saint Petersburg

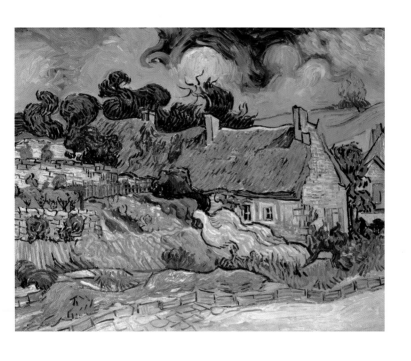

Cottages with Thatched Roofs · May 1890

Musée d'Orsay, Paris

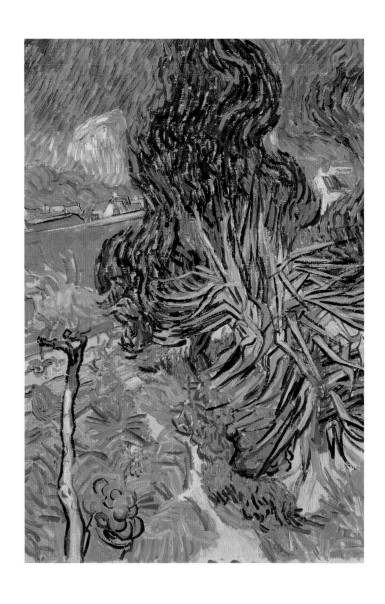

Doctor Gachet's Garden · May 1890

Musée d'Orsay, Paris

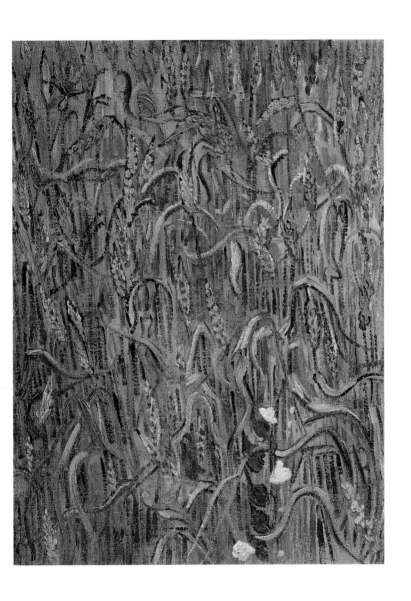

Ears of Wheat · June 1890
Van Gogh Museum, Amsterdam

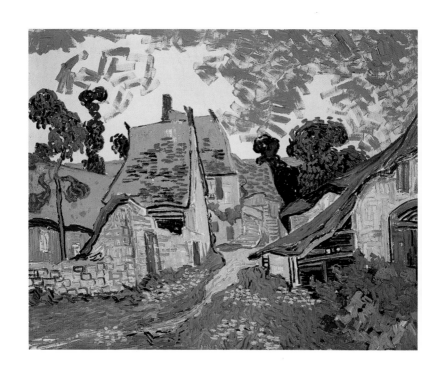

Village Street · May 1890

Atheneumin Taidemuseo, Helsinki

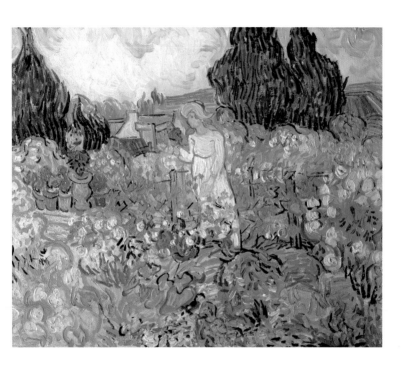

Marguerite Gachet in the Garden · June 1890
Musée d'Orsay, Paris

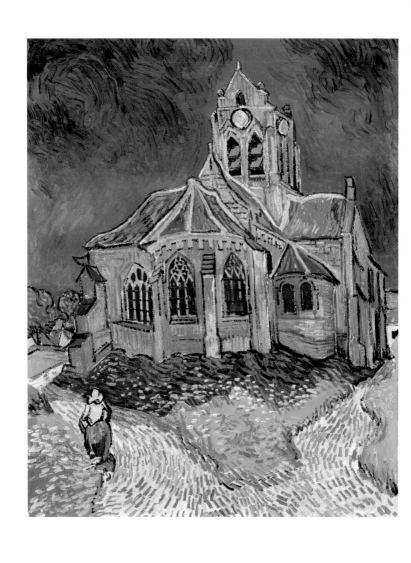

The Church in Auvers · June 1890
Musée d'Orsay, Paris

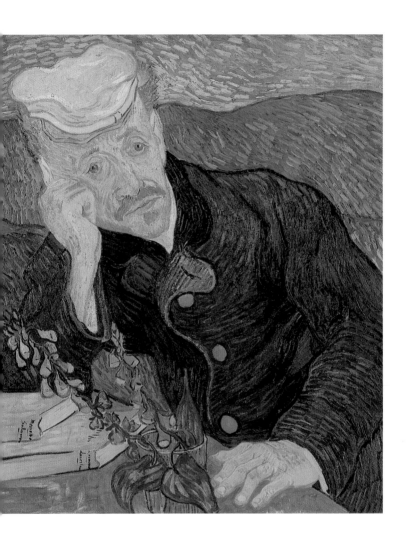

**Doctor Gachet Sitting at a Table with Books and a Glass
with Sprigs of Foxglove** · June 1890
Private collection

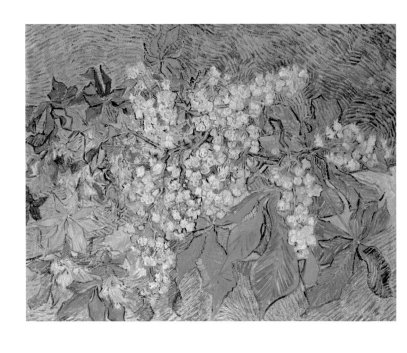

Blossoming Chestnut Branches · June 1890
Foundation E.G. Bührle, Zurich

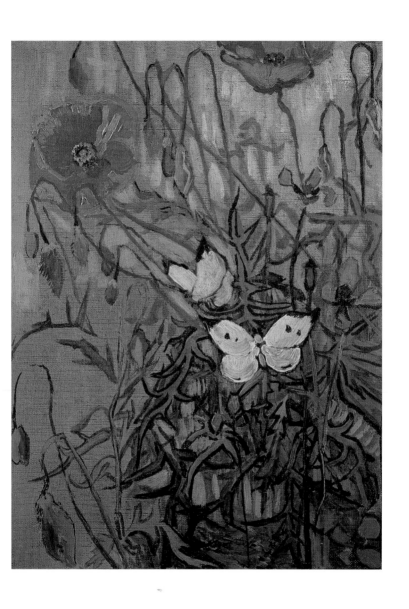

Poppies with Butterflies · May 1889
Van Gogh Museum, Amsterdam

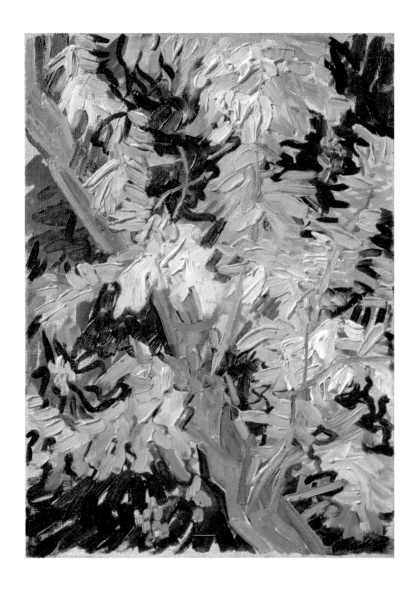

Branches of Flowering Acacia · June 1890
Nationalmuseum, Stockholm

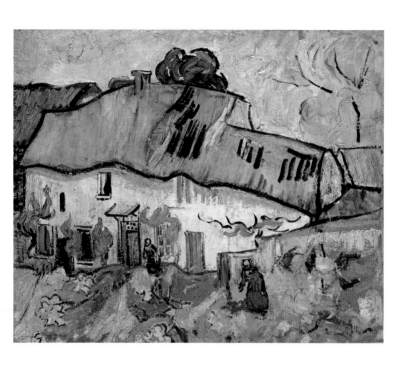

A House and Two Figures · June 1890
Van Gogh Museum, Amsterdam

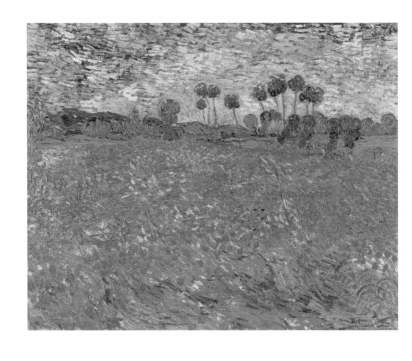

Field with Poppies · June 1890
Haags Gemeentemuseum, The Hague (on loan)

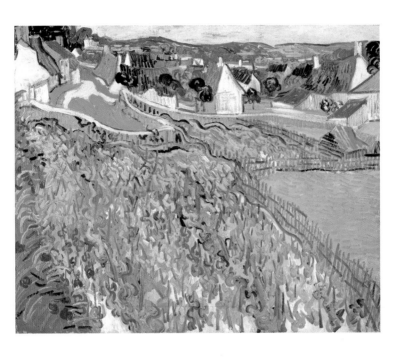

Vineyards with a Group of Houses · June 1890
The Saint Louis Art Museum, Saint Louis

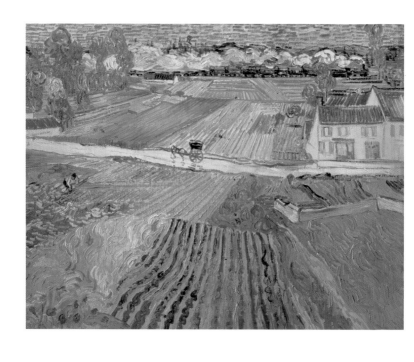

Landscape with Carriage and Train in the Background · June 1890
Pushkin Museum, Moscow

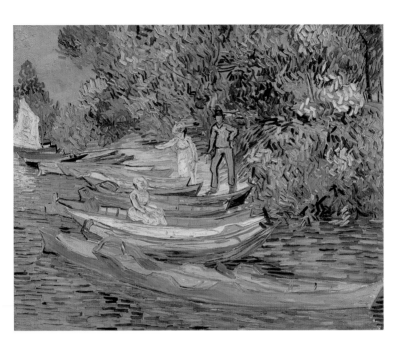

Riverbank with Rowboats and Three Figures · June 1890

The Detroit Institute of Arts, Detroit

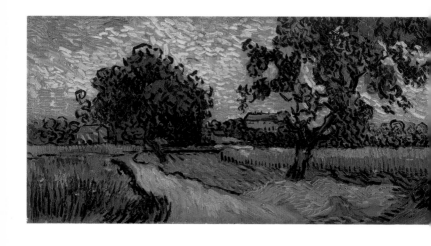

Field with Trees and the Château of Auvers at Sunset · June 1890
Van Gogh Museum, Amsterdam

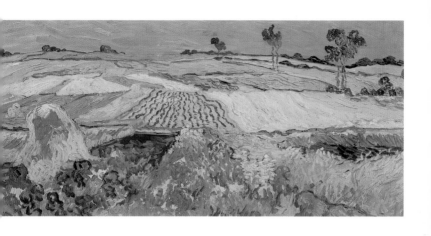

Wheat Fields · June 1890
Österreichische Galerie Belvedere, Vienna

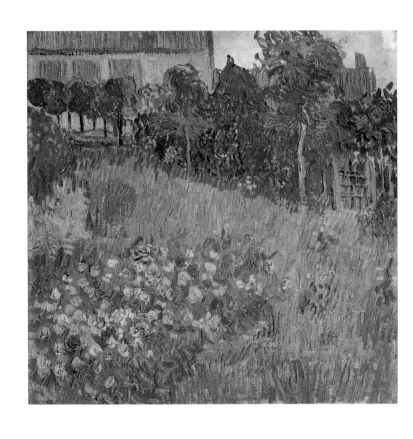

Corner of Daubigny's Garden · June 1890
Van Gogh Museum, Amsterdam

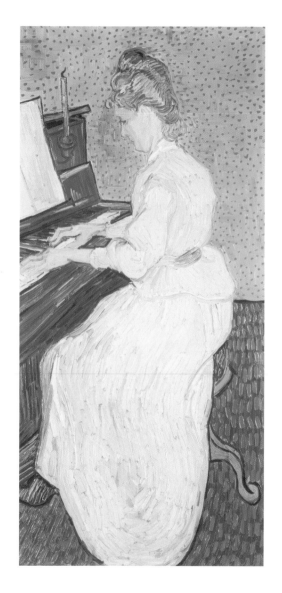

Marguerite Gachet at the Piano · June 1890
Offentliche Kunstsammlung, Kunstmuseum Basel

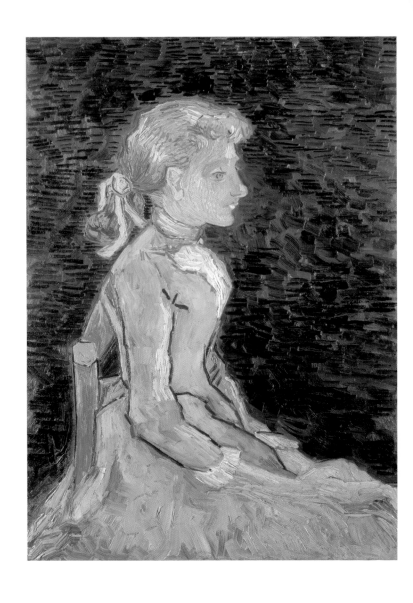

Adeline Ravoux, Half-Figure · June 1890
Private collection

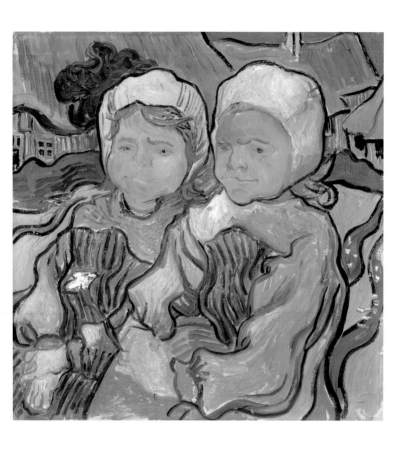

Two Children · June–July 1890
Musée d'Orsay, Paris

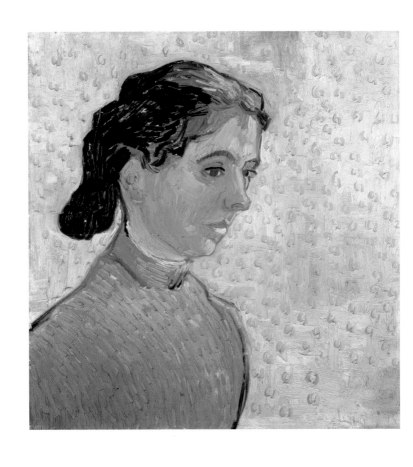

Head of a Girl · June 1890
Kröller-Müller Museum, Otterlo

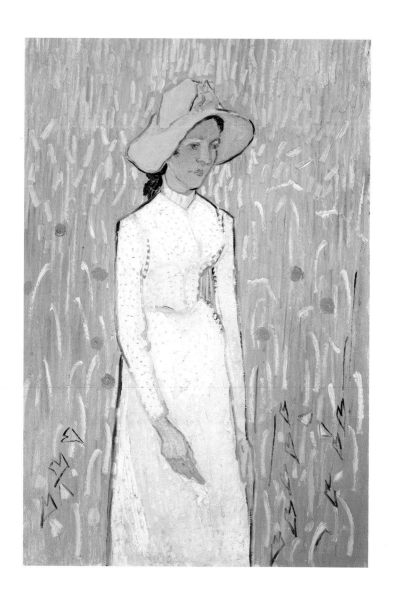

Girl, Standing in the Wheat · June 1890
National Gallery of Art, Washington

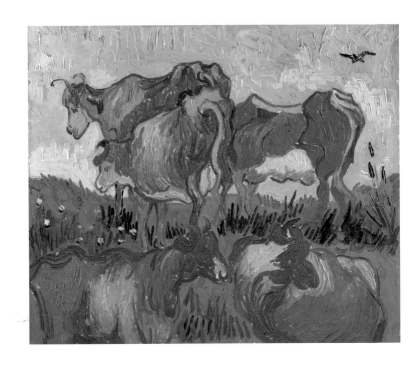

Cows (after Jordaens) · July 1890?
Musée des Beaux-Arts, Lille

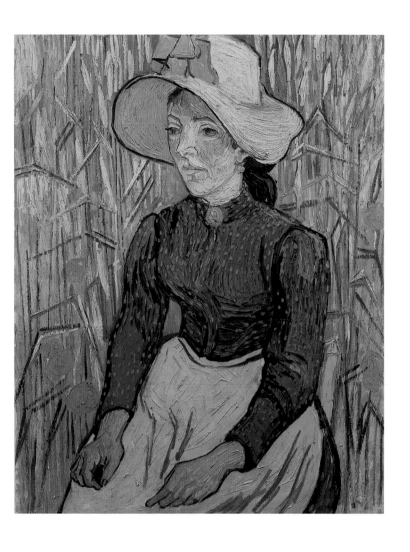

Girl with Straw Hat, Sitting in the Wheat · June 1890
The Bellagio Gallery of Fine Art, Las Vegas

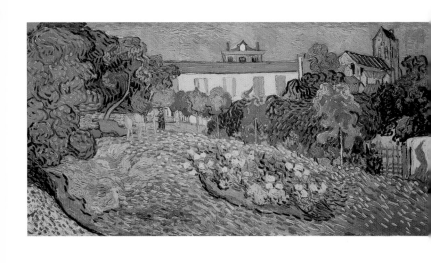

Daubigny's Garden · July 1890
Hiroshima Museum of Art, Hiroshima

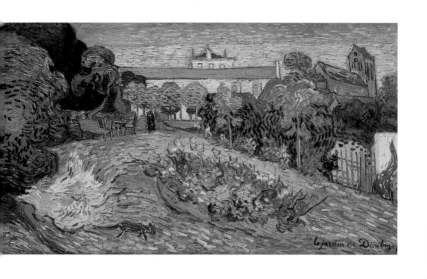

Daubigny's Garden with Black Cat · July 1890?
Collection Rudolf Staechelin, Basel

Landscape in the Rain · July 1890
National Museum of Wales, Cardiff

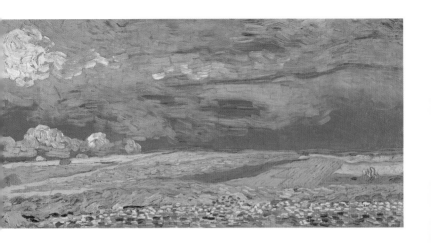

Wheat Field under Clouded Skies · July 1890
Van Gogh Museum, Amsterdam

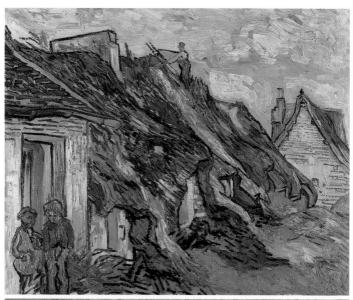

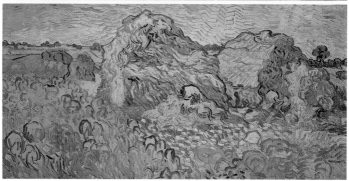

Cottages with Thatched Roofs and Figures · July 1890
Kunsthaus Zürich
Field with Two Stacks of Wheat or Hay · July 1890
Private collection

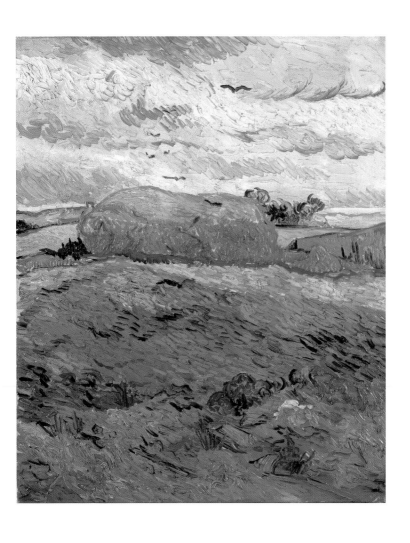

Field with a Stack of Wheat or Hay · July 1890

Kröller-Müller Museum, Otterlo

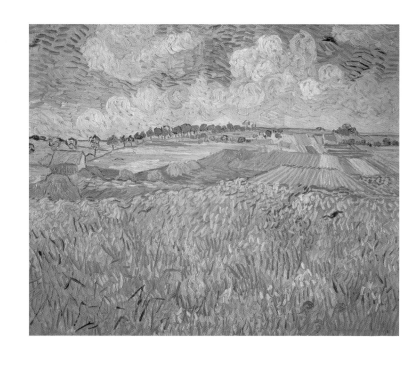

Wheat Fields · July 1890
Bayerische Staatsgemäldesammlungen, Munich

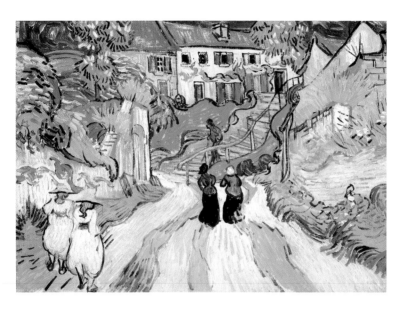

Street and Stairs with Five Figures · June–July 1890
The Saint Louis Art Museum, Saint Louis

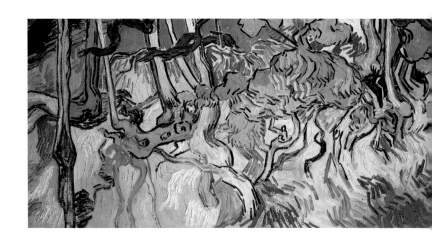

Roots and Trunks of Trees · July 1890
Van Gogh Museum, Amsterdam

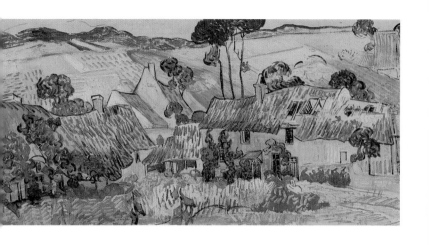

Group of Houses Seen against a Hill · July 1890
Tate Gallery, London
> **Wheat Field under Threatening Skies with Crows** · July 1890
Van Gogh Museum, Amsterdam

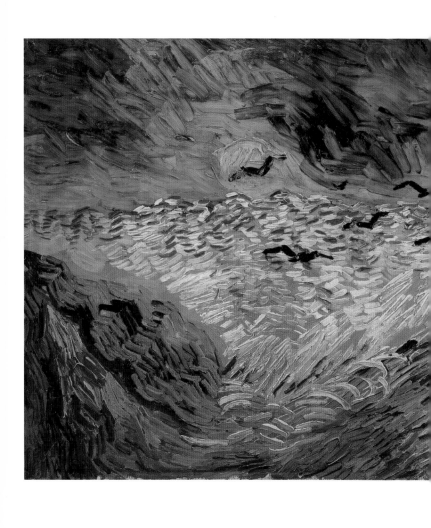

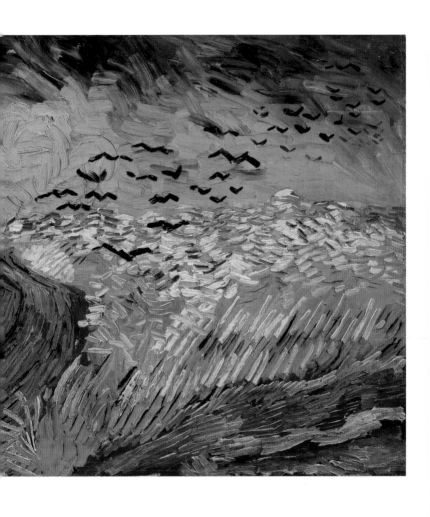

Biographical Chronology

1853 Vincent Willem van Gogh was born on 30 March 1853 in Zundert in the province of Brabant. His father Theodorus van Gogh, a pastor, and his mother, Anna Cornelia Carbentus, had another five children, including in 1857 his favorite brother Theo (Theodorus) van Gogh. **1861–1864** Vincent attended the village school in Zundert. **1864–1868** His parents sent him to a boarding school in Zevenbergen and another in Tilburg. He learned French, German, and English. His school education was interrupted for reasons that are unclear and Vincent returned to Zundert. He did not complete his education. **1869–1872** Thanks to his uncle Vincent, on 1 August Vincent became the youngest salesman at The Hague's branch of Goupil & Cie., an international art dealer with its main gallery in Paris. There he came into contact with art and artists. He read a great deal and visited museums. From August 1872 he wrote letters to his brother Theo. This correspondence, which persisted for practically the whole of his remaining life, contains a wealth of information about his personal and artistic development. **1873–1876** By intercession of his uncle Vincent, Theo took up a post in the Brussels branch of Goupil & Cie. In November he was transferred to The Hague. From June 1873 Vincent worked at the London branch of Goupil & Cie. He visited museums and galleries and admired the rural tableaux of Jean-François Millet and Jules Breton. His interest in his work at the art gallery, in London and Paris, flagged and his achievements and behavior at the company came under criticism. He shifted his attention to the Bible and decided to become a clergyman. As of 1 April 1876 he resigned from his job in Paris. Vincent returned to England and became a schoolmaster at a boarding school in Ramsgate. In July he became a teacher and curate. **1877–1880** In Amsterdam he applied for a course of study in theology, but he was not accepted. He did, however, attend an evangelical school in Brussels. He was sent to the Borinage, a poor mining district in the south of Belgium, where he worked as a lay preacher. He identified with the lot of the mine-workers and lived in abject poverty. He started to draw and paint and read a great deal (William Shakespeare, Charles Dickens, Victor Hugo). His fanaticism did not go down well with the church. The idea began to occur to Vincent that he could turn to God in another way: by painting. He moved to Brussels and decided to study independently. As Vincent had no financial resources of his own, his brother Theo supported him. He went on doing this until Vincent died. **1881–1882** Vincent left for Etten, where he drew landscapes. He fell deeply in love with his cousin Kee Vos-Stricker, but she rejected him. His interest in religion diminished. He visited Anton Mauve, whom he very much admired and with whom he took painting lessons. In 1882 he met Sien Hoornik, a pregnant, unmarried prostitute and took her and her young daughter to live at his house for a while. He often used Sien and the poor people from the surrounding area as his models. His uncle Cornelis

van Gogh gave him a commission to make twenty townscapes — this was his only commission for years. **1883–1885** In September, after breaking off his relationship with Sien, Vincent painted the barren landscape of Drenthe. That same year he moved in with his parents in Nuenen in Brabant. There he painted weavers and heads of peasants. In his two years in Nuenen he produced about 200 paintings, distinguished by their expressive style and dark, earthy colors. On 26 March 1885 his father died. Shortly afterwards he finished his Dutch masterpiece: *The Potato Eaters*. **1886–1888** The Catholic priest of Nuenen made it difficult for him to find models. This was partly the reason why Vincent moved to Antwerp, to the Ecole des Beaux-Arts. He went to museums and galleries, admired the work of Peter Paul Rubens, worked from the nude, and came into contact with Japanese wood carving. On 27 February 1886 he arrived at Theo's home in Paris. In spite of Vincent's difficult character, Theo took him in. In Paris he became acquainted with the Impressionists and their work: Paul Gauguin, Henri de Toulouse-Lautrec, Emile Bernard, Camille Pissarro, and John Russell. His palette became lighter and his brush technique freer. The subjects changed too: cafés, boulevards, the banks of the Seine. He experimented with pointillism, the technique using dots he had seen in the work of Georges Seurat and Paul Signac. He was also strongly influenced by the Japanese art of printing and the vivid colors and lines are recognizable in many paintings from this period. Lacking money for models, he painted many self-portraits, which give a good impression of his passion for experimenting during this period in Paris. By the time he exchanged Paris for Arles in 1888, after two years, he had made more than 200 paintings. **1888** In Provence he made flower paintings that reminded him of Japanese landscapes. He dedicated *Pink Peach Trees* to his friend Mauve, who had died. In Arles he continued to dream of a community of artists and he rented a studio, the "Yellow House" for this purpose. He invited Paul Gauguin to come to live and work with him. He made a series of sunflowers for his room. In the bright Provençal light his works became powerful, expressive, and vivid in color. He painted, in the open air, landscapes and numerous portraits of, among others, the postman Joseph Roulin and his family. In the spring Theo married Johanna Bonger (1862–1925). In the course of the nine weeks that van Gogh and Gauguin worked and discussed together tensions arose. In December Vincent threatened Gauguin with a razor; sometime later he cut off a piece of his own left ear. Vincent was taken to the hospital where he would stay until January 1889. **1889–1890** Out of fear of repetition — he was sleeping badly, repeatedly having crises and hallucinating — he had himself voluntarily admitted to an institution in Saint-Rémy, in the district of Arles. He stayed there for a year and made around 150 paintings from his cell, fitted out as a studio, and later also outside in the fields: the garden of the institution, irises, trees, yellow cornfields, olive trees, and cypresses. Because, after crises, he did not want to go outside to work, he concentrated on making copies ("translations") of works by Rembrandt, Millet, and Delacroix. In August he was stopped from painting for a

while, because he had swallowed poisonous paint during a crisis, and was only allowed to draw. Works were sent to the "Salon des Indépendants" in Paris, including *The Starry Night*. The avant-garde circle of artists "Les Vingt" invited Vincent to contribute to a group exhibition in Brussels. He selected six paintings. Reactions were very favorable. On 31 January 1890 Theo's son Vincent Willem was born. **1890** In May Vincent left the institution in Saint-Rémy and went to Auvers-sur-Oise, in the neighborhood of Paris, accompanied by Dr. Paul Gachet. He became friendly with Gachet, who was also a painter himself. Vincent felt much better and threw himself into work; he made almost one painting a day: cornfields, the garden of the painter Daubigny, Gachet's children. On 6 July Vincent visited his brother in Paris. Theo was very worried about his career and he warned Vincent of his worsening financial situation. Vincent was deeply moved by this, he felt he was a burden and it made him insecure. On 27 July he walked into a cornfield and shot himself in the chest. He went back to his room, where, two days later with Theo at his side, he died at the age of thirty-seven. He was buried, attended by Theo, Dr. Gachet, and a few friends from Paris, in Auvers-sur-Oise. Shortly afterwards, on 25 January 1891, Theo also died. They lie side by side in the churchyard at Auvers-sur-Oise.

Bibliography

J.-B. de la Faille. *The Works of Vincent van Gogh. His Paintings and Drawings*, Amsterdam 1970. **Jan Hulsker.** *Van Gogh en zijn weg. Al zijn tekeningen en schilderijen in hun samenhang en ontwikkeling*, Amsterdam 1977. **Jan Hulsker.** *The Complete van Gogh. Paintings, Drawings, Sketches*, Philadelphia/Amsterdam 1980. **Ronald Pickvance.** *Van Gogh in Arles*, The Metropolitan Museum of Art, New York 1984. **Ronald Pickvance.** *Van Gogh in Saint-Rémy and Auvers*, The Metropolitan Museum of Art, New York 1986. **Evert van Uitert.** *Van Gogh in Brabant. Schilderijen en tekeningen uit Etten en Nuenen*, Noordbrabants Museum, Zwolle 1987. **Louis van Tilborgh et al.** *Van Gogh en Millet*, Zwolle 1988. **Bogomila Welsh-Ovcharov et al.** *Van Gogh à Paris*, Musée d'Orsay, Paris 1988. **Sjraar van Heugten et al.** *The Graphic Work of Vincent van Gogh*, Cahier Vincent, Zwolle 1995. *The Letters of Vincent van Gogh.* Selected and edited by Ronald de Leeuw, London 1996. **Ronald de Leeuw.** *Van Gogh at the Van Gogh Museum*, Zwolle 1997. **Chris Stolwijk et al.** *Theo van Gogh 1857–1891: Art Dealer, Collector and Brother of Vincent*, Van Gogh Museum, Zwolle 1999. **Douglas Druick et al.** *Van Gogh and Gauguin. The Studio and the South*, London 2001.

Index of Works

in Nuenen with People Leaving 44, January 1884, oil on canvas, 41x32cm, Van Gogh Museum, Amsterdam. **Church Pew with Worshippers 28,** September 1882, watercolor, 28x38cm, Kröller-Müller Museum, Otterlo. **Coal Barges 241,** August 1888, oil on canvas, 71x95cm, Collection Mr. and Mrs. Carleton Mitchell, Annapolis, Maryland. **Corner of Daubigny's Garden 394,** June 1890, oil on canvas, 51x51cm, Van Gogh Museum, Amsterdam. **Corner of the Asylum and the Garden with a Heavy, Sawn-Off Tree 338,** October–November 1889, oil on canvas, 73.5x92cm, Museum Folkwang, Essen. **Corner of the Asylum and the Garden with a Heavy, Sawn-Off Tree 339,** November–December 1889, oil on canvas, 71.5x90.5cm, Van Gogh Museum, Amsterdam. **Cottage and Woman with a Goat 72,** June–July 1885, oil on canvas, 60x85cm, Städelsches Kunstinstitut und Städtische Galerie, Frankfurt am Main. **Cottage at Nightfall 66,** May 1885, oil on canvas, 64x 78cm, Van Gogh Museum, Amsterdam. **Cottage with Woman Digging 67,** June–July 1885, canvas on cardboard, 31x41cm, The Art Institute of Chicago, Chicago. **Cottages and Cypresses at Sunset with Stormy Sky 366,** March–April 1890, canvas on panel, 29x 36.5cm, Van Gogh Museum, Amsterdam. **Cottages with Thatched Roofs 377,** May 1890, oil on canvas, 72x91cm, Musée d'Orsay, Paris. **Cottages with Thatched Roofs and Figures 406,** July 1890, oil on canvas, 65x81cm, Kunsthaus Zürich. **Couple Walking among Olive Trees in Mountainous Landscape with Crescent Moon 372,** May 1890, oil on canvas, 49.5x45.5cm, Museu de Arte de São Paulo, São Paulo. **The Courtyard of the Hospital 290,** April 1889, oil on canvas, 73x92cm, Collection Oskar Reinhart, Winterthur. **The Courtyard of the Hospital 290,** April 1889, pencil, reed pen, brown ink, 45.5x59cm, Van Gogh Museum, Amsterdam. **Cows (after Jordaens) 400,** July 1890?, oil on canvas, 55x65cm, Musée des Beaux-Arts, Lille. **A Crab Upside Down 283,** January–February 1889, oil on canvas, 38x45.5cm, Van Gogh Museum, Amsterdam. **Cypresses 306,** June 1889, oil on canvas, 95x73cm, The Metropolitan Museum of Art, New York. **Cypresses 307,** June 1889, pen, reed pen, 62.5x47cm, Brooklyn Museum, New York. **Cypresses 308,** June 1889, oil on canvas, 92x73cm, Kröller-Müller Museum, Otterlo. **Cypresses with Two Women in the Foreground 357,** February 1890, oil on canvas, 42x26cm, Van Gogh Museum, Amsterdam. **The Dance Hall 276,** December 1888, oil on canvas, 65x81cm, Musée d'Orsay, Paris. **Daubigny's Garden 402,** July 1890, oil on canvas, 53x104cm, Hiroshima Museum of Art, Hiroshima. **Daubigny's Garden with Black Cat 403,** July 1890?, oil on canvas, 56x101.5cm, Collection Rudolf Staechelin, Basel. **The De Ruijterkade in Amsterdam 80,** October 1885, panel, 22.5x27cm, Van Gogh Museum, Amsterdam. **Death's-Head Moth 294,** May 1889, black chalk, pen, brown ink, 16x26cm, Van Gogh Museum, Amsterdam. **Death's-Head Moth on an Arum 294,** May 1889, oil on canvas, 33x24cm, Van Gogh Museum, Amsterdam. **Digger 15,** October 1881, black and colored chalk, watercolor, 62.5x47cm, Van Gogh Museum, Amsterdam. **Doctor Felix Rey 279,** January 1889, oil on canvas, 64x53cm, Pushkin Museum, Moscow. **Doctor Gachet Sitting at a Table with Books and a Glass with Sprigs of Foxglove 383,** June 1890, oil on canvas, 66x57cm, private collection. **Doctor Gachet's Garden 378,** May 1890, oil on canvas, 73x51.5cm, Musée d'Orsay, Paris. **Drawbridge with Carriage 198,** March 1888, oil on canvas, 54x65cm, Kröller-Müller Museum, Otterlo. **Drawbridge with Carriage 200,** April 1888, watercolor, 30x30cm, private collection. **Drawbridge with Carriage 201,** April 1888, oil on canvas,

60x65cm, private collection. **Ears of Wheat 379,** June 1890, oil on canvas, 65.5x47cm, Van Gogh Museum, Amsterdam. **Edge of a Wheat Field with Poppies and a Lark 155,** Spring 1887, oil on canvas, 54x64.5cm, Van Gogh Museum, Amsterdam. **Enclosed Field in the Rain 336,** November 1889, oil on canvas, 73.5x92.5cm, Museum of Art, Philadelphia. **Enclosed Field with Farmer Carrying a Bundle of Straw 325,** October 1889, oil on canvas, 73x92cm, Indianapolis Museum of Art, Indianapolis. **Enclosed Field with Reaper at Sunrise 324,** September 1889, oil on canvas, 59.5x73cm, Museum Folkwang, Essen. **Enclosed Field with Sheaves and Rising Moon 313,** July 1889, oil on canvas, 72x92cm, Kröller-Müller Museum, Otterlo. **Enclosed Wheat Field with Reaper 312,** June and September 1889, oil on canvas, 72x92cm, Kröller-Müller Museum, Otterlo. **Entrance to a Quarry 326,** July 1889, oil on canvas, 60x72.5cm, Van Gogh Museum, Amsterdam. **Exterior of a Restaurant with Oleanders in Pots 174,** Summer 1887, oil on canvas, 19x 26.5cm, Van Gogh Museum, Amsterdam. **Factories at Asnières 159,** Summer 1887, oil on canvas, 54x72cm, The Saint Louis Art Museum, Saint Louis. **The Family at Night (after Millet) 334,** October 1889, oil on canvas, 72.5x92cm, Van Gogh Museum, Amsterdam. **Farmer Sitting at the Fireplace 16,** November 1881, charcoal, washed, heightened with white and red, 56x45cm, Kröller-Müller Museum, Otterlo. **Farms 38,** September–October 1883, canvas on cardboard, 36x55.5cm, Van Gogh Museum, Amsterdam. **Field of Grass with Dandelions and Tree Trunks 368,** April 1890, oil on canvas, 72x90cm, Kröller-Müller Museum, Otterlo. **Field of Grass with Flowers and Butterflies 369,** May 1890, oil on canvas, 64.5x81cm, National Gallery, London. **Field with a Stack of Wheat or Hay 407,** July 1890, oil on canvas, 64x52.5cm, Kröller-Müller Museum, Otterlo. **Field with Poppies 388,** June 1890, oil on canvas, 73x91.5cm, Haags Gemeentemuseum, The Hague (on loan). **Field with Trees and the Château of Auvers at Sunset 392,** June 1890, oil on canvas, 50x100cm, Van Gogh Museum, Amsterdam. **Field with Two Rabbits 350,** December 1889, oil on canvas, 33x40.5cm, Van Gogh Museum, Amsterdam. **Field with Two Stacks of Wheat or Hay 406,** July 1890, oil on canvas, 50x100cm, private collection. **Fields with Pollard Tree and Mountainous Background 346,** December 1889, oil on canvas, 73x 91.5cm, Kröller-Müller Museum, Otterlo. **Fields with Poppies 299,** June 1889, oil on canvas, 71x91cm, Kunsthalle, Bremen. **Fisherman on the Beach 22,** August 1882, canvas on panel, 51x33.5cm, Kröller-Müller Museum, Otterlo. **Fisherman with Sou'wester, Sitting with Pipe 33,** February 1883, pen, pencil, black chalk, washed, heightened with white, 46x26cm, Kröller-Müller Museum, Otterlo. **Fishing Boats at Sea 4,** May–June 1888, oil on canvas, 44x53cm, Pushkin Museum, Moscow. **Fishing Boats at Sea 236,** August 1888, reed pen, 24x31.5cm, Royal Museums of Fine Arts of Belgium, Brussels. **Fishing Boats on the Beach 212,** June 1888, oil on canvas, 64.5x81cm, Van Gogh Museum, Amsterdam. **Flowering Shrubs 296,** May 1889, watercolor, 62x47cm, Kröller-Müller Museum, Otterlo. **Flowerpot with Chives 136,** Spring 1887, oil on canvas, 32x22cm, Van Gogh Museum, Amsterdam. **Fourteen Sunflowers in a Vase 234,** August 1888, oil on canvas, 93x73cm, National Gallery, London. **Fritillaries in a Copper Vase 142,** Spring 1887, oil on canvas, 73.5x60.5cm, Musée d'Orsay, Paris. **Garden with Flowers 222,** July 1888, oil on canvas, 72x91cm, Haags Gemeentemuseum, The Hague (on loan). **Garden with Flowers 225,** July 1888, oil on canvas, 92x73cm, private collection. **Garden with Flowers 237,** August 1888,

reed pen, 61x49cm, private collection. **Gas Tanks 20,** March 1882, chalk, pencil, 24x 33.5cm, Van Gogh Museum, Amsterdam. **Gauguin's Chair 273,** November 1888, oil on canvas, 90.5x72cm, Van Gogh Museum, Amsterdam. **A Girl in a Wood 24,** August 1882, oil on canvas, 39x59cm, Kröller-Müller Museum, Otterlo. **Girl, Standing in the Wheat 399,** June 1890, oil on canvas, 66x45cm, National Gallery of Art, Washington. **Girl with Straw Hat, Sitting in the Wheat 401,** June 1890, oil on canvas, 92x73cm, The Bellagio Gallery of Fine Art, Las Vegas. **Glass with Roses 108,** Summer 1886, cardboard, 35x27cm, Van Gogh Museum, Amsterdam. **The Good Samaritan (after Delacroix) 371,** May 1890, oil on canvas, 73x60cm, Kröller-Müller Museum, Otterlo. **Gordina de Groot, Head 57,** May 1885, oil on canvas, 41x34.5cm, Collection Mrs. M.C.R. Taylor, Santa Barbara. **The Green Vineyard 250,** October 1888, oil on canvas, 72x92cm, Kröller-Müller Museum, Otterlo. **Green Wheat Field with Cypress 301,** June 1889, oil on canvas, 73.5x92.5cm, Narodni Galerie, Prague. **A Group of Cottages 376,** May 1890, oil on canvas, 60x73cm, Hermitage, Saint Petersburg. **Group of Houses Seen against a Hill 411,** July 1890, oil on canvas, 50x 100cm, Tate Gallery, London. **Hand with Bowl and Cat 56,** April 1885, black chalk, 20x 33cm, Van Gogh Museum, Amsterdam. **Hand with Handle of a Kettle 56,** April 1885, black chalk, 21x34.5cm, Van Gogh Museum, Amsterdam. **Harvest Landscape 204,** June 1888, oil on canvas, 72.5x92cm, Van Gogh Museum, Amsterdam. **Harvest Landscape 230,** August 1888, pen, 24x32cm, Nationalgalerie, Berlin. **Haystacks near a Farm 209,** June 1888, oil on canvas, 73x92.5cm, Kröller-Müller Museum, Otterlo. **Head of a Girl 398,** June 1890, oil on canvas, 51x49cm, Kröller-Müller Museum, Otterlo. **Head of a Man, probably a portrait of Theo van Gogh 118,** Summer 1886, charcoal, colored chalk, 35x26cm, Van Gogh Museum, Amsterdam. **Head of a Woman with Her Hair Loose 82,** December 1885, oil on canvas, 35x24cm, Van Gogh Museum, Amsterdam. **Head of a Young Man, Bareheaded, with Pipe 51,** November 1884–February 1885, canvas on panel, 38x30cm, Van Gogh Museum, Amsterdam. **A House and Two Figures 387,** June 1890, oil on canvas, 38x45cm, Van Gogh Museum, Amsterdam. **Interior of a Restaurant 147,** Spring 1887, oil on canvas, 45.5x56.5cm, Kröller-Müller Museum, Otterlo. **Interior of a Restaurant 240,** August 1888, oil on canvas, 54x64.5cm, private collection. **Interior of a Restaurant (with Motifs of Bedroom) 258,** October 1888, pencil, 26x34.5cm, Van Gogh Museum, Amsterdam. **Irises 292,** May 1889, oil on canvas, 71x93cm, Getty Center, Los Angeles. **Japonaiserie: Bridge in the Rain (after Hiroshige) 162,** Summer 1887, oil on canvas, 73x54cm, Van Gogh Museum, Amsterdam. **Japonaiserie: Flowering Plum Tree (after Hiroshige) 161,** Summer 1887, oil on canvas, 55x46cm, Van Gogh Museum, Amsterdam. **Japonaiserie: Oiran (after Kesaï Eisen) 163,** Summer 1887, oil on canvas, 105x61cm, Van Gogh Museum, Amsterdam. **Joseph Roulin, Bust 285,** February–April 1889, oil on canvas, 65x54cm, Kröller-Müller Museum, Otterlo. **Joseph Roulin, Head 228,** July–August 1888, oil on canvas, 31.5x24cm, J. Paul Getty Museum, Malibu. **Joseph Roulin, Sitting in a Cane Chair 227,** July–August 1888, oil on canvas, 81x65cm, Museum of Fine Arts, Boston. **The Kingfisher 115,** Fall 1886?, oil on canvas, 19x26.5cm, Van Gogh Museum, Amsterdam. **"La Crau" with Peach Trees in Blossom 286,** April 1889, oil on canvas, 65.5x81.5cm, Courtauld Institute Galleries, London. **Lady, Sitting by a Cradle 125,** Winter 1886/87, oil on canvas, 61x 46cm, Van Gogh Museum, Amsterdam. **Landscape at Nightfall 39,** October 1883, water-

color, 41.5×53 cm, Van Gogh Museum, Amsterdam. **Landscape in the Rain 404,** July 1890, oil on canvas, 50×100 cm, National Museum of Wales, Cardiff. **Landscape near Montmajour with Train 221,** July 1888, pen, reed pen, black chalk, 49×61 cm, British Museum, London. **Landscape with Carriage and Train in the Background 390,** June 1890, oil on canvas, 72×90 cm, Pushkin Museum, Moscow. **Landscape with Snow 194,** March 1888, oil on canvas, 38×46 cm, The Solomon R. Guggenheim Museum, Justin K. Thannhauser Collection, New York. **Landscape with Sunset 63,** April 1885?, canvas on cardboard, 35×43 cm, Museo Thyssen-Bornemisza, Madrid. **Lane in a Public Garden at Asnières 156,** Spring 1887, canvas on cardboard, 32.5×42 cm, Van Gogh Museum, Amsterdam. **Lane of Poplars at Sunset 48,** October 1884, oil on canvas, 46×33 cm, Kröller-Müller Museum, Otterlo. **Lane with Chestnut Trees in Bloom 291,** May 1889, oil on canvas, 72.5×92 cm, private collection. **Lane with Poplars 79,** November 1885, oil on canvas, 78×97.5 cm, Museum Boijmans Van Beuningen, Rotterdam. **Lieutenant Milliet 247,** September 1888, oil on canvas, 60×49 cm, Kröller-Müller Museum, Otterlo. **Lilacs 160,** Summer 1887, oil on canvas, 27×34.5 cm, UCLA Hammer Museum, Los Angeles; The Armand Hammer Collection, gift of the Armand Hammer Foundation. **Lilacs 289,** May 1889, oil on canvas, 73×92 cm, Hermitage, Saint Petersburg. **Little Blossoming Pear Tree 2,** April 1888, oil on canvas, 73×46 cm, Van Gogh Museum, Amsterdam. **Marguerite Gachet at the Piano 395,** June 1890, oil on canvas, 102×50 cm, Offentliche Kunstsammlung, Kunstmuseum Basel. **Marguerite Gachet in the Garden 381,** June 1890, oil on canvas, 46×55 cm, Musée d'Orsay, Paris. **Meadow with Poppies 203,** May 1888, oil on canvas, 23×34 cm, Van Gogh Museum, Amsterdam. **Memory of the Garden at Etten 269,** November 1888, oil on canvas, 73.5×92.5 cm, Hermitage, Saint Petersburg. **Men Drinking (after Daumier) 354,** February 1890, oil on canvas, 60×73 cm, The Art Institute of Chicago, Chicago. **The Moulin de Blute-Fin 99,** Summer 1886, oil on canvas, 46×38 cm, Glasgow Museums: Art Gallery and Museum, Kelvingrove. **The Moulin de Blute-Fin 112,** Fall 1886, pen, black chalk, 53×39 cm, The Phillips Collection, Washington. **The Moulin de la Galette 110,** Fall 1886, oil on canvas, 38.5×46 cm, Kröller-Müller Museum, Otterlo. **Mountain Landscape Seen across the Walls 300,** June 1889, oil on canvas, 70.5×88.5 cm, Ny Carlsberg Glyptotek, Copenhagen. **Mountain Landscape Seen across the Walls; Green Field 298,** June 1889, oil on canvas, 73×92 cm, Kunsthaus Zürich (on loan). **Mountains with Dark Hut 315,** July 1889, oil on canvas, 72×91 cm, The Solomon R. Guggenheim Museum, Justin K. Thannhauser Collection, New York. **Mousmé, Sitting in a Cane Chair 226,** July 1888, oil on canvas, 74×60 cm, National Gallery of Art, Washington. **Newly Mowed Lawn with Weeping Tree 224,** July 1888, oil on canvas, 60.5×73.5 cm, private collection. **The Night Café 244,** September 1888, oil on canvas, 70×89 cm, Yale University Art Gallery, New Haven. **Noon: Rest (after Millet) 353,** January 1890, oil on canvas, 73×91 cm, Musée d'Orsay, Paris. **Nude Girl, Sitting 87,** Spring 1886, oil on canvas, 27×22 cm, Van Gogh Museum, Amsterdam. **Old Man with His Head in His Hands (after the lithograph "At Eternity's Gate") 363,** Spring 1890, oil on canvas, 81×65 cm, Kröller-Müller Museum, Otterlo. **Old Man with His Head in His Hands ("At Eternity's Gate") 31,** November 1882, lithograph, 55×36.5 cm, Van Gogh Museum, Amsterdam. **The Old Peasant Patience Escalier with Walking Stick 229,** August 1888, oil on canvas, 69×56 cm, Collection Stavros S. Niarchos. **An Old Woman of Arles 192,** Feb-

ruary 1888, oil on canvas, 55x43cm, Van Gogh Museum, Amsterdam. **Olive Orchard 305,** June 1889, oil on canvas, 44x59cm, Van Gogh Museum, Amsterdam. **Olive Orchard 341,** November 1889, oil on canvas, 74x93cm, Konstmuseum, Göteborg. **Olive Orchard 342,** November 1889, oil on canvas, 73x92.5cm, Van Gogh Museum, Amsterdam. **Olive Orchard 343,** November 1889, oil on canvas, 49x63cm, National Gallery of Scotland, Edinburgh. **Olive Orchard (Bird's-Eye View) 351,** December 1889, oil on canvas, 33x40cm, Van Gogh Museum, Amsterdam. **Olive Orchard with a Man and a Woman Picking Olives 340,** November 1889, oil on canvas, 73x92cm, Kröller-Müller Museum, Otterlo. **Olive Trees in a Mountain Landscape 304,** June 1889, oil on canvas, 72.5x92cm, Collection Mrs. John Hay Whitney, New York. **Orchard in Bloom with Poplars in the Foreground 288,** April 1889, oil on canvas, 72x92cm, Neue Pinakothek, Munich. **Orchard in Bloom with View of Arles 287,** April 1889, oil on canvas, 50.5x65cm, Van Gogh Museum, Amsterdam. **Orchard with Blossoming Apricot Trees 197,** March 1888, oil on canvas, 64.5x80.5cm, Van Gogh Museum, Amsterdam. **Orchard with Blossoming Plum Trees 196,** April 1888, oil on canvas, 60x80cm, Van Gogh Museum, Amsterdam. **Orchard with Cypresses 202,** April 1888, oil on canvas, 65x81cm, private collection. **Orphan Man with Top Hat, Drinking Coffee 30,** November 1882, black lithograph chalk, 49.5x28.5cm, Van Gogh Museum, Amsterdam. **A Pair of Shoes 107,** Summer 1886, oil on canvas, 37.5x45.5cm, Van Gogh Museum, Amsterdam. **A Pair of Shoes, One Shoe Upside Down 137,** Spring 1887, oil on canvas, 34x 41.5cm, Baltimore Museum of Art, Baltimore. **The Parsonage at Nuenen 78,** October 1885, oil on canvas, 33x43cm, Van Gogh Museum, Amsterdam. **Parsonage Garden 76,** March 1884, pen, heightened with white, 51.5x58cm, Kunstmuseum, Budapest. **Pasture in Bloom 154,** Spring 1887, oil on canvas, 31.5x40.5cm, Kröller-Müller Museum, Otterlo. **A Path in Montmartre 98,** Summer 1886, cardboard, 22x16cm, Van Gogh Museum, Amsterdam. **A Path in the Woods 173,** Summer 1887, oil on canvas, 46x38.5cm, Van Gogh Museum, Amsterdam. **A Path through the Ravine 347,** December 1889, oil on canvas, 72x 92cm, Kröller-Müller Museum, Otterlo. **Path to the Entrance of a Belvedere 151,** Spring 1887, black chalk, watercolor, 31.5x24cm, Van Gogh Museum, Amsterdam. **Peasant Cemetery 65,** May–June 1885, oil on canvas, 63x79cm, Van Gogh Museum, Amsterdam. **Peasant, Head 52,** January–February 1885, oil on canvas, 47x30cm, Kröller-Müller Museum, Otterlo. **Peasant Man and Woman Planting Potatoes 62,** April 1885, oil on canvas, 33x41cm, Kunsthaus Zürich. **Peasant Sitting by the Fireplace ("Worn out") 14,** September 1881, pen, watercolor, 23.5x31cm, P. and N. de Boer Foundation, Amsterdam. **Peasant Woman, Carrying Wheat in Her Apron 69,** August 1885, black chalk, washed, 58.5x38cm, Kröller-Müller Museum, Otterlo. **Peasant Woman, Head 50,** December 1884–January 1885, black chalk, 40x33cm, Van Gogh Museum, Amsterdam. **Peasant Woman, Head 53,** February 1885, oil on canvas, 40x30cm, Kröller-Müller Museum, Otterlo. **Peasant Woman, Head 54,** March 1885, oil on canvas, 42x35cm, Van Gogh Museum, Amsterdam. **Peasant Woman, Head 55,** February 1885, oil on canvas, 37.5x 28cm, Kröller-Müller Museum, Otterlo. **Peasant Woman, Sitting by the Fire 58,** May–June 1885, canvas on panel, 29.5x40cm, Musée d'Orsay, Paris. **Peasant Woman, Stooping and Gleaning 71,** July 1885, black chalk, 51.5x41.5cm, Museum Folkwang, Essen. **Peasant Woman, Stooping, Seen from the Back 70,** July 1885, black chalk, washed, 52.5x

43.5 cm, Kröller-Müller Museum, Otterlo. **Peat Boat with Two Figures 36,** October 1883, canvas on panel, 37×55.5 cm, Drents Museum, Assen. **People Walking in a Public Garden at Asnières 149,** Spring 1887, oil on canvas, 75.5×113 cm, Van Gogh Museum, Amsterdam. **People Walking in Front of Snow-Covered Cottage 364,** March–April 1890, pencil, 24×32 cm, Van Gogh Museum, Amsterdam. **Pietà (after Delacroix) 317,** September 1889, oil on canvas, 73×60.5 cm, Van Gogh Museum, Amsterdam. **Piles of French Novels and a Glass with a Rose (Romans parisiens) 182,** Winter 1887/88, oil on canvas, 73×93 cm, private collection. **Pine Trees Seen against the Wall of the Asylum 330,** October 1889, pencil, 29×18.5 cm, Van Gogh Museum, Amsterdam. **Pink Peach Trees 195,** March 1888, oil on canvas, 73×59.5 cm, Kröller-Müller Museum, Otterlo. **Plaster Statuette of a Female Torso 88,** Spring 1886, cardboard, 35×27 cm, Van Gogh Museum, Amsterdam. **Plaster Statuette of a Female Torso 89,** Spring 1886, oil on canvas, 41×32.5 cm, Van Gogh Museum, Amsterdam. **Plaster Statuette of a Horse 86,** Spring 1886, cardboard, 33.5×41 cm, Van Gogh Museum, Amsterdam. **A Plate with Lemons and a Carafe 139,** Summer 1887, oil on canvas, 46×38 cm, Van Gogh Museum, Amsterdam. **Plate with Onions, Annuaire de la Santé and Other Objects 282,** January 1889, oil on canvas, 50×64 cm, Kröller-Müller Museum, Otterlo. **Plowed Field 252,** September 1888, canvas on cardboard, 72.5×92 cm, Van Gogh Museum, Amsterdam. **Plowman and Potato Reaper 45,** August 1884, oil on canvas, 70.5×170 cm, Von der Heydt-Museum, Wuppertal. **Poppies with Butterflies 385,** May 1889, oil on canvas, 33.5×24.5 cm, Van Gogh Museum, Amsterdam. **Portrait of a Man 123,** Winter 1886/87, canvas on panel, 31×39.5 cm, National Gallery of Victoria, Melbourne. **Portrait of a Man 274,** December 1888, oil on canvas, 65×54.5 cm, Kröller-Müller Museum, Otterlo. **Portrait of a Patient 332,** October 1889, oil on canvas, 32×23.5 cm, Van Gogh Museum, Amsterdam. **Portrait of a Woman with a Scarlet Bow in Her Hair 83,** December 1885, oil on canvas, 60×50 cm, Collection Alfred Wyler, New York. **Portrait of a Woman with Carnations (Agostina Segatori?) 189,** Winter 1887/88, oil on canvas, 81×60 cm, Musée d'Orsay, Paris. **Portrait of Alexander Reid 144,** Spring 1887, cardboard, 41.5×33.5 cm, Glasgow Museums: Art Gallery and Museum, Kelvingrove. **Portrait of Alexander Reid, Sitting in an Easy Chair 124,** Winter 1886/87, cardboard, 41×33 cm, Museum of Art of the University of Oklahoma, Norman, Oklahoma. **Portrait of an Old Man with Beard 85,** December 1885, oil on canvas, 44×33.5 cm, Van Gogh Museum, Amsterdam. **Portrait of Armand Roulin 238,** December 1888, canvas on cardboard, 66×55 cm, Museum Folkwang, Essen. **Portrait of Armand Roulin 275,** December 1888, oil on canvas, 65×54 cm, Museum Boijmans Van Beuningen, Rotterdam. **Portrait of Eugène Boch 239,** September 1888, oil on canvas, 60×45 cm, Musée d'Orsay, Paris. **Portrait of Père Tanguy 188,** Winter 1887/88, oil on canvas, 65×51 cm, Collection Stavros S. Niarchos. **Portrait of the Chief Orderly (Trabuc) 318,** September 1889, oil on canvas, 61×46 cm, Kunstmuseum Solothurn, Dubi-Muller Foundation, Solothurn. **Portrait of Van Gogh's Mother 255,** October 1888, oil on canvas, 40.5×32.5 cm, The Norton Simon Museum, Pasadena. **Portrait of Woman in Blue 122,** Winter 1886/87, oil on canvas, 46×38 cm, Van Gogh Museum, Amsterdam. **The Potato Eaters 59,** April 1885, canvas on panel, 72×93 cm, Kröller-Müller Museum, Otterlo. **The Potato Eaters 60,** April–May 1885, oil on canvas, 82×114 cm, Van Gogh Museum, Amsterdam. **Prisoners Round (after Gustave Doré) 355,**

February 1890, oil on canvas, 80x64cm, Pushkin Museum, Moscow. **Public Garden 253,** October 1888, oil on canvas, 72x93cm, private collection. **Public Garden with a Couple and a Blue Fir Tree 254,** October 1888, oil on canvas, 73x92cm, private collection. **Quay with Men Unloading Sand Barges 232,** August 1888, pen, reed pen, 48x62.5cm, The Cooper Hewitt Museum, New York. **Quay with Men Unloading Sand Barges 233,** August 1888, oil on canvas, 55x66cm, Museum Folkwang, Essen. **The Raising of Lazarus (after Rembrandt) 370,** May 1890, oil on canvas, 48.5x63cm, Van Gogh Museum, Amsterdam. **Red Cabbages and Onions 184,** Winter 1887/88, oil on canvas, 50x65cm, Van Gogh Museum, Amsterdam. **The Red Vineyard 270,** November 1888, oil on canvas, 75x93cm, Pushkin Museum, Moscow. **Restaurant de la Sirène at Asnières 146,** Spring 1887, oil on canvas, 57x68cm, Musée d'Orsay, Paris. **Restaurant de la Sirène at Asnières 148,** Spring 1887, oil on canvas, 51.5x64cm, Ashmolean Museum, Oxford. **Riverbank with Rowboats and Three Figures 391,** June 1890, oil on canvas, 72x92cm, The Detroit Institute of Arts, Detroit. **Road Menders in a Lane with Massive Plane Trees 344,** December 1889, oil on canvas, 74x93cm, The Cleveland Museum of Art, Cleveland. **Road Menders in a Lane with Massive Plane Trees 345,** December 1889, oil on canvas, 73.5x92.5cm, The Phillips Collection, Washington. **Road with Men Walking, Carriage, Cypress, Star, and Crescent Moon 374,** May 1890, oil on canvas, 92x73cm, Kröller-Müller Museum, Otterlo. **Road with Men Walking, Carriage, Cypress, Star, and Crescent Moon 375,** June 1890, sketch in Letter 643, Van Gogh Museum, Amsterdam. **Rocks with Tree 217,** July 1888, oil on canvas, 54x65cm, Museum of Fine Arts, Houston. **Rocks with Trees 220,** July 1888, pencil, pen, reed pen, brush, black ink, 49x60cm, Van Gogh Museum, Amsterdam. **The Roofs of Paris 92,** Spring 1886, oil on canvas, 44.5x37cm, Van Gogh Museum, Amsterdam. **Roots and Trunks of Trees 410,** July 1890, oil on canvas, 50.5x100.5cm, Van Gogh Museum, Amsterdam. **Scheveningen Woman 23,** August 1882, oil on canvas on panel, 52x34cm, Kröller-Müller Museum, Otterlo. **Scheveningen Women and Other People under Umbrellas 17,** July 1882, watercolor, 28.5x21cm, Haags Gemeentemuseum, The Hague. **Self-Portrait 117,** Fall 1886, oil on canvas, 39.5x29.5cm, Haags Gemeentemuseum, The Hague. **Self-Portrait 135,** Spring 1887, cardboard, 19x14cm, Van Gogh Museum, Amsterdam. **Self-Portrait 143,** Spring 1887, oil on canvas, 41x33cm, Van Gogh Museum, Amsterdam. **Self-Portrait 145,** Spring 1887, cardboard, 42x34cm, The Art Institute of Chicago, Chicago. **Self-Portrait 165,** Summer 1887, oil on canvas, 41x33cm, Van Gogh Museum, Amsterdam. **Self-Portrait 167,** Summer 1887, canvas on cardboard, 43.5x31.5cm, Van Gogh Museum, Amsterdam. **Self-Portrait 168,** Summer 1887, oil on canvas, 41x33cm, Van Gogh Museum, Amsterdam. **Self-Portrait 171,** Winter 1887/88, oil on canvas, 47x35cm, Musée d'Orsay, Paris. **Self-Portrait 246,** September 1888, oil on canvas, 62x52cm, Fogg Art Museum, Harvard University, Cambridge (Mass.). **Self-Portrait 266,** November–December 1888, oil on canvas, 46x38cm, private collection. **Self-Portrait 320,** September 1889, oil on canvas, 57x43.5cm, National Gallery of Art, Washington. **Self-Portrait 321,** September 1889, oil on canvas, 65x54cm, Musée d'Orsay, Paris. **Self-Portrait in Front of the Easel 190,** Winter 1887/88, oil on canvas, 65x50.5cm, Van Gogh Museum, Amsterdam. **Self-Portrait with Bandaged Ear 280,** January 1889, oil on canvas, 60x49cm, Courtauld Institute Galleries, London. **Self-Portrait with Bandaged Ear and Pipe**

281, January 1889, oil on canvas, 51×45cm, private collection. **Self-Portrait with Dark Felt Hat 90,** Spring 1886, oil on canvas, 41×32.5cm, Van Gogh Museum, Amsterdam. **Self-Portrait with Dark Felt Hat in front of the Easel 91,** Spring 1886, oil on canvas, 45.5× 37.5cm, Van Gogh Museum, Amsterdam. **Self-Portrait with Grey Felt Hat 128,** Winter 1886/87, cardboard, 19×14cm, Van Gogh Museum, Amsterdam. **Self-Portrait with Grey Felt Hat 129,** Winter 1886/87, cardboard, 41×32cm, Rijksmuseum Amsterdam. **Self-Portrait with Grey Felt Hat 191,** Winter 1887/88, oil on canvas, 44×37.5cm, Van Gogh Museum, Amsterdam. **Self-Portrait with Pipe 116,** Fall 1886, oil on canvas, 46×38cm, Van Gogh Museum, Amsterdam. **Self-Portrait with Pipe 120,** Fall 1886, oil on canvas, 27× 19cm, Van Gogh Museum, Amsterdam. **Self-Portrait with Pipe and Glass 121,** Winter 1886/87, oil on canvas, 61×50cm, Van Gogh Museum, Amsterdam. **Self-Portrait with Straw Hat 127,** Winter 1886/87, cardboard, 19×14cm, Van Gogh Museum, Amsterdam. **Self-Portrait with Straw Hat 166,** Summer 1887, canvas on cardboard, 42×31cm, Van Gogh Museum, Amsterdam. **Self-Portrait with Straw Hat 169,** Summer 1887, canvas on panel, 35.5×27cm, The Detroit Institute of Arts, Detroit. **Self-Portrait with Straw Hat 170,** Summer 1887, cardboard, 41×33cm, Van Gogh Museum, Amsterdam. **Self-Portrait with Straw Hat and Pipe 164,** Summer 1887, oil on canvas, 41.5×31cm, Van Gogh Museum, Amsterdam. **Sheaf-Binder (after Millet) 322,** September 1889, oil on canvas, 44×32.5cm, Van Gogh Museum, Amsterdam. **Sheaves of Wheat in a Field 68,** August 1885, oil on canvas, 40×30cm, Kröller-Müller Museum, Otterlo. **Sheep-Shearers (after Millet) 323,** September 1889, oil on canvas, 43×29cm, Van Gogh Museum, Amsterdam. **Sheet with Sketches of Working People 364,** March–April 1890, pencil, 24×31.5cm, Van Gogh Museum, Amsterdam. **Sheet with Two Groups of Peasants at a Meal and Other Figures 365,** March–April 1890, black chalk, 34×50cm, Van Gogh Museum, Amsterdam. **Sheet with Two Sowers and Hands 365,** March–April 1890, pencil, black chalk, 23.5×32cm, Van Gogh Museum, Amsterdam. **Sien with Cigar Sitting on the Floor near Stove 19,** April 1882, pencil, black chalk, pen, brush, sepia, heightened with white, 45.5×56cm, Kröller-Müller Museum, Otterlo. **Skull with Burning Cigarette between the Teeth 84,** February 1886, oil on canvas, 32.5×24cm, Van Gogh Museum, Amsterdam. **A Small Stream in the Mountains 327,** October 1889, oil on canvas, 31×40cm, Van Gogh Museum, Amsterdam. **Sorrow 18,** April 1882, black chalk, 44.5×27cm, Walsall Museum and Art Gallery, Walsall. **Sower 251,** November–December 1888, oil on canvas, 33×40cm, The Armand Hammer Museum of Art, Los Angeles. **Sower (after Millet) 13,** April–May 1881, pen, washed, heightened with green and white, 48×36.5cm, Van Gogh Museum, Amsterdam. **The Sower (after Millet) 356,** February 1890, oil on canvas, 64×55cm, Kröller-Müller Museum, Otterlo. **Sower with Setting Sun 210,** June 1888, oil on canvas, 64×80.5cm, Kröller-Müller Museum, Otterlo. **Sower with Setting Sun 268,** November 1888, oil on canvas, 32×40cm, Van Gogh Museum, Amsterdam. **Spectators in the Arena 271,** December 1888, oil on canvas, 73×92cm, Hermitage, Saint Petersburg. **The Starry Night 302,** June 1889, oil on canvas, 73×92cm, The Museum of Modern Art, New York. **The Starry Night 248,** September 1888, oil on canvas, 72.5×92cm, Musée d'Orsay, Paris. **The State Lottery Office 27,** September 1882, watercolor, 38×57cm, Van Gogh Museum, Amsterdam. **Still Life with a Bearded-Man Jar and Coffee Mill 47,** November 1884, panel, 34×43cm,

Kröller-Müller Museum, Otterlo. **Still Life with Five Birds' Nests 77,** September–October 1885, oil on canvas, 38.5×46.5cm, Van Gogh Museum, Amsterdam. **Still Life with Open Bible, Candlestick and Novel 75,** October 1885, oil on canvas, 65×78cm, Van Gogh Museum, Amsterdam. **Still Life with Plaster Statuette, a Rose and Two Novels 187,** Winter 1887/88, oil on canvas, 55×46.5cm, Kröller-Müller Museum, Otterlo. **Still Life with Pots, Jar and Bottles 46,** November 1884, oil on canvas, 29.5×39.5cm, Haags Gemeente-museum, The Hague. **Still Life with Pottery and Three Bottles 74,** November 1884, oil on canvas, 39.5×56cm, Van Gogh Museum, Amsterdam. **Still Life with Red Herrings 100,** Summer 1886, oil on canvas, 45×38cm, Kröller-Müller Museum, Otterlo. **Stone Steps in the Garden of the Asylum 297,** May 1889?, black chalk, pencil, brown ink, watercolor, 63×45cm, Van Gogh Museum, Amsterdam. **Storm-Beaten Pine Trees against the Setting Sun 337,** December 1889, oil on canvas, 92×73cm, Kröller-Müller Museum, Otterlo. **Street and Stairs with Five Figures 409,** June–July 1890, oil on canvas, 51×71cm, The Saint Louis Art Museum, Saint Louis. **Street in Saintes-Maries 208,** June 1888, oil on canvas, 36.5×44cm, private collection. **Street Scene (Boulevard de Clichy) 131,** Winter 1886/87, oil on canvas, 40×54cm, Van Gogh Museum, Amsterdam. **Street Scene (Boulevard de Clichy) 132,** Winter 1886/87, oil on canvas, 46.5×55cm, Van Gogh Museum, Amsterdam. **Street Scene, Celebration of Bastille Day 103,** Summer 1886, oil on canvas, 44×39cm, Villa Flora, Winterthur. **Street with People Walking and a Horsecar near the Ramparts 158,** Summer 1887, watercolor, pen, pencil, 24×31.5cm, Van Gogh Museum, Amsterdam. **A Suburb of Paris 114,** Fall 1886, canvas on cardboard, 46.5×54.5cm, whereabouts unknown. **A Suburb of Paris, Seen from a Height 157,** Summer 1887, watercolor, heightened with white, 39.5×53.5cm, Stedelijk Museum, Amsterdam. **A Suburb of Paris with a Man Carrying a Spade 150,** Spring 1887, oil on canvas, 48×73cm, private collection. **Sun over Walled Wheat Field 295,** May 1889, black chalk, pen, brown ink, heightened with white, 47.5×56cm, Kröller-Müller Museum, Otterlo. **A Table in front of a Window with a Glass of Absinthe and a Carafe 138,** Spring 1887, oil on canvas, 46.5×33cm, Van Gogh Museum, Amsterdam. **The Tarascon Stagecoach 262,** October 1888, oil on canvas, 72×92cm, The Art Museum, Princeton. **Terrace of a Café (La Guinguette) 111,** Fall 1886, oil on canvas, 49×64cm, Musée d'Orsay, Paris. **Three Hands, Two with a Fork 56,** April 1885, black chalk, 20×33cm, Van Gogh Museum, Amsterdam. **A Timber Auction 41,** December 1883, watercolor, 33.5×44.5cm, Van Gogh Museum, Amsterdam. **Traveling Artist's Cara-vans 231,** August 1888, oil on canvas, 54×51cm, Musée d'Orsay, Paris. **Trees and a Stone Bench in the Garden of the Asylum 330,** October 1889, pencil, black chalk, 18.5×29cm, Van Gogh Museum, Amsterdam. **Trees in Front of the Entrance of the Asylum 331,** October 1889, oil on canvas, 90×73cm, The Armand Hammer Museum of Art, Los Angeles. **Trees in the Garden of the Asylum 309,** June 1889, oil on canvas, 64.5×49cm, private collection. **The Trinquetaille Bridge 257,** October 1888, oil on canvas, 73.5×92.5cm, Kunsthaus Zürich (on loan). **Trunks of Trees with Ivy 314,** July 1889, oil on canvas, 74×92cm, Van Gogh Museum, Amsterdam. **Twelve Sunflowers in a Vase 235,** August 1888, oil on canvas, 91×71cm, Neue Pinakothek, Munich. **Two Boats near a Bridge across the Seine 153,** Spring 1887, oil on canvas, 49×58cm, The Art Institute of Chicago, Chicago. **Two Children 397,** June–July 1890, oil on canvas, 51.5×51.5cm, Musée d'Orsay, Paris. **Two Cut

Sunflowers 180, Summer 1887, oil on canvas, 50×60 cm, Kunstmuseum Bern. **Two Cut Sunflowers, One Upside Down 178,** Summer 1887, oil on canvas, 43×61 cm, The Metropolitan Museum of Art, New York. **Two Cut Sunflowers, One Upside Down 181,** Summer 1887, oil on canvas, 20.5×26.5 cm, Van Gogh Museum, Amsterdam. **Two Diggers (after Millet) 335,** October–December 1889, oil on canvas, 72×92 cm, Stedelijk Museum, Amsterdam. **Two Peasant Women Digging in a Snow-Covered Field at Sunset 367,** March–April 1890, oil on canvas, 50×64 cm, Foundation E.G.Bührle, Zurich. **Two Peasant Women Digging Potatoes 73,** August 1885, canvas on panel, 31.5×42.5 cm, Kröller-Müller Museum, Otterlo. **Two Self-Portraits and Several Details 119,** Fall 1886, pencil, pen, 32×24 cm, Van Gogh Museum, Amsterdam. **Two Women Working in the Peat 40,** October 1883, oil on canvas, 27×35.5 cm, Van Gogh Museum, Amsterdam. **Undergrowth 172,** Summer 1887, oil on canvas, 46×55.5 cm, Van Gogh Museum, Amsterdam. **Undergrowth 175,** Summer 1887, oil on canvas, 32×46 cm, Centraal Museum, Utrecht (on loan from the Van Baaren Museum Foundation, Utrecht). **Vase with Asters and Other Flowers 104,** Summer 1886, oil on canvas, 70.5×34 cm, Haags Gemeentemuseum, The Hague. **Vase with Asters and Phlox 95,** Summer 1886, oil on canvas, 61×46 cm, Van Gogh Museum, Amsterdam. **Vase with Fourteen Sunflowers 284,** January 1889, oil on canvas, 95×73 cm, Van Gogh Museum, Amsterdam. **Vase with Gladioli 101,** Summer 1886, oil on canvas, 48.5×40 cm, Van Gogh Museum, Amsterdam. **Vase with Hollyhocks 105,** Summer 1886, oil on canvas, 94×51 cm, Kunsthaus Zürich. **Vase with Honesty 49,** Fall 1884, canvas on cardboard, 42.5×32.5 cm, Van Gogh Museum, Amsterdam. **Vase with Myosotis and Peonies 96,** Summer 1886, cardboard, 34.5×27.5 cm, Van Gogh Museum, Amsterdam. **Vase with Peonies and Roses 97,** Summer 1886, oil on canvas, 59×71 cm, Kröller-Müller Museum, Otterlo. **Vase with Violet Irises against a Yellow Background 373,** May 1890, oil on canvas, 92×73.5 cm, Van Gogh Museum, Amsterdam. **Vegetable Gardens in Montmartre 141,** Spring 1887, oil on canvas, 96×120 cm, Stedelijk Museum, Amsterdam. **The Vestibule of the Asylum 328,** October 1889, black chalk, gouache, 61.5×47 cm, Van Gogh Museum, Amsterdam. **Viaduct 152,** Spring 1887, cardboard on panel, 33×40.5 cm, The Solomon R.Guggenheim Museum, Justin K.Thannhauser Collection, New York. **The Viaduct 256,** October 1888, oil on canvas, 71×92 cm, Kunsthaus Zürich (on loan). **View from a Window (Restaurant Chez Bataille) 134,** Winter 1886/87, pen, colored chalk, 54×40 cm, Van Gogh Museum, Amsterdam. **View from Vincent's Window 140,** Spring 1887, oil on canvas, 46×38 cm, Van Gogh Museum, Amsterdam. **View of a Town with Factories 130,** Winter 1886/87, oil on canvas, 20.5×46 cm, Van Gogh Museum, Amsterdam. **View of Paris with the Panthéon 102,** Spring 1886, red, black and white chalk, 22.5×30 cm, Van Gogh Museum, Amsterdam. **View of Roofs and Backs of Houses 93,** Spring 1886, cardboard, 30×41 cm, Van Gogh Museum, Amsterdam. **View of Saintes-Maries 206,** May–June 1888, pen, 43×60 cm, Collection Oskar Reinhart "Am Römerholz," Winterthur. **View of Saintes-Maries 207,** May–June 1888, oil on canvas, 64×53 cm, Kröller-Müller Museum, Otterlo. **Village Street 380,** May 1890, oil on canvas, 73×92 cm, Atheneumin Taidemuseo, Helsinki. **Vincent's Bedroom 259,** October 1888, sketch in Letter 554, Van Gogh Museum, Amsterdam. **Vincent's Bedroom 260,** October 1888, oil on canvas, 72×90 cm, Van Gogh Museum, Amsterdam. **Vincent's Bedroom 352,** September 1889, oil on canvas, 73×92 cm,

The Art Institute of Chicago, Chicago. **Vincent's Chair 272,** November 1888, oil on canvas, 93×73.5cm, National Gallery, London. **Vincent's House 249,** September 1888, oil on canvas, 76×94cm, Van Gogh Museum, Amsterdam. **Vineyards with a Group of Houses 389,** June 1890, oil on canvas, 64×80cm, The Saint Louis Art Museum, Saint Louis. **Weaver Facing Left with Spinning Wheel 43,** April 1884, oil on canvas, 61×85cm, Museum of Fine Arts, Boston. **Weaver Facing Right, Interior with One Window and High Chair 42,** January 1884, pencil, pen, brown ink, 32×40cm, Van Gogh Museum, Amsterdam. **Weed Burner, Sitting on a Wheelbarrow with His Wife 35,** July 1883, watercolor, 20×36cm, private collection. **Wheat Field 214,** June 1888, canvas on cardboard, 54×65cm, Van Gogh Museum, Amsterdam. **Wheat Field under Clouded Skies 405,** July 1890, oil on canvas, 50×100cm, Van Gogh Museum, Amsterdam. **Wheat Field under Threatening Skies with Crows 412,** July 1890, oil on canvas, 50.5×100cm, Van Gogh Museum, Amsterdam. **Wheat Field with Cypresses 310,** June 1889, oil on canvas, 72.5×91.5cm, National Gallery, London. **Wheat Field with Cypresses 311,** June 1889, black chalk, pen, reed pen, brown ink, 47×62cm, Van Gogh Museum, Amsterdam. **Wheat Field with Setting Sun 211,** June 1888, oil on canvas, 74×91cm, Collection Oskar Reinhart, Winterthur. **Wheat Field with Sheaves 215,** June 1888, oil on canvas, 53×64cm, Honolulu Academy of Arts, Honolulu. **Wheat Field with Sheaves 216,** June 1888, oil on canvas, 50×60cm, The Israel Museum, Jerusalem. **Wheat Fields 393,** June 1890, oil on canvas, 50×101cm, Österreichische Galerie Belvedere, Vienna. **Wheat Fields 408,** July 1890, oil on canvas, 73.5×92cm, Bayerische Staatsgemäldesammlungen, Munich. **Wheat Fields with Reaper at Sunrise 316,** September 1889, oil on canvas, 74×92cm, Van Gogh Museum, Amsterdam. **White Grapes, Apples, Pears, Lemons and Orange (Dedicated to Theo van Gogh) 186,** Winter 1887/88, oil on canvas, 49×65cm, Van Gogh Museum, Amsterdam. **Window of Vincent's Studio at the Asylum 329,** October 1889, black chalk, gouache, 61.5×47cm, Van Gogh Museum, Amsterdam. **Woman at a Table in the Café du Tambourin 126,** Winter 1886/87, oil on canvas, 55.5×46.5cm, Van Gogh Museum, Amsterdam. **Woman Binding Sheaves 319,** September 1889, oil on canvas, 43×33cm, Van Gogh Museum, Amsterdam. **Woman on a Road among Trees 349,** December 1889, oil on canvas, 33.5×40.5cm, Kasama Nichido Museum of Art, Kasama. **Woman Sitting on a Basket, with Head in Hands 32,** March 1883, black chalk, heightened with white, 49×30.5cm, The Art Institute of Chicago, Chicago. **Women Miners 29,** November 1882, watercolor, 32×50cm, Kröller-Müller Museum, Otterlo. **Women Picking Olives 348,** December 1889, oil on canvas, 73×92cm, National Gallery of Art, Washington. **The Woodcutter (after Millet) 333,** October 1889, oil on canvas, 43.5×25cm, Van Gogh Museum, Amsterdam. **Zouave, Half-Figure 218,** June 1888, black chalk, watercolor, 30×23cm, The Metropolitan Museum of Art, New York. **Zouave, Half-Figure 219,** June 1888, oil on canvas, 65×54cm, Van Gogh Museum, Amsterdam.

First published in the United States of America in 2002
By UNIVERSE PUBLISHING
A Division of Rizzoli International Publications, Inc.
300 Park Avenue South
New York, NY 10010

Photo credits:
The Armand Hammer Museum of Art, Los Angeles; The Art Institute of Chicago;
Bridgeman Art Library; Centraal Museum, Utrecht; Collection Oskar Reinhart,
Winterthur; Foundation E.G. Bührle, Zurich; Getty Center, Los Angeles; Glasgow
Museums: Art Gallery and Museum Kelvingrove; Kröller-Müller Museum, Otterlo;
Kunsthaus Zürich; Museo Thyssen-Bornemisza, Madrid; Museum of Art of the
University of Oklahoma, Norman; National Gallery of Art, Washington; RMN
Réunion des musées nationaux, Paris; The Saint Louis Art Museum; The Solomon
R. Guggenheim Museum, New York; Städelsches Kunstinstitut und Städtische Galerie,
Frankfurt am Main; Stedelijk Museum, Amsterdam; UCLA Hammer Museum,
Los Angeles; Van Gogh Museum, Amsterdam (Vincent van Gogh Foundation);
Villa Flora, Winterthur; Virginia Museum of Fine Arts, Richmond.

Designed by Griet Van Haute
Translated by Suzanne Walters (biography)

Cover: *Self-Portrait*, September 1889, Musée d'Orsay, Paris, and *Vincent's Chair*,
November 1888, National Gallery, London
Frontispiece: *Little Blossoming Pear Tree*, April 1888, Van Gogh Museum, Amsterdam
p. 4 : *Fishing Boats at Sea*, May–June 1888, Pushkin Museum, Moscow

2002 2003 2004 2005 2006 / 10 9 8 7 6 5 4 3 2 1

Printed in China

Library of Congress Control Number: 2002107034

ISBN 0-7893-0803-7